Art and Architecture on the Mediterranean Islands
With photographs taken by the author

Art and Architecture
on the Mediterranean Islands

ERICH ARENDT

Translated by Edith Andersen

ABELARD-SCHUMAN

London New York Toronto

Copyright 1966 by Verlag der Kunst, Dresden
First published in Great Britain 1968
First published in U.S.A. 1968
Library of Congress Catalogue Card Number 68–14887
Standard Book Number 200.71547.X
Printed in Germany (East)

LONDON
Abelard-Schuman
Limited
8 King Street, WC2

NEW YORK
Abelard-Schuman
Limited
6 West 57 Street

TORONTO
Abelard-Schuman
Canada Limited
896 Queen Street West

This sea lies stretched between two polar hemispheres. Although a watershed, it binds to itself the two continental extremities of the earth's structure and their civilizations and ultimately connects them with one another, mellowing the polar, the alien to an accommodation, a fructification for man. Southward, across desert and burning rock, the brightness of Africa; northward the sway of the glaciers that pushed south in the cosmic oscillation of the earth's axis, extinguishing vegetation and life for thousands of years. At all events, an elemental and deadly wilderness in both zones. As in the geological, so also in the human sphere: when prehistoric man, making his mark without letters, came forth in the south from his silence, his anonymity, empires arose in the Nile valley, on the alluvial banks of the Euphrates and the Tigris, as unyielding and cruel to man as the timeless vaulted brightness over his head. Stone primacy of the Pharaohs, of priestly castes and almighty bureaucracies. Hierarchical ruling classes, who once came riding in hordes from the steppes of the north and of Asia, had made abject slaves of the aborigines of the fertile alluvial lands. In the rigid edifice of their social forms, which stripped man of power for the exclusive godlike existence and glory of a ruler and his noble and priestly castes, there came to be an impenetrable loneliness of faces, a reign of fear inspired by the powers of heaven and earth, partly as the heritage of prehistory surviving in the breast. And as the first creation to outlive time we find the human image and the human form in the hieratic immotility of an art where realistic forms were unconditionally subordinated to a set of ideas, as to an absolute—the expression of that society's rigid structure.

From the north, the home of wanderers, where existence was a struggle against nature, there came the barbaric tribes of nomadic herdsmen and horsemen, forcing their way south in search of better living conditions, breaking into the Mediterranean regions and destroying the first wondrous civilizations. Thus began, after twenty thousand years of matriarchal cultivation of the soil, the division of humanity into masters and slaves — historic times.

Yet here, too, prehistoric obscurity prevails at first; man still hunts, and his whole day is determined by it, for hunger is his goad, and he hunts the wild horse, the bison, the mammoth, the stag, just as he did half a million years ago. The world is still inexplicable, uncanny, a chaos; and all is one, the self a part of an overwhelming flood of existence which can only be comprehended or exorcised through magic. Fox, wolf and gazelle are my ancestors, and sacred. Self is identical with all, part is identical with whole,

symbol and object are interchangeable, image and reality are mystically twinned. Everything is independent of cause or logic, everything is sacral; my hand, my dance magically influence sun, moon and beast.—In the midst of prehistoric time we travel in a modern ship from the artistically laid-out salt gardens of the Sicilian coast, strewn as far as the eye can see with glittering white pyramids; we sail away from trade, from wealth and poverty, from the ugly industrial districts of Trapani, to a sea that surrounds us today as it surrounded Stone Age man sixty thousand, twenty thousand years ago; and out of its waters rises the island of Levanzo, bare and studded with boulders. From the tiny harbour we wander over a rocky path across the almost uninhabited, stone-dreary island. Nothing but loneliness. On the north side, only the silence of rock and sea. Down a pathless cliff we find the cave at the rockslide twenty metres above the everlasting surging and foaming of the tides. Invisible from the land, invisible from the sea. A mother cave of the earth, not made by the hand of man. Dark, uneven its interior. Walls rounded outward, inward. And distant from the entrance, far from the daylight, wrapped in absolute night, the pictures—little human phantoms painted black and red, in an alien rhythm, distributed according to some law unknown to us, as if scattered over the rock, frameless and limitless. But with an inner tension sometimes supported by juttings of the wall, and thought out, designed according to a plan—one senses this—before the details were carried out. Some of the magic shapes are high up near the ceiling, out of reach. And here, at the height of the eyes, tenderly scratched into the rock twenty thousand years ago, we find a horse, noble, perfect, great in its abstraction.

The art of the ancient Stone Age was linear; the outline determined the form. Only later was modelling with colour added to it—the approach to nature, for the sake of magic. The development of the cave drawings progressed from strict stylization to realism, from the ideoplastic to the physioplastic, only to return again about the end of the Ice Age to an abstraction which, in contrast to the archaically severe and compact first epoch, became expressive and dynamic, as man became the main subject of the cave painting.

The images and symbols of the Stone Age men, like those on Levanzo, or in Altamira and Lascaux, the most significant ones up to date, were always hidden deep in the earth womb of the caves, often more than seven hundred metres from the entrance, in absolute darkness. They served exclusively ritualistic, magical purposes. No one lived in these caves, as in

the ones over Sperlinga in Sicily, from which one can see far out over the countryside; no one stirred a fire with mammoth bones here, or consumed a meal. Here the sorcerer conjured for the assemblage with his burning brand; here images and symbols, in order to become still more potent, absorbed the mysterious forces of the earth, whose interior gave birth to the beasts.— The great awakening to representation, that conquest over naked instinctuality and cosmic fear of life, had been prepared by hundreds of thousands of years of magic, before the act of creation, the immortality of image and symbol was achieved, and man, at last free, made the form that defeated time: a beginning of thought and of representation, triumphal anticipation of all the civilizations and ingenious creations to come. The painter of the Ice Age was the sorcerer of the tribe or clan whose images, abstract or true to nature, were meant to influence the processes of nature, bringing about the death of the hunted animal, or its fertility through repetition and accumulation, up to five hundred of the same kind in some caves. In this world of sorcery, the act of representation is always an influencing of the powers of life. The prehistoric artist was never concerned with mere depiction or imitation of nature, even when, as in Lascaux, his figures were direct and true to life in the highest perfection. His intent was solely the mystical connection between image and reality. Pre-logical man, in his belief in the cosmic power of the image, created a realism whose origin was fundamentally different from the kind which has dominated, exclusively in Europe, since the Renaissance. The aim of the latter, with its faithfulness to reality, was, in accordance with the trends of society, the conquest of space and man; in the multiplicity of its artistic concerns an exceptional case among human societies and civilizations.

But the greatest miracle and spiritual achievement at the inception of man's will to representation, as old as prehistoric realism, and perhaps even older, is a perfectly abstract art. Instinctively defending himself against the undertow of the teeming, reeling universe he sees around him, in order not to go down in its maelstrom, the cave-dweller seeks a systematizing principle that permits him to recreate mentally a world that is limitless and chaotic; he makes laws for himself in form: symmetry and repetition. The simplification is a mental principle, in absolute contrast to any naturalism.— In his first attempt at self-assertion against the dark powers, he lays his hand—magical claim to dominion—upon the rock, and blows red and black colouring onto it through hollow bones forming a negative of the hand. His fingertips trace the first lines in the clay—confused, accidental patterns

from which, as if created in a dream, in a stroke of luck, human-looking forms, shapes, heads appear (Altamira). In this process, the same object inspires both the utmost capacity for abstraction and an intensive grasp of reality. Challengingly now, the opportunity presents itself for reproducing once again, with flint-knife or brush, the surprising results obtained by the artist's finger. The capacity of pre-logical man for abstraction must already have been enormous, to be able to discover in the confusion of blindly traced lines the outline of an animal's head, that artist's abstraction of a thing, when the animal had always been experienced, observed and conjured as something real! The mentality of sorcery created an intellectual simplification and interpretation of realities. The oldest representations by human hands have an emphatically abstract character. At any rate we find them thousands of years later by the side of realistic depictions. Abstraction and realism, the mental and the sensory comprehension of the world, are both rooted in human nature and are found in its artistic utterances from the very beginning, either side by side or interpenetrating one another. Any approach to reality here can be boldly traced back to purely geometrical forms which interrelate with rhythmic harmony, like the Venus of Předmost in Moravia, engraved more than forty thousand years ago on the tusk of a mammoth: everything appears to be a play of curves and straight lines around an austere vertical symmetry. The delicately incurved triangle of the face, the encompassing arc formed by the arms, the shell-shaped breasts, the oblong, concentrically growing arena form of the pelvis—here is the direct ancestor of Picasso's boldest symbolic drawings.—Or abstraction and realism merge into new inescapable forms of expression, as in the count-less little Venus figures, symbols of fertility, which mark the feminine sexual forms, breast, pelvis and pubic triangle, or make them concretely stand out. The figure as a whole, however, is transformed into a purely abstract image, geometrically severe or curved like the outline of a violin; or else doubly symmetrical, both in the natural verticals and the invented horizontals—a double reflection of the torso without limbs.—In her austere architecture the Great Goddess of the Cyclades from Paros, a late Stone Age art work made in about 2200 B.C., is a late magnificent variant of the little Venus figures, like them a symbol of a pre-mythical and mythical world, representing the Earth Mother, fertility incarnate, the absolute Goddess who rules over birth, growth, death and resurrection—Earth herself—a symbol which was an active part of their lives. Grandeur, self-sufficiency, inaccessibility are pro-claimed by the Goddess of the Cyclades in the impenetrable square of her

crossed arms and shoulders, within which the symbols of fertility are hinted, and geometrically above them the oval of the head, which is like a part of the body, absolutely mute, all-powerful Earth without the spiritual symbols of eye or mouth.

At the very beginning, prehistoric artists had made form the main problem of art by placing its emphasis on symmetry and repetition and on the geometrical principle in representation, anticipating the later artistic discovery made by Ucello, a Renaissance painter who wrote, "The square and the triangle, along with the curve, form the basis of composition in painting". The human mind strove from the beginning to capture the sum of the real in one elemental act, and found it in geometric form. This was also the moment when the primacy of the static-monumental animal picture on the ritual cave walls was broken, and a new form of expression, a new representational impulse appeared about 6000 B.C. In sudden consciousness of himself as the lord of the beasts, within a framework now completely permeated with rhythm, man proclaims the dynamic of his actions in the hunt, the dance, the battle. Now everything has become movement, ecstasy, passion. Expression and form have become intensified, overwrought reality, jumbling it up and exploding it. The object represented by post-Ice Age man becomes unnaturalistic, purely expressive. Colour is used only compositionally, line is the means of expressing a tremendous emotional overflow, as it became again thousands of years later in the works of the Gothic period and in expressionist painting and sculpture.—Probably the farthest advanced in boldness of line and imaginative expressive vision are the late cave-drawings of the western Mediterranean in Spain. Here we discover the artistic attempt to represent something purely mental, an abstraction of the demonic in nature, the spirit world of pre-logical existence, where the eye floats beneath the armpit, where the sphere of plant, animal and man is surrealistically mingled in one being and the body can become a mere stroke. Here we have the first draft of the monstrous. This, too, anticipates the surrealistic way of looking at things and representing them, as in Bosch, Miró or Klee. All the future art of Europe was to be perfected and fulfilled in these essential basic attitudes of Stone Age man in his art—in change, in conflict, in the interpenetration of abstraction, realism, phantasm and expression. But in regard to the cave-paintings, one question remains: was this art pure sorcery in its intention, or did it represent the creation myths of that epoch of mankind—or was it both at once? In any case, its original foundations were exclusively religious.

We also come questioning to the soil of Knossos: What is the meaning of the art of Minos? What spirit does it reflect? How much nearer is it to our feelings, our spiritual existence, than the Great Goddess of the Cyclades? Is it nearer than the sacral immotility of Egyptian statues— that absolute spell of a death cult that overshadowed everything—, nearer than the tyrannical power and monumentality of the pyramids and temple structures of the Nile?—Here also in Minoan Knossos, a centre of Cretan city culture about 2000 B.C., the Mother Goddess of time immemorial, the world of prehistoric procreation and fertility symbols still reigns in a people who live and express themselves essentially in magic:

The Sacred Bull is sacrificed instead of the Sacred King, in order to make the earth fertile; the double axe appears on walls and vessels, symbol of the authority of the priestess, representing the waxing and waning of the moon as well as life and death; the snake twists in the hands of a naked-breasted, doll-sized goddess, the Great Mother, as a symbol of wisdom and of the earth's secret, the creature that sheds its skin being a revelation of cosmic immortality. Here in the matriarchal realm of cultivation of the soil the feminine snake still represents the good forces of life, she protects the house and the dead; until under male domination, under the warriors, heroes and horse-breeders, Creation is no longer ascribed to the female. Historic time begins, and the domination of man; now Zeus kills Typhon, the snake demon; now, in the Biblical myth of Creation the snake is introduced as the demon enemy of life, in order to strip the ancient mother symbol of power. — The realm of Minos, at least from 2000 B.C. on, must nevertheless be included in recorded time with its abundant historical existence, its writing, its city culture—despite the matriarchal cultivation of the soil as a basis—with its market economy and its commerce, which radiated out from the prince-doms of Knossos, Phaistos, Mallia, Hagia Triada, Palaikastro and Gurnia all the way to Egypt and far into Asia. Yet for all its mythical strangeness and ancient matriarchal magic, for all its talismans worn about the neck or planted in the earth, how free, how blessed the life represented in Knossos seems to us moderns, how humanly familiar the facial expressions on the colourful frescoes, the joy of living, the peacefulness of the painted scenes of life, of play, of religious ceremonies. Here the overwhelming might of the religious, imposed on life for thousands of years at the Euphrates, the Tigris and the Nile as a discipline, a principle, has been banished. No death pyramid reminds Crete of the other world. No gigantic temple edifice, no monumental sculpture impresses man with the omnipresence, the over-

shadowing omnipotence of a god. Here in the realm of Minos, long before Delphi and Athens, everything has become a symbol of earthly living, the ritual horns of the sacrificed bull (Delphi also had its altar built of bull horns) ornament the pinnacle of the palace to a height of two metres; and much has become an implement, a ritual implement, such as the double axe which evokes the killing of the bull. The religious ritual, carried out without sternness, like a festival, takes place under the open sky, in front of a tree or a spring, or in a grotto, the ancient symbol of maternity and rebirth. Bird and snake only signify the vitality of the godhead, the dove which settles on the head of the goddess, the snake which darts out of secrecy, out of the inner earth. The religious ceremony is a joyous procession, an ecstatic country dance, weightless, as if liberated from the secret dark powers which once ruled absolute from the beginnings of time in the first great civilizations of the Nile and the Euphrates as if they were all that mattered. All other expressions of Cretan art make an impression as worldly and profane as the graphic representations of Minoan worship—a *joie de vivre*, a delight in plant and animal, an almost pantheistic inclination towards and unity with all creatures, with nature, in natural concord and harmony. As in paradise, an innocence and peacefulness of plant, man and animal interwoven on frescoes and pictures, in a motionful, harmonious interplay of blue, yellow, green, orange and light grey. The rhythm of life, the joy of living as a polarity to the rigid laws of Assyrian or Egyptian existence, the only laws which had prevailed until then.

Expression of an untroubled existence whose aim was to rejoice, to gladden. To praise the delicious hour that man has on earth, to live conscious of the happiness of this gift of life. We find an unending ring of life circling over vases and vessels and tub coffins, with a magic never again achieved by the potter's art, as long ago as the early Minoan period, about 2500 B.C.— spirals, curves, waves of fish and ornaments, constellations. And from 2000 to 1580 B.C., with still more movement, we find the water birds, the papyrus stalks, the tendrils of flowers and the beasts of the field added to the webs of coral and seaweed and the eight-armed octopi, nature form wedded to ornamentation in consummate art, spreading out harmoniously from the centre to all sides, as if overflowing the rims, as if the orbits of life knew no ending. On mugs, peaceful enamoured cattle, wild bulls being tamed. On vases, the exuberance of the reapers, the harvest one grand ecstatic procession and song; on others the life of the shepherds. The spell of the powers hostile to life, which made everything rigid and stationary, is

broken here for the first time. And the people on the frescoes, male and female, have that same centrifugal outflow from the centre, from their narrow waists, as much a wave of life as the octopus, as the ornamentation of flower and animal. A spinning that extends through torso and limbs, through head, foot and hand, an onward current of life.—Whether a blue monkey moves like a dancer in a red and yellow rockscape between eye-like flowers or a narrow-hipped, supple boy gracefully picks saffron blossoms, as if floating, everything breathes youthfulness and is far removed from the fear of the cave-dwellers, from the unfreedom of Egyptian slave existence. A golden age, an interregnum, a deep breath of relief drawn by the earth between the dark magic powers of death on the banks of the Nile and the coming Iron Age, which was to begin with the myths and battles of the Greeks.

The first portraits in Europe, the representation of Minoan women, are pure exaltations of life, a eulogy of the living beauty of the sex: the urban elegance of the décor, brocade and abundant folds, tightly bound waists, the breasts free as nature, the bell-skirt with flounces, and everything enchantingly crowned—with dark eyes, black curling hair, the head on a slender neck, dainty and proud. The whole an image of conscious charm, feminine self-realization, of the seductive freshness and naturalness of a cultivated life. Every representation of the human being is an expression of intense delight in life, of pure, deep enjoyment of living, a weightlessness without weakness, without over-refinement, such as we later find dominating rococo with its similar grace, sensuous pleasure and colourfulness.

Even the earthen sarcophagi seem related to life. They reflect no terror in the face of death. Graceful, marked with coloured garlands of flowers or with wavy lines as the expression of life, they stand before us like a promise of never-ending existence. The bucolic picture of a lamb and a mother goat on a coffin as companions of death tell of an Other World without fear, without shadow, without mourning. For the first time in human history.

The same delighted feeling of being on earth is conveyed by the sprawling and yet very graceful palaces of Knossos, Phaistos, Mallia and Hagia Triada. Here is architecture conducting a dialogue with the landscape; standing there in the open, unprotected, unsheltered. The countless rooms of the extensive palace complex of Knossos are small and loosely connected; the whole occupies an oblong 160 by 150 metres. It all seems so improvised —one room grows out of another, one seeming to enter the next, no two alike, and scaling upward to six stories by way of pleasing staircases

set about with columns that grow younger towards the base—cypress trunks standing on their heads, painted in red, black and golden yellow. The throne room is also pleasing, indeed it might be called modest, not situated centrally where it might command awe. And everywhere one can see into the interior of the structure and out into the landscape, to the spacious gardens overhanging the slopes, the modern, intelligently ordered rhythm of a voluminous building and the continuous, lively alternation of closed rooms, open verandas, galleries, vestibules, pavilions, winding corridors, the continuous change from stone architecture to painted beams, luminous columns, alabaster-covered walls, frescoes and niches. The gleam and flash of light, guided downwards, is broken to make the glare of the sky bearable, a blessing in the sun-deaths of the summer. (It would appear that the realm of Minos died several times, not only from the violence of earthquakes and tidal waves, but from the sun when no rain fell on Crete for years and even decades.) The colourful play of nature on the island penetrates the rooms everywhere in painted symbols, on the walls the gaily glistening feathers of birds, the marine play of waves and dolphins, not seen or felt as mere decoration but as an element of cosmic religious feeling. There are griffins and shrubs in radiant colour on the wall of the throne room behind the simple stone throne, the oldest one preserved on earth. And at the centre of the whole structure, the heart of it, 60 metres long and 28 wide, the smoothly paved courtyard, the stage for ritual and display, for the labyrinthine, ecstatic dance, for games. Knossos charmingly displays the endless possibilities for elaborating a royal dwelling. This ancient building tradition is still followed in the Mediterranean area today and has spread to the hot zones of Central America, where the social life of the household takes place in court and patio.

In its satisfaction with life on earth, in its relaxation, the first island art of the Mediterranean, Minoan art, whose essence is embodied in Daedalus, the first mythical artist and inventor, has never again met with its like in historic times. Here there was never any show of power, never any crushing, overbearing monumentality, the sign of despotism or inner decay. Everything served life, was a function of life; everything was an endeavour to capture the beauty of the world and to integrate it in the glorious moment of experience. As Knossos appears to us, its existence was an untroubled paradise, pure bright day. Here were the beginnings of the great Mediterranean civilization, surrounded by nations which did not share its sense of reality.

The life aim of the next Mediterranean people, the Achaians, was not to raise existence to a higher level, not to drink in its pleasures or to share them. Its essence was the battlefield, the conquest; its virtue was warlike valiance; life to the Achaians meant domination. A people of horsemen and conquerors, they came from the north to the peaceful shores of the Mediterranean, occupied the Peloponnesos, attacked Crete and destroyed Knossos—and with it, for the time being, the culture of Minos. Yet its earthly harmony, its grace, and that first womanly smile, if one may call it that, which influenced the world, compelled the unbridled war power to respect the first culture and art of Europe. Without Minoan artists, Mycenae is unthinkable, it could not have come about.

The invasion by the Dorians which followed in the Mediterranean area put an end to the mild rule of Crete which set an early standard of human culture, a miracle amidst the demonic, prehistoric formlessness all around and the Egyptian absolutists' measureless contempt for man. After their devastation of the islands and the mainland of the eastern shore, a prehistoric obscurity returned for five centuries, out of which there came no human utterance, no light. How the most original of human cultures developed out of these annihilators and oppressors of the first Pelasgian inhabitants and their Greek cousins, the Ionians, who retreated from the invaders eastward along the Asian coast of the Mediterranean, remains incomprehensible, unexplained. What could have caused the great transformation in these originally nomadic, semi-peasant, warlike tribes of Doric horse-breeders? What made them settle down and found city-states, what caused the impetuous development towards a humane attitude as the meaning of life—a new form of existence which for thousands of years was to influence the self-realization of man, his emergence towards freedom of the spirit, the foundation of a human ethic and a human example in actions and in artistic creation?

Prehistoric shepherds and peasants everywhere had worshiped the stone as a deity, had stood it in the earth, erected it as a symbol of permanence, as a brother of man, but indestructible as the earth's foundations; also as a god, or the stone body which is the deputy of the dead; as a gravestone in ritualistic worship or, like the Betili in Sardinia, as a phallic symbol containing the inexhaustible within itself, a symbol of potency. Now, however, among the Greeks, the column finally arose out of this ancient figure of versatile symbolic power. They saw in it the symbolic-physical image of man. In the first early Greek representations of man we can still sense the

original forms of the erect stone and the column. The Greek columns and the caryatids that support the structure seem interchangeable, except that the latter carry it more freely. We only discover the corporeality and lifelike quality of the column, the way it seems to breathe in the easy swell of the shaft, a living thing, when we see it standing alone before us in sky and light, a relic of time—whether amidst the death rubble of the temple on Delos, where the stretched-out trunks of columns still breathe like living beings, or standing slim and upright, one after another, beside the rudimentary torso of the Naxian god, or in white loneliness, amidst waving umbels, at the Samian Sea near Tigani: a torso of tambour upon tambour, rising up steeply and full of life, or in earthly grace and power still bearing the entablature, columns bearing columns which in turn support the sky, as in the Aphaia temple on Aegina. Whether in the powerful colonnades of the uncompleted temple of Segesta (in Sicily the colonial style often exceeds the original proportions) or in the older hall of columns in Lindos high above the sea, a mute flight of bodies in a ring dance, or, a later work, the ruins of Cos—everywhere the column has been given a genuine corporeity and is magnificently effective even when it has been built into a Christian church, as in Syracuse, where it is the thing that is really alive, although our eyes are still impressed by the dynamic movement and the abundance of lines in the powerful baroque façade. The physical quality, the life of the severely grooved columns, has more reality, greater tension than the most sweeping of the curves.

It is always this bodily quality of the columns around the Greek temples that speaks to us like the presentiment of an early human form which desires to emerge, to become fully visible. What a different feeling from that of the Egyptian columns, stones standing on end that have no life of their own, that remain strictly a building element, even where whole sacred avenues are formed of rams and sphinxes, and yet merely stand there like so many walls. The Egyptian column is never set off by air and light, free, an independent being. The pillars and columns of Egypt bear the mighty, crushing temple, that stone immutability in time; its plant columns, lotus shafts, whole palm forests in dim gigantic halls are frighteningly monumental, irremovable, forever under a non-human law, forever in a state of unconditional superiority in the face of constant death and the kingdom of the dead. Their purpose is to give man a foothold in the rushing river of time, which the Egyptians experienced hourly and cruelly. In controlled freedom, liberating those who look upon it, the Greek column arises in the light of

the temple hills, so arranged that each is an individual, one of a moderately limited number, which is not fulfilled through vanishing into the mass, through subordination to structural considerations. Every cylindrical column of Greece, whether smooth or grooved, is an organic being, far more organic than the purely plantlike representations of the Egyptian papyrus and palm columns, which remain everlastingly rigid stone. Even the Mediterranean culture of Crete, whose merchants traveled up the Nile as far as Thebes during the time of the Middle Egyptian Kingdom, selling wines, textiles, oils, cypress wood and pottery, so that they were perfectly familiar with the Egyptian building style, retained the consummate moderation of its columns and their subjection to man.

During the historic vacuum after the Dorian invasion, from 1200 to 700 B.C., the column seems to have been made of wood, expression of the trammels of earth. It was a fetish of procreation, of fertility in the midst of an impenetrably reigning chaos. In the five hundred years of nameless obscurity, in order to survive, the Greek nations were forced into a struggle to wrest form from the formless, the dreadful. And out of this gruesome, human-intellectual struggle, columns and temples and images magnificently emerged in the same process of creation as the myths of the genesis of the earth and the life of the gods. For the first time in the history of mankind, an interpretation of man arose here in myth and art, a groping inner conquest of his being that sharply contrasted with everything which had seen him as a mere object, as in the worlds of Egypt and Mesopotamia, where he could only figure in the sacral edifice of an absolute state. Gradually, out of the corporeity of the column, the torsal curvature, emerges the complete figure of a man. But on Attic soil, on the Greek islands, this is at once an emergence into freedom—the essential element of the Greek image of man. The first human figures, which seem only just now to have escaped their earthly condition and whose hieratic-sacral origin, whose descent from columns is overpoweringly obvious, are the archaic Kouroi, consecration tributes to the god or goddess, like the "Philippe" of the sculptor Geneleos or the grave-steles of life-sized nude youths such as the splendid Kouros of Melos or the gigantic one from the Acropolis on Thasos, holding a ram, or that perfect, beautiful, marvelously modeled torso in the Syracuse National Museum—yes, even the still imperfect Kouroi in the rock wilderness of Naxos lying beneath the naked sky for thousands of years as if they meant to rise again some day in the innocence of Paradise, messengers of man's pride in his incontestable beauty. Even the earliest Grecian sculp-

16

tures that have come down to us, exhibit as the most characteristic expression of Greek existence and ambition a complete, pure plasticity triumphing over the ancient fear of death, which had been the motive and the reason for all art expressions of developed cultures up to that time. While the restrained stride of the Kouroi or the unusual monumentality of the ram carrier on Thasos—a youth who is a demigod—may still distantly recall the overwhelming presence of death, his protection of the animal is a humanly touching gesture, a break-through of the pre-archaic impulse to stylize, which had expressed a belief in chthonian forces with absolute power, a universe perceived purely magically.

A first eager groping and yet a decisive step towards the humanization of man, towards his emergence into free existence as a person: here, achieved in a very difficult process of resolution, is the beginning of the first *profane* art on earth, whose goal is man and his destiny and which gradually destroys the eternity myth of the ancient demon, sun and moon cults. We find the archaic ephebe (Museum of Agrigento) raising his arm in the daring of first self-discovery. There is a godly independence about the way he puts forth one foot, as if out of the darkness. A human figure whose body is flawless, beautiful, visible from all sides, admirable; self-contained—a power. This proud step is a sort of leaving behind of the most ancient myth, and at the same time a transformation of it. No longer to be bound to an overpowering temple façade means no longer to be the creature of godly caprice, of the Powers, not to be a mere symbol or counter-symbol, not to represent something else or to be lost in stone. No longer to be only visible from the front means no longer to be the everlasting inferior of death, of blind fate. The Kouros of Melos strides inexorably into a certain future; we sense that this boldly begun self-liberation, this striding forth will grow surer, and that this determination, evident in the posture of the Kouros, has a goal which is on the point of fulfillment—namely, to become like a god. All of man's future development begins here in this stepping forth into brightness, into the Greek miracle of light that reigns over the island sea and bestows grace: to see the god in man, the man in god, a mutually heightening, deepening union towards the perfection of man.

Probably the purest human countenance ever created gazes at us stirringly in the Kouros. A smile that still knows what fear is, the magic fear of old, yet no longer feels it—a first liberated human smile, young, tender and strong, full of confidence in a life that must be shaped only according to human values and laws and shall be so shaped from now on, on that archi-

pelago of the gods and the first free men. The smile of the Kouros has broken the absolutism of the sacral that prevailed since ancient times; the eternity myth has been guided towards an earthly-human one, taking root in it. Within the sphere of this smile, the demonic and bloody which was man's beginning is brought into harmony with the intellectual. Heroic in a strictly peaceful sense, that of achievement, of the struggle for self-perfection, the marble figures of the ephebes stand before us in the faultless nakedness of the youthful contestants in the Olympic Games. Heroic: for man's ancient heritage—carnal, wild, dark—may break out again at any moment, as it does in the raging intoxication of the bacchants. Precisely this latent danger of chaotic powers whose existence in man is well known, which is manifested in the Dionysian element that everyone feels breaking forth in himself again and again (and which has taken form in the "stony-eyed Gorgon", more subdued in the Naxian sphinx), this constant implied danger is what gives the Kouroi (its first vanquishers) their tremendous inner tension, their burden of destiny. The limit-defying cosmic relations, after tens of thousands of years of an existence in dread, has found a limit for the first time; and sure of himself, god and man in one, the Kouros strides with wide-open eyes through his day, in wakeful enterprise against the dark devouring powers that are always potentially present. The blood-bath of the women of Lemnos against their men, the fight against the matriarchal Amazons and their blood cult, the pursuit and rape of the nymphs by Zeus, all this, not only myth but the elevation of reality, takes place hourly within each one—and externally it takes place in the contest, in the Olympic struggle, where self-discipline, harmonious heightening of all the powers of mind and body, and highest morality are achieved—naked.

As early as 800 B.C., the archaic epoch saw human grandeur in the figure of the god. And the god was experienced as myth and realized over and over again in daily life, myth and religion being spun anew by each individual. No dogma, no priesthood, no sacral autocracy arose. Each man recreated the god and the god's life and deeds.—Not that man's daily life was a harmonious, radiant thing. We know: The Achaians, whose gods were as unscrupulous, covetous and selfish as human beings, the Achaians in their insatiable greed (Troy had to fall!), murderous, violent, false, whose means of production was the sword, had nevertheless found one kind of measure, stern and meaningful, a centre of life which was their support in the dark raging of their blood—the structure that was theirs alone, their house. The clear space with the front court, ancestor of the much later

temple, provided a first ordered measure. The fireplace, the hearth—fire, token of civilization—was the place which centuries later would be occupied by the image of a god—image, token of civilization.—And the Dorians? Their inordinate passion for war depicted in thousands on thousands of vases, their belligerence, their struggle of city against city to the point of annihilation and self-destruction, whose only intermission was during the peaceful Olympic festivals that united all Greece, lived lives full of strife, envy, danger and cruelty. It was a world of absolute father worship, patriarchal law, whose most powerful expression was in the symbols of the horse, the sun and the phallus. (In Athens, in honour of the godly fructifier, in the early Dionysian festivals, mighty phalli were carried in the ceremonial processions, and four centuries later on Delos as a consecration tribute to the god, a gigantic phallic monument pointing to heaven was erected which has outlasted time.) Only when we consider their daily life in terms of its barbarousness and tragedy do we become clear about the lofty image of man in all its greatness that was achieved in myth, sculpture, personal discipline and self-realization, culminating in the Olympics. And then—ever and again, out of the early world of the "Mothers"—the other menace broke out, the intoxication of the Panic-Dionysian with its untrammeled ecstasies, originating in northern Thrace, or with the fertility rites of Astarte, the cult of Cybele, radiating out from the Asian regions all the way to Grecian Sicily, with their symbols of the winged ram and the portraits of the Asian earth goddess as she appears in the Cybele image of Acreide hewn in the rock.

With his soul obsessed by the powers of birth and death and full of bloody history, his body in the grip of indomitable chthonian frenzies, man advanced towards humanness, through an initial containment visible in the geometrical style, in the early bronzes of the 8th century B.C., such as were found on Samos, a rapid progression towards form, thought, representation and humanity which was astounding at that time in a primitive, barbaric people.—But continuously threatening and interrupting this process, overwhelming influences from the land of the Nile and the ancient Orient made their way to the shores of the Mediterranean. They represented the fetish world of a strange religion in which the prehistoric deification of the beast as a force of nature had assumed semi-human form in the sphinx, the animal with a human face, worshiped in its own temples where winged lions and bulls were the terrifying guardians of the ruler and of a super-natural Other World. In its continuous striving for expansion and trade, the

young Greek nation, itself semi-barbarian, increasingly feels the impact of all these phenomena of magic and of a still present past. And then suddenly, as if out of a purely human sphere of life, we find the sphinx of Delos, winged but without wild terrors, we find the bodies of lions as gravestones for heroes and venerated leaders, disciplined, stern; we find the earliest Greek representations of animals, the marble lions of Delos, glittering in their whiteness, slender and tense under the calm, transparent austerity of the sky, no longer watching over the kingdom of the dead but sheltering the birth of a god born of a nymph—Apollo of the sunlight, of the mind. The demonic wings of the harpies (original symbols of the Cretan goddess of death, who raged in the form of a whirlwind) soon cease to beat in the vicinity of the Aegean Islands. The Nike of Delos from the shrine of Apollo, still built frontally into the pediment of the temple, already proclaims the victory of the open, human female countenance. Her wings are no longer the expression of an incomprehensible wild force of nature. Here nature and human being are already merged into one—proclamation of the victorious human spirit. The Nike of Samothrace (Paris, Louvre) celebrates still more passionately, more victoriously, the marriage of heaven, earth and man—a desire to be purely a bright rustling of wings and garments, an embodiment of the life forces and of nature in its dazzling beauty. The brightness of the Greek sky, the winds blowing about its earth and the Aegean Sea, the free rhythmic beat of the waves, become humanized, corporeal in this marble Nike. The deity is now realized only in human form; the god becomes body, and the body is god's. This is the striving of the new human consciousness, the new, revolutionary feeling for nature. And everything must become plastic, visible, tangible, real. The light we sense in every arch, every flow of line, every corporeity of a figure, is stronger than the darkness that served in fear and shackled the day and man.

This was the basic experience of an early people: everything must become visible, so that there should be no more room for the ancient musty powers of savagery. Visibility as a spiritual element emerged from the menace that resided within the individual. And then came the lofty principle of improvement, of perfection, and the harmony that maintained a balance between the conflicting realities. The goal was not reality itself, nor was realism the principle of Greek art, either in the early period or at its peak in classic times. Rather balance, harmony and then a law that comprehended the finite and the infinite—the golden section. Plain representation of reality only began in the period of decline.

Now the wings of Nike proclaim in an eternal rhythm the triumph of light. No winged Assyrian bull rages over these islands, no Minotaur devours the creature he loves. The plantlike quality of the tops of Egyptian columns give place in the Aeolian capital to volutes on slender shafts, to spiritual forms convoluted under the roof, with a certain heaviness at first (the early Aeolian capital at Mytilene), but soon afterward acquiring a victorious grace and marked sensitivity, a serene, almost dancing ease in bearing the weight. In contrast, the volutes and signs on the Bronze Age gate of a vault from the Necropolis of Castelluccio in Sicily make one feel plunged into worlds before time—symbolistic, unfathomable, secretive, a language alien to the Hellenic spirit. Something demonic out of the oriental-sacral sphere of the instincts has been expressed in that heavy stone. But in Ionia, on the coast of Asia Minor and on the islands off the coast, the inhuman undergoes its most decisive transformation and its most lucid shaping, it turns into completely spiritualized corporeity and sensitive movement. Here, where no such warlike people as the Dorians had settled, but the freer Ionians, there arose the world's first freedom of thought in philosophy and science, there arose the spiritual discovery of man and also the first lyrical poetry which sang of that most personal of all things, the loving and suffering self, of man, the independent being, who had become the highest object of respect. In the poems of archaic Sappho, we find the same grace and ease as we see incarnate in the Ionic column, which looks feminine beside the more peasantlike, compact Dorian one, as if the Minoan heritage were making itself felt here on the eastern margin of the Aegean Sea. Here the consecration statues of girls, the Korai, in contrast to their Doric sisters with their almost pillar-like figures draped in straight gowns without folds, exhibit the gentle play of braided locks, loose hems, austere folds and gently flowing fabrics, which enhance the dreamlike poise of the faces.

The culmination of this boldly conceived sense of life was achieved when the Greek god, originally a natural being who was now completely transformed into an ethical one, found his residence in the *cella* of the temple, thereby guaranteeing order in the world.—The way to this image of god was preceded by the two-hundred-year archaic epoch. In the life of society it was preceded by the reign of the kings in Homer's day, in the 9th and the 8th century B.C., and of the great cruel families of blue-blooded exploiters in the 7th and 6th centuries, against whom the Tyrants rose during the 6th century in the midst of the archaic epoch, in the service of their city and in

alliance with the small citizens and peasants. But what had already been anticipated in the expression and style of archaic art, which created free and perfect man in the image of god, was the fourth phase of Greek society— democracy— which began in Athens about 600 B.C. under Solon, the poet, statesman and merchant, with his Constitution. Now no group and no individual any longer had power in the state, in the *polis*; if we except the slaves—the slave economy was a factor in the entire world of antiquity— power was directly wielded by the whole community of free citizens. The free man, master of himself, had attained the form of life that fitted him. And now, for not quite a century, there developed an unprecedented flowering of creative power, intellect and art. When the people of Athens rebuilt the Acropolis, which had been destroyed by the Persians, they used every one of the statues and metopes of the old Acropolis for the foundations, in the consciousness of their own unvanquishable creative power. While the art expressions of preceding epochs had already been democratic in the deepest sense, completely founded on the free individual, on self-development and a full life, and while Hellas, even at the time of the kings and the old noble families, knew neither king's temples nor statues of rulers, now the symbol of the city-state, the *polis* of the people, in which every single citizen, along with all the others, publicly wielded power and managed the affairs of society, became the protective godhead in the temple, the centre of the city's life. No remote, unapproachable being, no dreaded demon, no gigantic fetish or oriental spirit, he stood before the people quite physically as an individual who was the best and highest among them, outstanding only through his power and beauty, through the variety of his life, through his immortality—a guarantee of the prosperity of society. His body, which conceals nothing, reflects his whole nature, a perfection towards which everyone strives. He is an inspiration, a mirror, both a reproach and a goal in one's own life. It is the completely visible body which is good—this is a fundamental axiom of the Greek view. The body has nothing unfathomable about it, it has no concealments, yet it is not the incorporation of mere vitality alone. Athene, Apollo prove it clearly: wisdom and clear understanding are the vital basis for this bodily powerful beauty which knows no excess, which has a living harmony and tension that lend expression to the limbs and torso. The acme is the perceptive head, poetically thoughtful yet also corporeal. Apollo is the essence, the temporal meaning of Greek existence. Its law is made only for man. Its ethic is developed entirely out of the earthly, for the earthly, for human activity in all time to

come. The ethical basis of Christianity was the idea of eternity, a projection into the Other World; the Greek god, present in everything, was himself the present, imposing an obligation on the living. In him the former underground forces, the instinctual powers, stepped forth into the illumination of mental effort, into the abundance of human existence, not suppressed or "exorcised" as in Christian thinking, not a thing of the devil, of sin, unaware in the zealot's ignorance of nature that the worlds of instinct are not to be eliminated, that when suppressed they mutilate and disarm man and burst forth to revenge themselves one day. The Greek god was one to whom one never kneeled, whom one approached with one's hand open and outstretched, just as any peasant on horseback still greets people today; his passions were like those of man, he was no stranger to wrath or cunning; he lived among and with men. The "godly" man could be accepted now in the circle of the gods, as immortal as they.

The image of the Greek god is not set apart in some solitary world, on a mountain-top or at an inaccessible distance; only three steps up, he is close to man in the *cella* of his temple which, like himself, is intended to be seen from all sides, to be walked around; it is an architectural entity both enclosed and open to man, intended to be seen as a whole, like a living body with limbs, moderate in its dimensions, balanced in its proportions, happy in its form and its crown of columns, humane in its effect. Its beauty is not frontally determined, one-sidedly limited; its pediment and its long sides are equally balanced and significant. The interest of the reliefs on the pediment is equalled by the multiple rhythm of the columns along the sides. Originally more powerful, more "oriental" in its proportions, as the ruins of the Heraion on Samos with their many-columned double peripter indicate, the Greek temple develops increasingly, as time goes on, into a purely plastic, prehensible, sculptural form which limits the number of columns at the front to five to seven and the row on the long side to fifteen to seventeen. It is the peripter, the circuit of columns, that transforms the building into a living organism, something plastic, whether the more compact Doric columns strengthen and enliven the poetic rhythm of the whole or the Ionic enhances its movement and lightness. The relationship of the column to the human torso, as well as its symbolic origin (incorporating duration, procreation, immortality), project it into the sphere of the godly; only the free-standing sculpture has ritual value for the Greeks, not the relief, the surface picture or the painting (vases) as in the later Byzantine period or in Christian Rome. An unprecedented balance of contrasts, of

23

horizontals and verticals prevails in this structure, a gracefully joined architectural work rich in tension, which conforms to reasonable laws, excluding any monumentality, any rigidity, any stony deathliness as disproportionate and inhuman. As in the Temple of Athene on Aegina or in the Temple of Segesta, like the Propylaea on Lindos, the fallen or still erect ruins on Delos, each column has that faint swelling of the shaft; and the foundation of all the rows of columns rises slightly at the middle of each row, a curve not noticeable at first sight but decisive in creating the vitality of the whole structure. The *organic* beauty of the Greek temple comes precisely from this unmathematical, extrarational manner of building, from taking liberties with the law.—In the completely independent Greek colonial cities, such as on Sicily, this desire for a human measure and harmony is mingled with a new element: detached from the mother city, size is now intended to underline significance. The mighty drum-bases of the temple ruins of Selinunt and Agrigento speak a language of exorbitance, like late Hellenistic architecture when Greek society was already disintegrated, when the *polis* no longer led a life of its own as the nucleus of existence; for the purely expansionist imperial policy of Alexander of Macedonia and of Rome had burst the hard-won human law of moderation, and the real core of Greek strivings was shattered—despite the abundance of still actively influential talents. What had been achieved, however, was moderation as a goal, as a design of life, which itself was by no means moderate or reasonable. Art and the struggle of athletes set this lofty standard for an existence that was often quite trivial, shallow and evil, for people who were unscrupulous and entangled in petty strife. But that such a standard was set at all, as a goal that could actually be achieved in thought, deed and representation— that was the greatness of the Greek ethos and the significance of its art in the life of the people: an equal development of spirit and body and all capacities and potentialities to the maximum degree, in harmony; this was the ambition of all men. The Olympic Games, celebrated for over nine hundred years, were the confirmation, the fulfillment of this desire. On the very same island with Apollo, the god who embodied artistic-spiritual perfection—on Delos—Dionysos, the god of frenzy, was celebrated and honoured, in order to give life and form to the unconscious in man. Here the cult of both gods was celebrated alternately. The god of intoxication, who had brought the grape-vine from Asia to Greece, symbolized death and rebirth; he let man experience the subterranean powers of the blood and the earth in mad transports, in the flinging aside of self-control. Beside himself,

24

man became filled with the god, his ego was exploded and he entered the bloodstream of nature. Hellas never denied the *ekstasis* nor banished it beyond the borders of its religion. To the people of Greece it was an extension of emotion, a means of penetrating into the deeper regions of existence, into the primal foundations of being, where consciousness and reason were inadequate. It was from the cult of Dionysos that the Greek tragedy sprang, the tragic clash of the powers of the blood, of fate, and of the mind and the will, played until late Grecian times in the presence of the god Dionysos, whose statue stood in the centre of the theatre. The structure of the theatre came likewise from this cult and was put up for each celebration —stage, chorus stalls and auditorium, all out of wood. Only from the 4th century B.C. did it become hewn stone, open, offering a wide view, a part of the landscape, often like the theatre in the mountains of Segesta where the setting presented seemed to be the entire island, with the sea glittering in the distance. It was a seat for gods, with heaven and earth near and present, seemingly an element of the play, of the course of destiny, of the cosmic law to which every Greek submitted, for even the gods were subject to it. The tragedies of the great poets that shook all of Greece were played in modest wooden structures as rites of the Dionysos cult.

As an expression of the measureless instinctual forces experienced in ecstasy, the original cult of Pan-Dionysos had no place in plastic art. The powers of nature that it celebrated were too lawless for that. It was depicted only on vases and vessels used mainly by country folk close to nature. This was where the goat-footed lived their lives, the sileni and the maenads, on the outskirts of the *polis*, in the midst of a more countrified world. Yet nowhere, never regarded only as a necessary evil; the experiencing of the elementary forces was too much a frankly approved condition of man's life for that. In the nature of the instinctual, however, the Greeks saw no subject for a design for life which they could project in their elevated art. A different natural creature seemed to them worthy of its standards—the horse.

This, beside phallus and sun, was the third main symbol of their masculine culture. The taming of the horse in Asia Minor about 2800 B.C.—it had been wild until then—wrought a thoroughgoing revolution in the life of mankind, gave the herdsman his first chance to move from place to place, to be independent of the peasant soil of his birth, created the cattle-breeder par excellence, a completely new type of man, history-making man, who broke the ancient law of the matriarchal creed and peace, since he, no

longer bound to the earth and its fertility myths, in a greater perfection of power, made new gods for himself, masculine, procreative, freer, and made himself master over others. As his weapons on the horse-drawn chariots of war became more versatile and powerful, as his hunt became more rewarding, his herds bigger, his life itself given greater tensions, bolder impulses (one need only think of the gauchos, the lance riders in times nearer to the present, in the South American wars of independence), the horse became the natural object of highest veneration, as well as the worthiest sacrifice. It was a godly animal that drew the chariot of the sun; it was the cleverest, an oracular being born with mythical wisdom; indeed, the gods themselves, like Poseidon, assumed the shape of a horse. And the chariot race in the Isthmian Games not only celebrated the victorious driver but at the same time paid honour to the divinity of the winning horse. Among all the nations of conquerors, unthinkable without the existence of the horse (the Hittites, Persians, Egyptians, Etruscans and Greeks), it became a symbol and an object of veneration because of its indispensability. Among the Greeks it occupied a lofty position in the neighbourhood of the gods; and on friezes, as in the winged horse protome on Thasos, it was represented and made immortal a thousand times over. In the frieze of the Parthenon we find 140 riders and 24 four-horse chariots with their charioteers. On other friezes, Helios, Athene and Poseidon guide their teams of horses. Belonging equally to the worlds of man, god and beast, its symbolic character in the domains of patriarchal law is as comprehensive and strong as was only that of the snake in the matriarchal organization of agriculture. But it was not only for its quality as servant and giver of power to the hunter, herdsman, conqueror and warrior that Greek art seized upon it as the object of most beautiful representation. The trainability of the animal itself (the Greeks deeply believed in the educability of man and the world), and its cleverness, its playful grace, its fire, its courage, its quality of freedom, its joy in movement made it exemplary, made it a symbol for Greek man, who loved the disciplined. The winged horse, mediator between heaven and earth, an early creation of the Chinese and of the first myths of the Greeks and of the Bible, remained the symbol of the poet until late Grecian times and within the cultural radius of Rome.

Just as the horse was never depicted as any particular animal but solely as what it was meant to symbolize, its noble characteristics, thus in the depictions of gods and people no individual, no one in particular was ever shown, either in archaic times or in the century-long flowering of Greek classicism. In man it was the divine, in god it was the human greatness: ethos shaped the figure, a consciousness of life in which the world was experienced in the tension between man and demon, between luminous reason and dark basis of existence, and decided in favour of the light. To create balance and harmony in the presence of the shatteringly experienced knowledge of the lower forces is the decisive concern of Greek art in the Golden Age, the 5th century B.C.—Art as the pure representation of flawless beauty first appears with Praxiteles, who introduced the cult of the beautiful and feminine, during the period of the decline of Athens, the beginning of the decay of the *polis*. The Kouroi and the Korai were also beautiful; their beauty was an emanation from other meanings, it came of the hazardous enterprise of being the first men to step forth into freedom, it came of their sacredness. And the beauty of the Nike of Delos or of the Boreas and the Oreithyia from the Temple of Athene on the same island comes of the magic power of a superior, godly-human existence, not of the perfection of form of this or that individual or of the beauty of a body. For centuries it was the effort to give form to the powers of life, the enthusiasm for what was essential in man's existence that helped create beauty. Now it became a goal for its own sake. And the goddess who was born of the foam, who emerged from the sea enveloped in her gown, pure deity, now stepped forth naked from the waves, not a goddess, no longer a symbol, but only beauty, to delight the eye. Now the female body, its earthly grace, its blossoming, its blessed curves, became pleasure. No elemental force of creation in the rustle of a Nike's wings or the fluttering of her gown, no dreamlike quality of a Kore, no vital potency in her breathing body speak any longer of the substantiality or the duration of human beings; nor of the depth of the day, going back into time or forward into the certain future. From now on the aim is the moment and aesthetic pleasure. A trail is blazed which ends in the charming, the idyllic, the sentimental, ultimately in the portrait and in realistic imitation, which in a more subtle way anticipates Rome, because the centre of Greek existence, the creative community of the *polis*, has fallen into decay, and belief in their own destiny as a high call to interpret and represent the world has been smashed. Smashed against a myth-destroying philosophy, a striving for economic expansion in which

27

the productive forces of the *polis*, with craft and slave labour as the machines, were inadequate; smashed against wealth in the hands of a limited few, which disintegrated the community. Ultimately it was destroyed in the suicidal rivalries for predominance among the city-states. A long-lasting epoch, that of Hellenism, had thus begun. Under the domination of Macedonia and the Diadochi, Grecianism, in expanding as far as the Indus, acquires a major colonialist character; foreign elements from Egypt, Asia and later Rome, find their way into its opinions and its art. It is a period of wonderful individual advances, especially on the Aegean coast of Asia Minor, but also of a great decline. Technical skill comes into the foreground. Hence the smoothness, the noncommittalness of many works. The torso of the Aphrodite in the museum of Thira shows its purely feminine, alluring beauty, which betrays no sign of any feeling that life is a great thing. The statue of Hippocrates on Cos is merely a picture from memory, a sort of portrait, ephemeral. The head is only an attempt to resemble nature and is the main subject, despite the ambitiously conceived draperies, which remain stone. In the great, rising epochs, the head was not the emphasized part of a figure; as in the rest of the body, it was brought into full harmony both with that which was individual and that which was above the personal. And the Roman-Hellenic portrait head of a woman on Cos shows purely individual features, but a certain softness and dreaminess out of the spiritual spheres of the Greeks still influence it.—Whereas in archaic and classic times the statues contained their existence within themselves, constituting a cosmos all their own, now their plasticity is unfolded, they relax, they raise their limbs; as in the Dionysos on Cos, the figure becomes exaggeratedly slender, playful, the vertical axis inclines to one side or, as in the Laocoön group, thrusts diagonally into space. While the Dionysos statue was formerly a noble sculpture in the Greek theatre, now he leans indolently against a tree-trunk wound round with grape-vines, sensuous, like a tempter, purely in the present, an almost feminine being whose perishability can be sensed despite all its ephebic beauty.

Polis and temple are no longer criteria either for life or for art. An upper class of traders, officials, state functionaries and individual kings are now the commissioners and adjudicators of art, which is supposed to be a means to pleasure, or to contribute to the ornamentation of their lives or the fame of their own person through portrait-like imitation and glorification. True, even before this, persons were honoured and celebrated in statues set up in or near the temple or in a public square, and these bore the name of the

28

person honoured; but the facial features of the victor in the Olympic Games, of the charioteer, the wrestler, the horseman were not graven in. Greek art was always aimed at the generally typical in figure and physiognomy. The countenance of Boreas shows only his age and sex, both the physiognomy and the body those of a being which was the incarnation of a myth. They are completely individual beings at the same time, full of life, with an aura all their own, but there is no purely personal, momentary facial expression, which would have destroyed the organic whole, the entire symbolic quality of a form of existence, the myth of their lives. Since the belief in gods and myths, which had revealed themselves in everyday life, faded with the dominion of the *polis*, the profane life moves into the centre of artistic interest, both in architecture and in sculpture. The temple, now erected as a representative of its civilization's worth, takes on immense proportions, as formerly in the colonial cities of Sicily. The building, which once could have been termed a plastic work, now opens itself entirely to nature, drawing it into the structure as the baroque did two thousand years later. The view from the top of the terrace structure of the Asclepieion on Cos (high, wide flights of steps lead up to the shrine) looks far out into the country, across the plain and the sea all the way to the Asian coast. Here, there is a new conception of life that desires distance, breadth, that strays out into the unconfined and no longer recognizes any tie to one place. Staircases and terraces determine the architectural structure as they had done formerly in another type of world, the Egyptian, and as the coming epoch of Roman Mediterranean civilization was to bring to perfection in its non-ritual, powerful vaulted edifices and the series of arches of the viaducts, of which we still find a fragment on the island of Siros, products of a then "modern" technique which in the interest of prosperity and a comfortable life was overestimated as basic progress.

The myth—origin and innermost content of the great art of Greece—becomes a farce under Hellenism, a mere decorative object. And wherever it appears, it seeks to please, it is just a game, is no longer intended to convince. The sacred, deeply felt seriousness has been driven out of it, and the late antique fresco in the museum of Delos is an unskilled, childish imitation of early archaic representation; and the small late antique group of two lovers on the island of Apollo presents only a sensual charm, a moment of pleasure. Anything above the personal, anything which is in its real essence passionate or spiritually bold is foreign to it. At the height of his cultivation, naked man struggled in the Olympic Games under the eyes of the god; now

the contest had deteriorated into a sport practised by professionals who earned their living by it. Once Pindar sang of the victory of the charioteer; and in the victory, the lineage of the hero all the way back to prehistoric times was sung as a present thing; history and myth were present along with the sea and the imperishability of this manly man and of the god. Now the profanation of the body in pursuit of gain ran parallel to the profanation, the materialization of art.

If we look into the courtyard of the museum of Mykonos, at the torsi of Roman statues set up side by side, we almost feel they have come off an assembly line. Technique has pushed itself into the foreground without any desire for style, without a creative intelligence. The same is true of the Roman bust of a woman in the museum garden of Mytilene, which only offers a summary resemblance; and the same with those portrait heads which, built into the façades of houses in Thasos, look down at us today like mass production wares. A certain nimbus that lingers about them is due solely to the decay of the stone; it is the working of time that appeals to us. The mass production of art had already begun in the period of Hellenism. Divorced from its original task of dedication and celebration, creating a balance in an existence threatened by the Forces, it had become a commodity for an inordinately increasing art market on the shores of the entire Mediterranean and far into the domains of the Diadochi. Copies of statues and portraits traveled all over the world; every collector (a new sociological phenomenon, like the museum) wanted a copy of the most famous works. In accordance with their conception of the portrait-like reproduction of life, the Romans were content with copies of the heads of the Greeks' great gods and statues of heroes. This social phenomenon hastened the uprooting of art; the work lost its uniqueness as an inherent quality; what had once been a necessity of life became a mere token in the spread of a civilization, an object of pleasure, of cultivation, of decoration, of luxury. What was dominant was an aesthetic way of looking at art objects. Sculptures such as the Laocoön group and the Maenad of Skopas, giving form to human greatness, tragedy and passion, still stand like mountain peaks above the mass of mediocrities, which are nevertheless still created out of the traditionally rooted feeling for measure and a beauty above the personal; but an untold number of figures reproduce only the purely private and are nothing but decoration. Reduced in meaning and format,

30

gods and mythical figures are capricious beings that only serve the enjoyment of the viewer.

Rome's barbaric ignorance in the realm of art banishes the last breath of reverence for life's greatness and finally completes the process of making a mere shell of the myths. On Delos the floors of Roman homes and mansions are covered with mosaics which, with conscious naïveté, represent the old gods as toy-like figures. Childish Cupids ride on dolphins, Psyche sits on a panther as a decorative beauty. The original goddess, chaste and naked, becomes a half-dressed girl in a sort of bikini, playing ball in a circus pose, as in the Roman palace villa in Casale, Sicily. An "art" for Roman millionaires and state functionaries "overseas" in the colonies. Pompeii, at least, developed painting to a high technical level.

Such a pragmatic people as the Romans, poor in imagination, materialistic, whose thinking and planning was completely concentrated on realities, on the extension and reinforcement of power, whose ethos was exhausted in the performance of duty, permitted no freedom to the spiritual or the artistic. They were bound to feel that the Greek way of life and art (which united mythical emotion, the sense of freedom, respect for human existence, and a sensitive intelligence, and conveyed the idea of a more profound life) was a threat to their existence. The unknown elemental force of art effective in ancient Greece would have burst the framework of state and family which bounded the Roman's existence. Only later did Rome begin to dare portraying human beings, after centuries of condemning Greek nakedness as corrupt and Greek leisure and art as subversive. In the end Etruscan and Greek artists had to make Rome's temples and statues.

Its own particular artistic contribution, however, was developed in portrait art, on coins and in busts which often impressively captured the character of the model in an austere and lapidary style. This art had been prepared in the ancestor cult of the Roman families, which preserved the naturalistically painted death masks of the deceased and had actors wear them during the obsequies, according to ancient custom. While the Greeks raised the deceased or the living man to a timeless hero in their representations, above the personal, the Roman's image remained an outright portrait. It achieved its essence—personalness and temporal identity—mostly by means of a strongly linear formation of the features and a bold abstraction concentrated on the characteristic. Yet in the technical approach to skin, hair, bones, textiles, any naturalism was avoided, in order to lend the permanence of stone to the ephemeral being. Seldom do we find in the

stone, as in the early Greek portraits, that smile born of man, mysterious, victorious; gravity, sternness, harshness, ruthlessness, brutality, matronly and imperial dignity look out at us from the Roman marble busts, without moving the viewer or inspiring the slightest enthusiasm, since they convey nothing essentially universal or above the personal. The plastic element in Greek art, expression of man's complete attachment to life, vanishes under the Roman touch; their sculptures lack that terrestriality. Like those of the Egyptians, they are part of the façade of a building, although the capital of the Roman Empire was filled with an overabundance of marble copies of Greek originals since the birth of Christ. The back of the statue remains an unworked surface, the sides become unimportant, disappearing half covered in the shadows of niches, so that all that remains for the viewer is the front of the "sculpture", as in the Roman city-gate of Ibiza.

If the artistic thinking of the Greeks could be termed plastic, then that of the Romans was spatial. An immense empire that had to be administered, organized and defended was the reason and the reinforcement for this basic approach, which found its expression in bridges, viaducts, strategic roads, immense tenements, gigantic amphitheatres, and façade formations. In this process Rome developed an architectural property which became a model for Europe over many centuries. The vaulting and the bold successions of arches as essential structural elements, invented by Rome and applied in a thousand ways (the great cistern construction of the amphitheatre of Delos provides a modest insight into the spatially powerful achievements of Rome), became the determining factor in the dome structure of the East Roman Empire, from the Hagia Sophia to the countless Byzantine city and country churches whose domes were vaulted in all sorts of different variations; they influenced the Islamic mosque construction and the development of Gothic and of baroque. The vertical development of the many-storied house and the interior stairway exerted an influence on the palace of the Renaissance and on our modern tall buildings.

Rome created the city made entirely of stone (antique Athens consisted of clay houses) which, begun in the Hellenistic Orient, pointed the way to the future modern metropolis. Rome invented the window façade on the street side; as a substitute for the former countrified inner courts it invented the balcony, whose development reached its peak in the baroque; it created arcades for shops on the street floor, initiated the passage from the inner to the outer room, and broke up the wall by means of columns and niches, from a spatial point of view similar to that of the baroque. It built aqueducts

32

as long as 50 kilometres, bridges consisting of 64 granite arches and having a span of 790 metres; barrel vaults and semi-barrel vaults, domes, semi-domes, arches in continuously new compositional and structural variants, anticipating European architecture by a thousand, sometimes even two thousand years. Rome's well-paved roads bordered with overnight stopping-places crossed entire countries, civilized nature, made the earth more livable, forged links from man to man. It was a great civilizing culture sub-ordinated to practical utility. It offered little to people's spiritual needs, to their souls, or to art. The Roman column, mostly superdimensional, whose capital abounds in ornamentation, has none of the corporeity of the Grecian, it does not breathe, it has the appearance of an industrial product made to standard. The temple is built for show. The chief purpose of the amphi-theatre is for popular entertainments, gladiatorial contests, fights with animals. It was not used for ritual plays; tragedies were not the culmination of their people's life, as in Greece. The Roman building is the profane construction par excellence, with every architectural potentiality boldly exploited, its basic element the brick, which was used from the first century A.D. The careful, beautiful paving of early heathen Erice in Sicily, the cultivation of paving on many Greek islands, seems to originate in Roman traditions. The devotional Greek and the civilizing Roman— in many places these both entered the structure and created the face they have today.

With the division of the Roman Empire, completely new art elements reached the Mediterranean region by way of Eastern Rome-Byzan-tium (a thousand-year-old theocratic-absolute realm under the influence of Christianity). Although based upon Greek culture, above all on its philoso-phy, Byzantium together with the spiritual world of Christianity brought an oriental, irrational phenomenon into being. The Byzantine country church of Kritzas on Crete, like many others, shows the double nature of this art. The absolute plasticity of the structure as a whole, emphasized by strong masonry, powerful organic spurs, tautly rounded apses, is Greek architecture in its earthly feeling for life; and the interior, plunged utterly in mystical darkness, the arches and the vaulted walls covered with coloured frescoes, negating the stone interior, is oriental irrationality. Yet even the frescoes with their pure lines still display Greek spirituality, although the simultaneous unplasticity of the figures documents a sense of mysticism and

33

the desensualization of nature. In the spatially limited Byzantine country churches, we do not find that rhythmic, mystic quality of the light, that essential element of a "spiritualized" interior architecture which is developed in the major sacral structures of Byzantium. They must be content with semi-darkness. In the Hagia Sophia the play of light, the effect of the light, is everything, is all-dominating, as it glides over the arches, vanishes downward, comes forth out of the obscurity, illumines it tenderly, dematerializes the stone, breaks on the curves, and in its magnificent consummation draws the gaze upward to the dome. The twilight of the endless number of Byzantine country churches and chapels (the town Ios has over three hundred, as does Mykonos), with their shimmering hanging-lamps, rugs, silk curtains, golden candlesticks, frescoes and icons, is a place of meditations and, through its splendour, of reverence for God.—Byzantine mosaics, frescoes and icons portray saints and angels in pure transcendental abstraction and reduce corporeality to severe, bold lines and colour surfaces, with the colour applied unplastically, non-sensuously, and the surfaces having a life of their own and sounding a mystical chord. In the mosaic, which emphasizes the geometrical structure of the body, the glittering of the gold, which outdazzles the colours, produces a deliberate immateriality whose purpose is to conjure the spiritual out of the earthly.

The invasion of Byzantine spirituality into the art of the Mediterranean had already been prepared under Hellenism, when the religious art of Asia penetrated with the Roman legions from oriental spheres and began to undermine the plastic harmony of Greek representation and the Greek way of looking at things. Plato's moralistic art ideology, the Hellenistic philosophy of Plotinus, and the spread of Christianity hadan equally destructive effect on the representation of the visible world: the soul became a dominant alongside the plastic. To make the soul visible, tangible, was to become the sole purpose of art. Nature assumed merely the role of a symbol, the picture became a sign. In Minoan Crete the fish had also been a symbol of fertility, of the water's inexhaustible life-giving power; now it is the symbol of a spiritually mystical eternity. The philosophy of the Neo-Platonists had taken root most intensively in Byzantium itself and merged with Slavic-Oriental as well as with Christian mysticism. And it developed its imaginary world with icons, reliefs and the architecture of light. Art had become purely the medium of an ideology, a means of attaining religious aims. The light as well as the brilliance of the mosaics, the flow of lines, the colour abstraction of the frescoes, the fantastic capitals fraught with symbols

(Monreale) were nothing but spiritual conjuring. The glass painting of the Middle Ages pursued the same aim.

Only in the Gothic (here the smile returns, on the countenance of the Madonnas) and in the Renaissance does the counter-movement to reconquer reality, world, earth and man take effect. But the root contribution of Mediterranean culture was concrete form, Greek sculpture. With the invasion of spirituality from the cultures of Asia Minor, this had become a transitional object in which a soul was to be manifested. (Something similar is suggested by Delacroix, one of the founders of modern art, who called painting "a silent power that speaks only to souls … a mysterious language".) Irrational Byzantium had crowded Apollo out of the Greek world. Now, under the domination of the Genoese, the Venetians, Normans and crusaders, with their citadels, castles, fortresses, continuing Roman architecture (as on Lemnos, Mytilene, Rhodes, in Iraklion, Bonifacio, Catania), a mundane emphasis was brought into life and art again, the spiritualism of the Orient as the sole valid law was forced to retreat until, with the Renaissance, the will to reality once more took complete possession of the mainlands and islands of the Mediterranean. Whereas Byzantium was concerned with the mastery of the inward man, now the aim was the reinstatement, the mastery and conquest of the outer world. The discovery of perspective, from now on almighty, the space element as the goal and meaning of art, ran parallel with the economic expansion of the Renaissance burghers. Now the pendulum often swung to the opposite extreme, according no recognition at all to the claims of a spiritual world. The Greek archaic had combined the superhuman world and reality in a harmonious whole; Byzantium had brought only the irrational to bear; but the particular concern of Renaissance and baroque were the representation of the outer world, its consolidation (Renaissance) and its dynamic expansion (baroque). The conquest of the seas and the continents formed a real and imaginary background to their arts. The Renaissance is a proud, unconditional making-oneself-at-home on earth, a mighty taking-possession; and its element of beauty, expressed in structure, proportion and colour, is purely rational. When we regard the Palazzo Koundouriatis on Hydra, a patrician court on Mallorca, a Pisan church on Sardinia, the palace of Steripinto in Sciacca in Sicily, everywhere we sense a strong grasp of life that is after the tangibles and the beauty on earth and intends to hold them fast and enhance them. In the tautly spanned arches of the galleries, in the fortress-like façade of a palace where rhythm is built into the masonry, in the open spaciousness of

an inner court that has staircases from end to end, in the beautiful high-and-mightiness of a city-gate, the robust terrestriality of a country church in the interior of Sardinia (Fonni), the affirmation of the earthly as a possession and as beauty is intensely perceptible. Many burgher façades of the Renaissance have the defensive capacity of citadels; they are fortress walls whose windows and cornices lend them harmonious form, a civilian Castel Urbino of Catania. Only in the period of baroque (now the burghers have their city and their trade firmly in hand) do the façades begin to flourish, to play, to become boundless as the sea over which the ships of the wealthy citizens ply, boundless in the attempt to burst the perspectivistic rigidity of the artist's view, as in the circling, hovering bodies of Tintoretto, and even in the less pompous basilicas and baroque churches of Sicily in Modica, Syracuse, Ibla-Ragusa and Scicli. Now the ornamentation of a house (Scicli), the carving of a portal, the movement of a balcony (the Benedictine monastery in Catania) acquire importance and mundane meaning.

If we look today at a city like Mykonos, where the *kubus*, the original element of the Greek temple, determines all the architecture, or into a street of Erice with its beautifully laid paving, at the classically simple portal of the enclosure of a country church on Ibiza, at a house-gate in the city of Lipari, at the boldly ascending stair up Mt. Calvary in Pollensa on Mallorca, at the stony geometry of the country church of Santa Eulalia on Ibiza, its shimmering completeness and movement, at a modern country house there, or one of the beautiful field walls on Formentera, at the splendid sweep of the automobile highway near Castelmola in Sicily—everywhere we encounter the unbroken tradition of an architectural feeling whose whole focus is man, a tradition that goes back to the beginnings of Mediterranean civilization, back to Knossos, or to the constructive architectural thinking of the Romans, which was aimed at duration and livability.

While the Mediterranean brought North, South and East together in many respects, indeed united them, it did not succeed in merging the plastic view of existence, the sensual-transcendental consummation of reality, with the cultural expressions of the soul, with the meditative eastern cultures whose meaning and goal were wisdom, human wisdom—nor with the regions of the human unconscious, the world of emotion heavy with symbolism.—Since the Renaissance, the principal concern of art, the basic approach of civilization in Europe has been the conquest of the spatial world, whether in respect to the world's roundness or, as now, to the vertical endeavour for conquest of the solar system (although precisely here,

new spiritual mutations can occur). The worlds of feeling, the poetic in man, the spirituality of his mental states, the irrationality of the unconscious, have lain fallow for the most part and are waiting to be drawn into a purely positivistic civilization, so that the reality and autonomy of the spiritual forces which have dwelt in emptiness up to now or have had a mere use value will bring our mental culture with its sheer absence of limits into equilibrium, into marriage with ethical, humane fundamental attitudes. A humanity which has an indestructible belief in itself and integrates all things can only arise when it makes man with all his worlds of emotion and consciousness its chief inalienable value, its centre, not only as a person, not only as part of the community, but as *the* essential thing that demands to be felt unconditionally and without compromise, as is revealed in the rare happy moments of art, in ancient Chinese art, in the late Rembrandt portraits and, with a new meaning, striving for the inviolability of the universe, the integral whole of ego and world, in the rotational space representation of Cézanne's perspective planes. While Tintoretto had already begun the attempt to burst the rigidity of perspective space, the space sense of the genius Cézanne anticipates the world's new conception of space, that of the universe in motion, before Einstein's time—the global world in which man enters into a new, not simply mental-rational relation to Creation. An art approach which primarily seeks the external realities of life, as the main current of European painting and sculpture has done since the 15th century, drives the remaining forces of the human soul into the representation of mere subjectivisms, into pure abstraction as an expressive value, into the symbol world of surrealism, without creatively opening up the quantitative —which means the representation of the external, perspective world— to a further advance towards the qualitative. But we have the example, in Europe's beginnings, of Greek archaic. It has different mythical roots from our world, whose profound transparency derives from the visibility of the history of man, of the earth and of the cosmos, a history out of which a new myth of mankind is growing. The Greek archaic stands before us as the first legacy of such a potentiality in art.

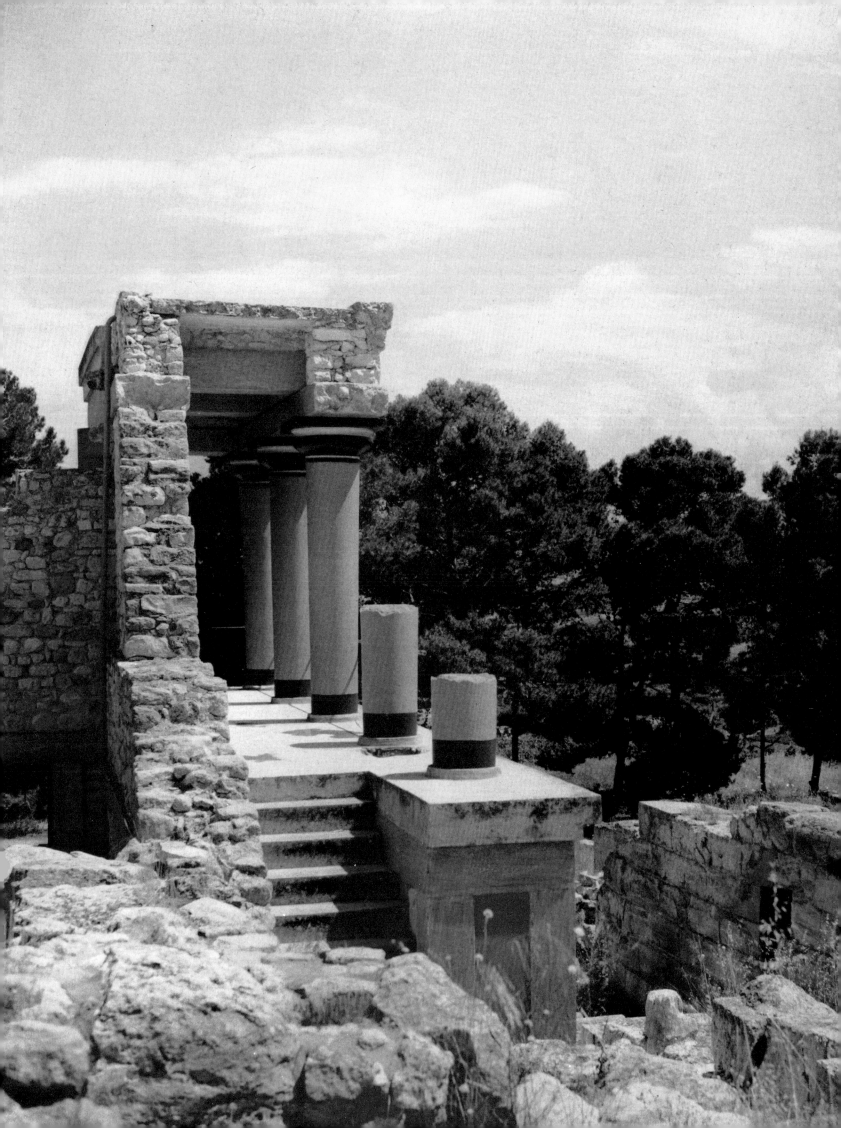

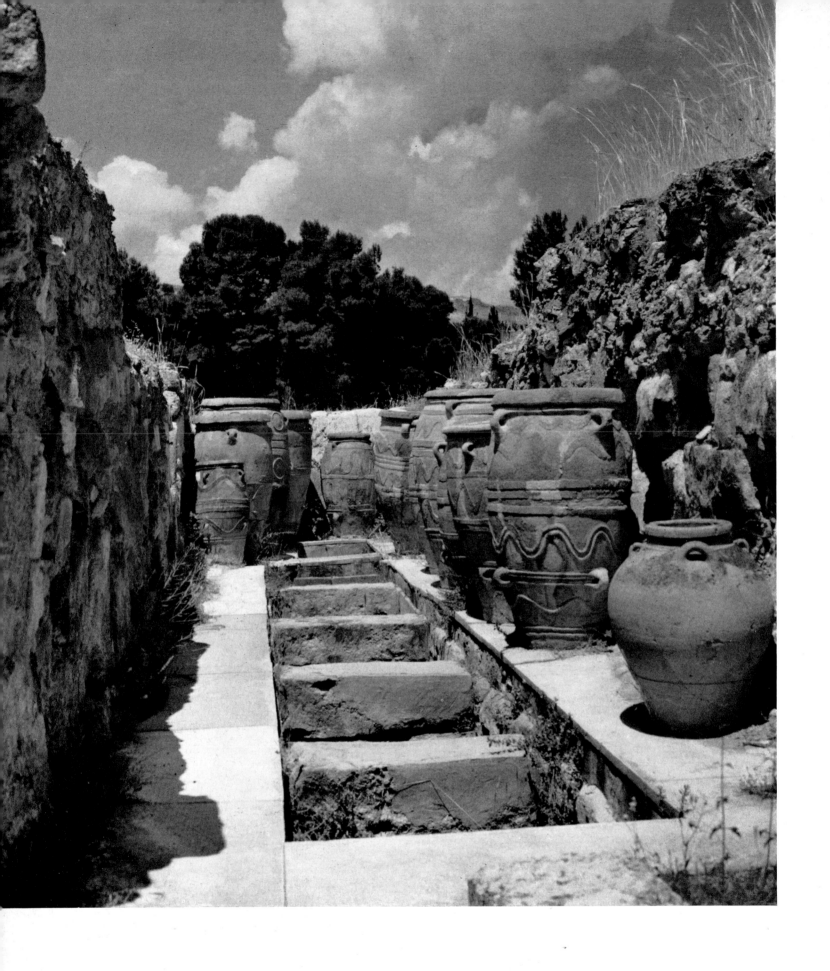

2 *Store-Rooms with Large Pithoi at the West Flank of Knossos Palace*

3 *Inner Court in the Royal Palace at Knossos*

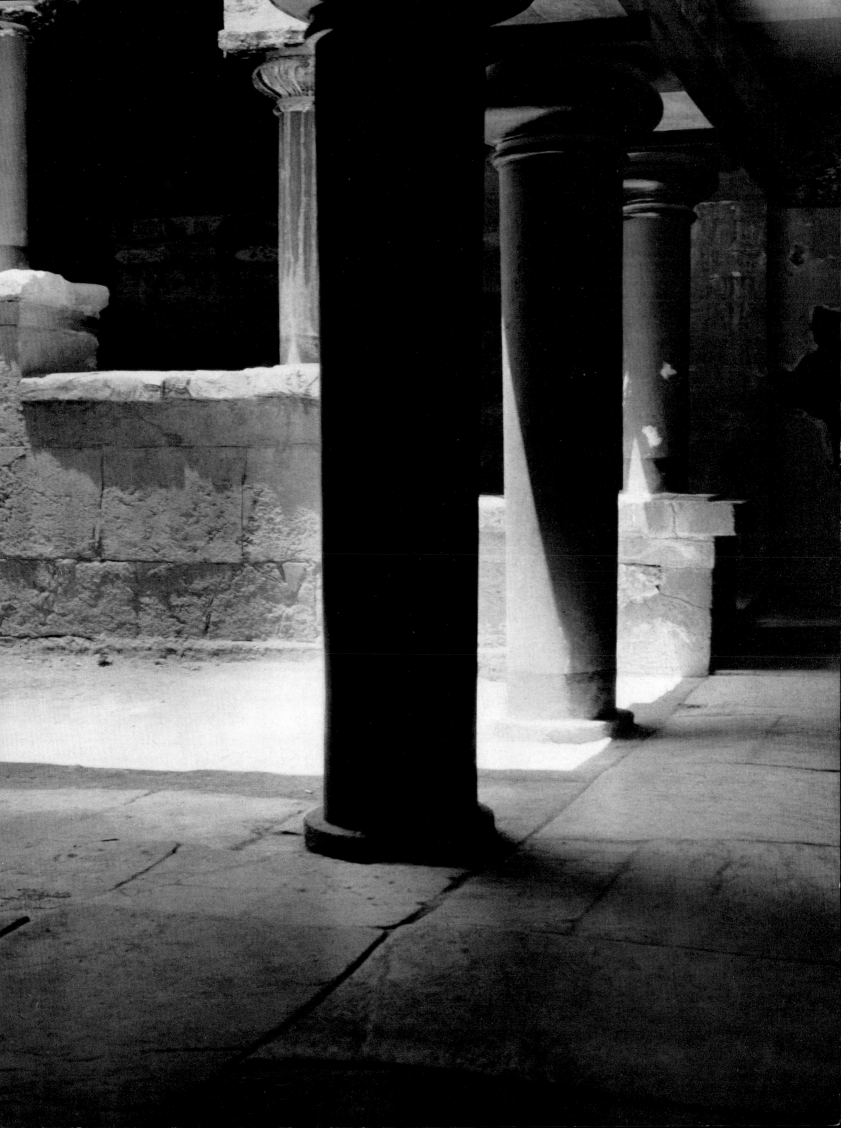

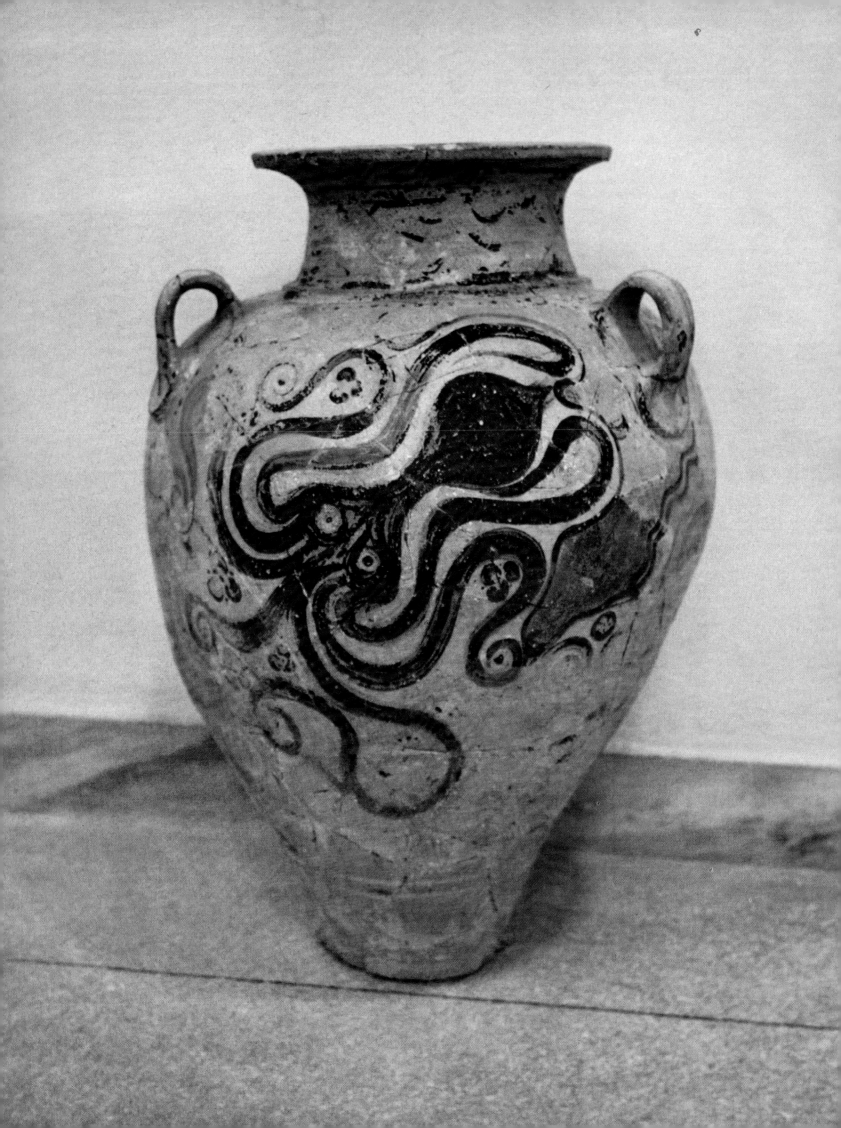

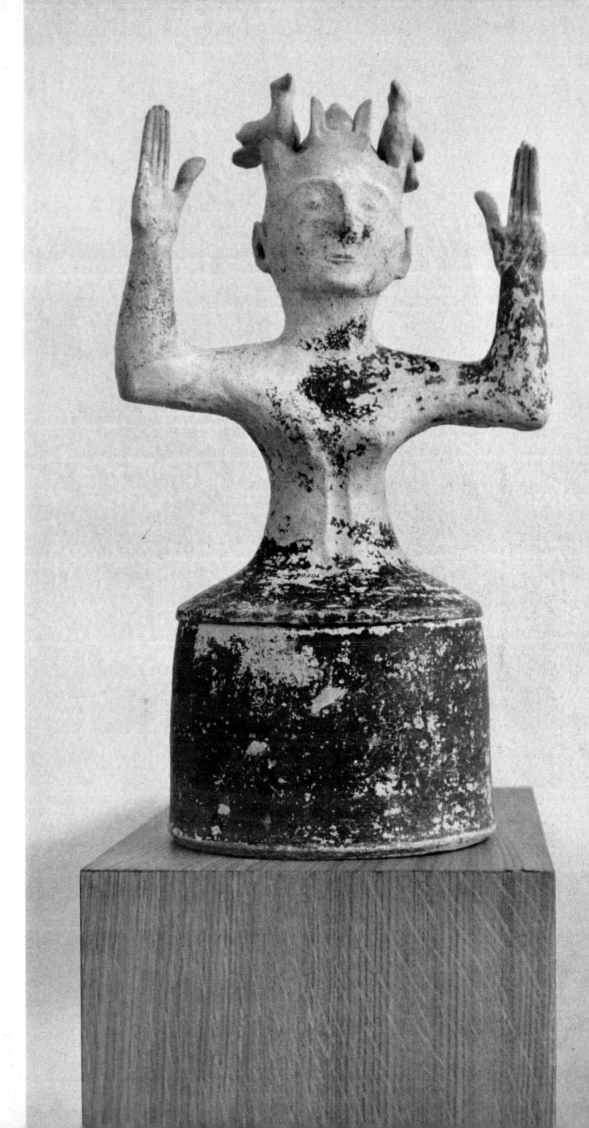

4 *Minoan Amphora with*
Octopus Décor from Knossos
5 *Minoan Earth Goddess*
with Doves from Knossos

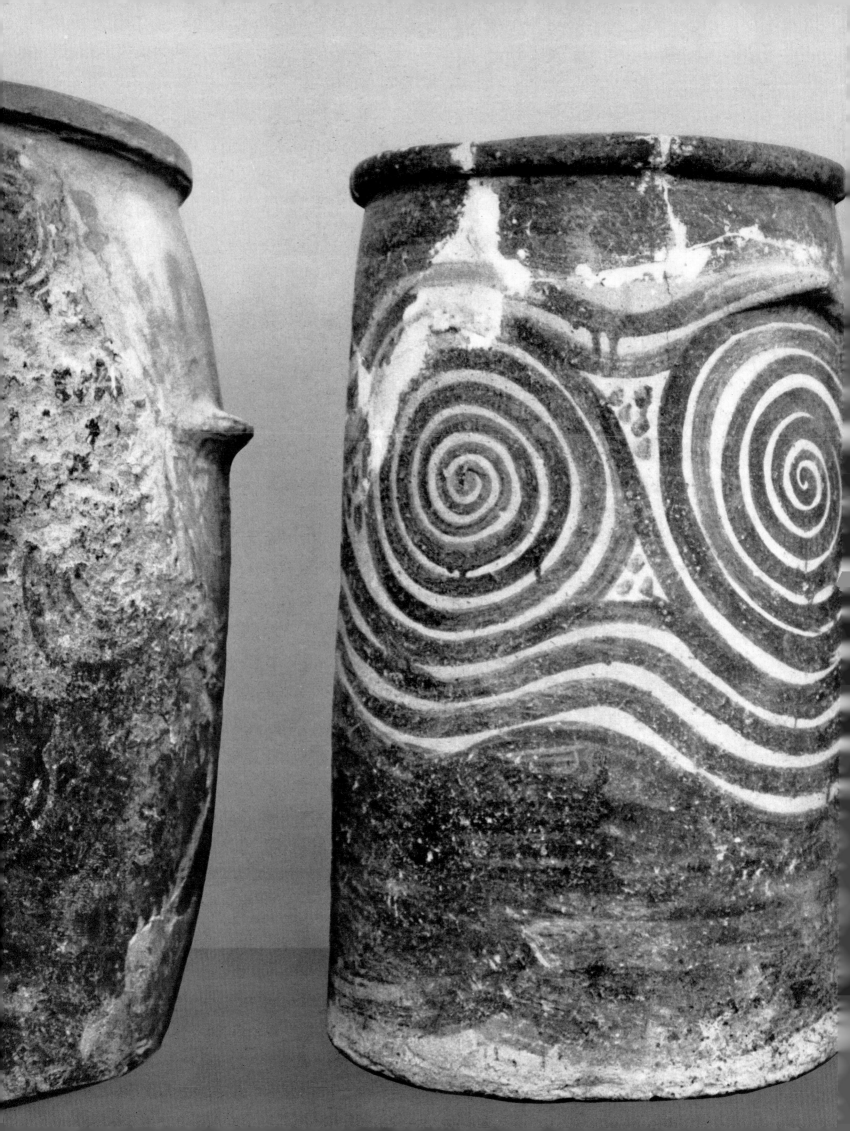

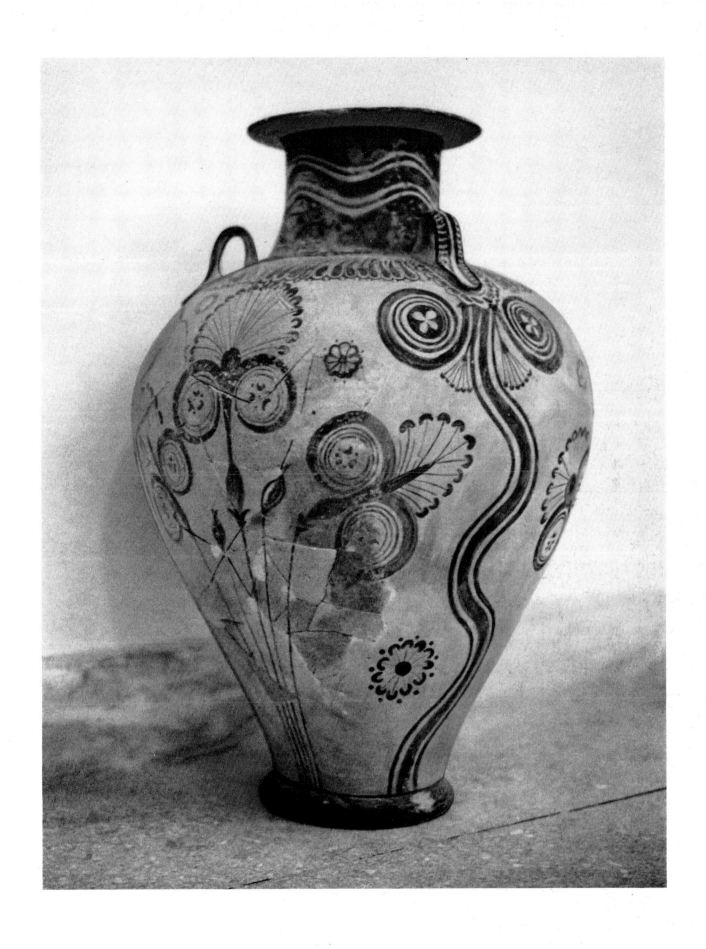

6 *Pithos with Magical Linear Ornamentation from Knossos*
7 *Amphora with Papyrus Décor from the Palace of Knossos*

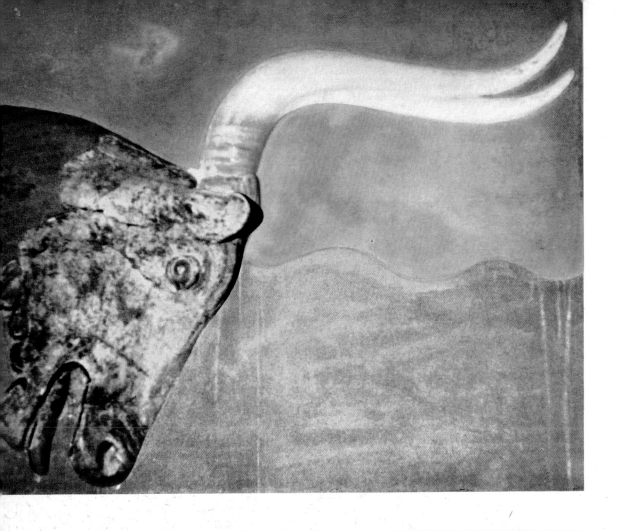

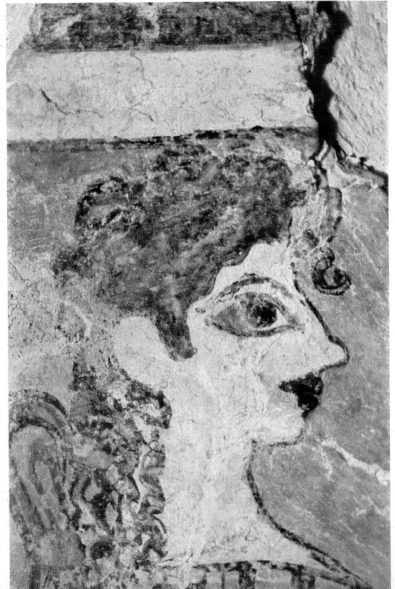

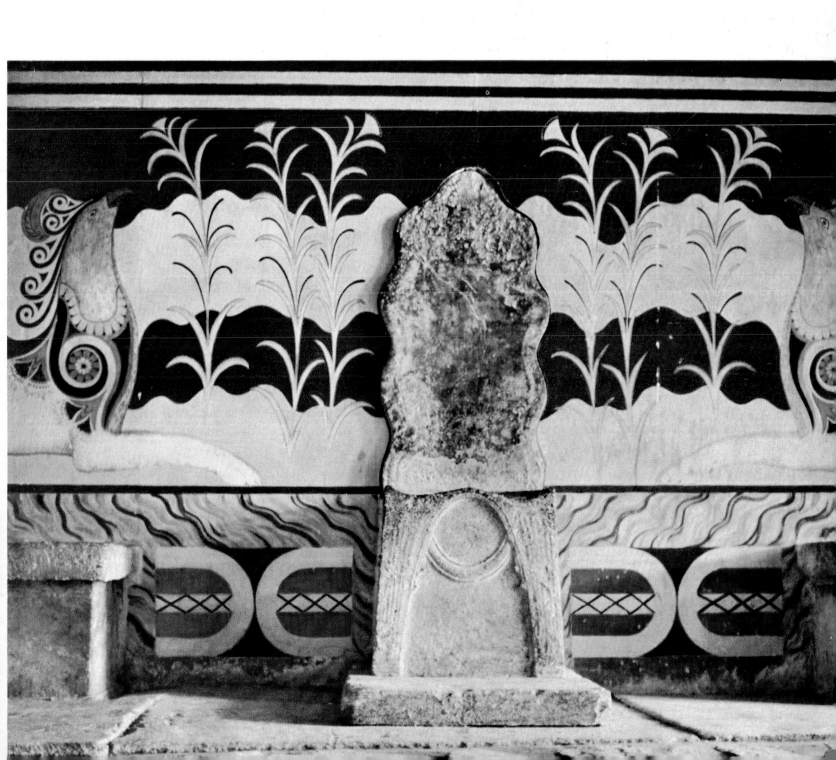

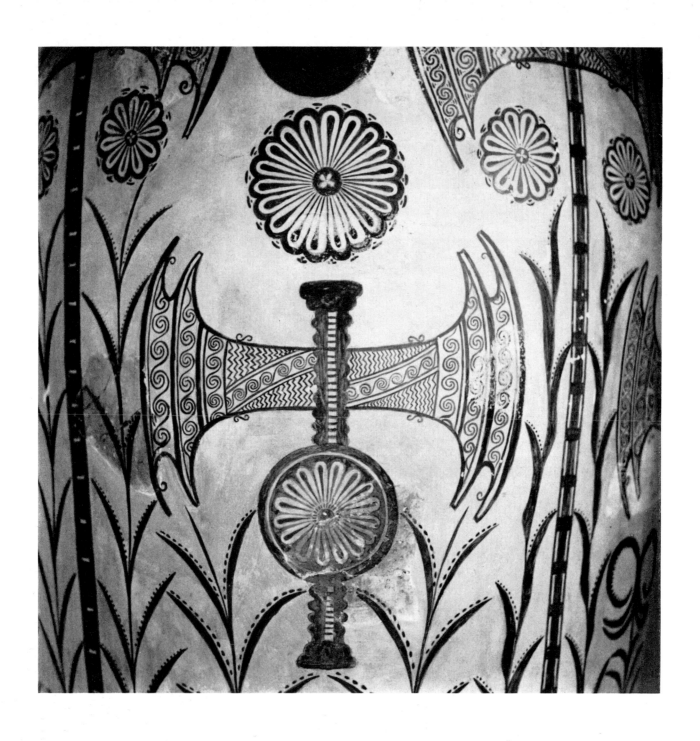

11 *Double Axe Symbol, Power Emblem of the Moon Goddess, on a Minoan Vase*

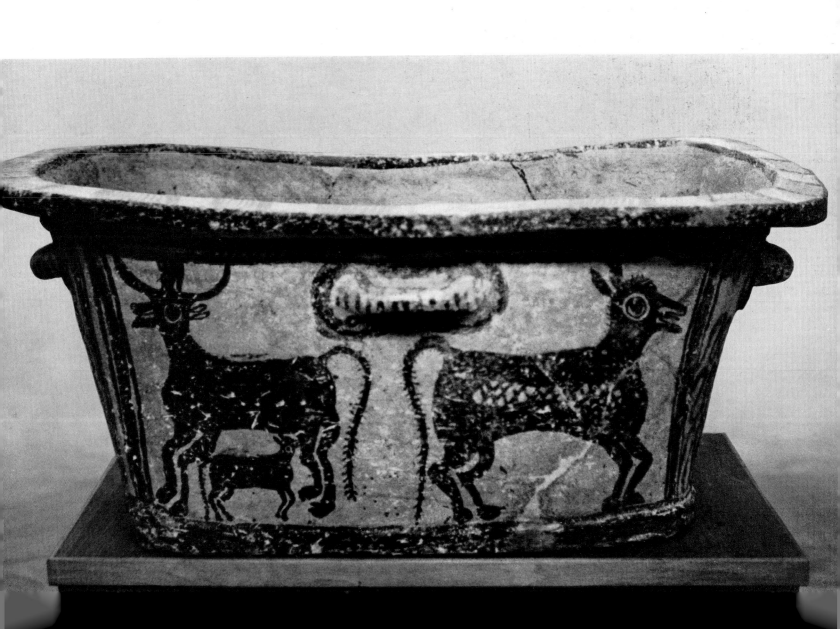

13 *Minoan Snake Goddess from Knossos*
14 *Bullhorn Ornament from the Palace at Knossos*

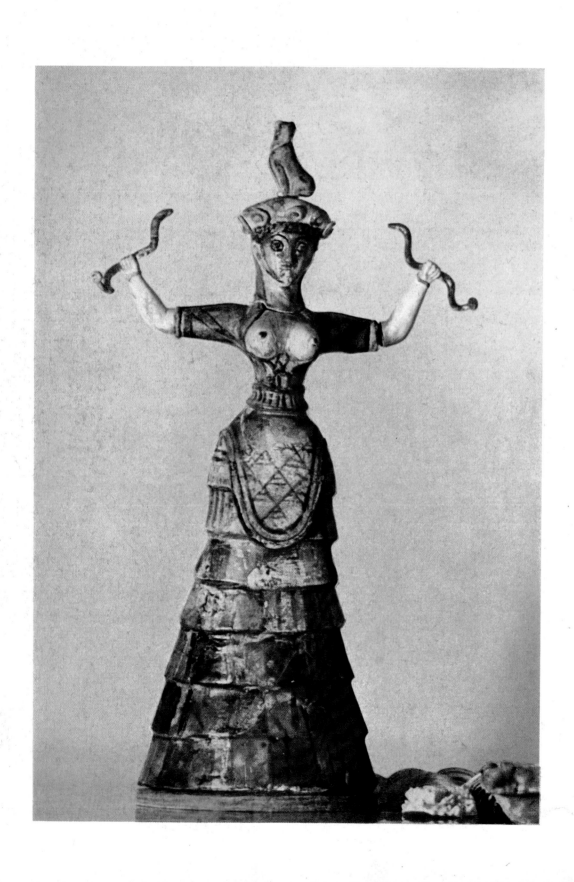

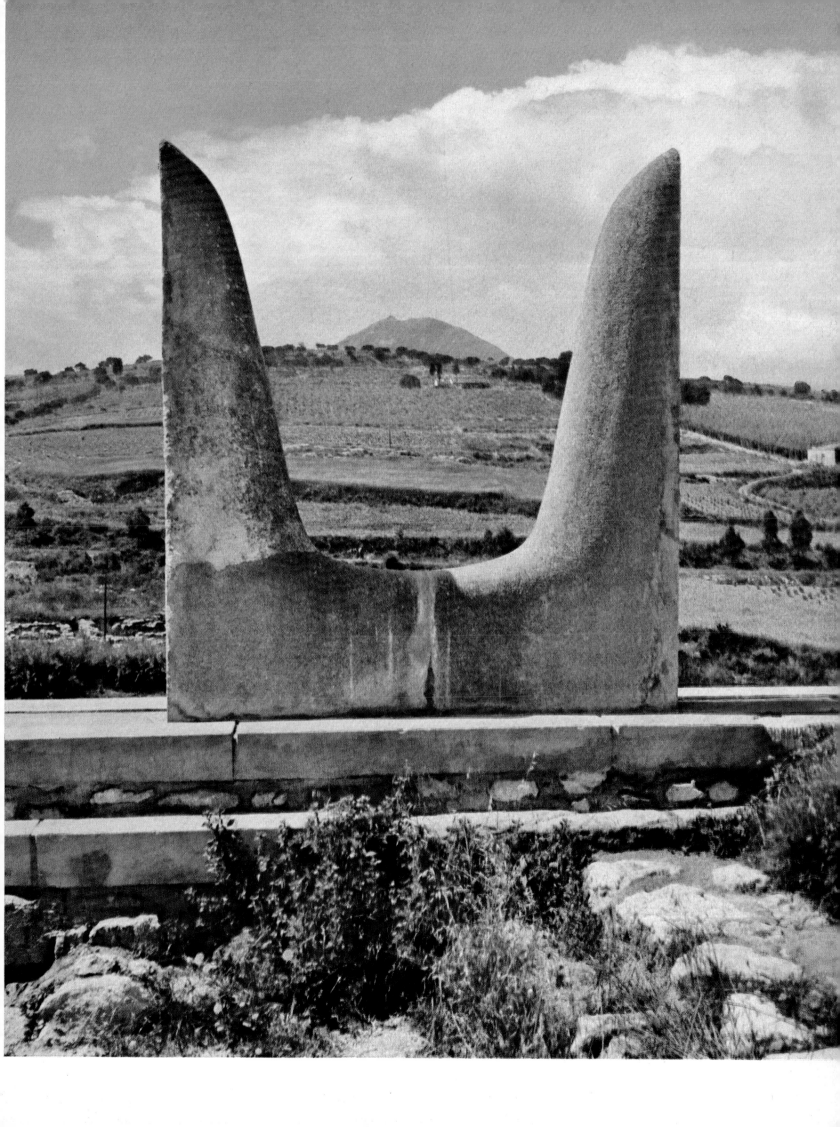

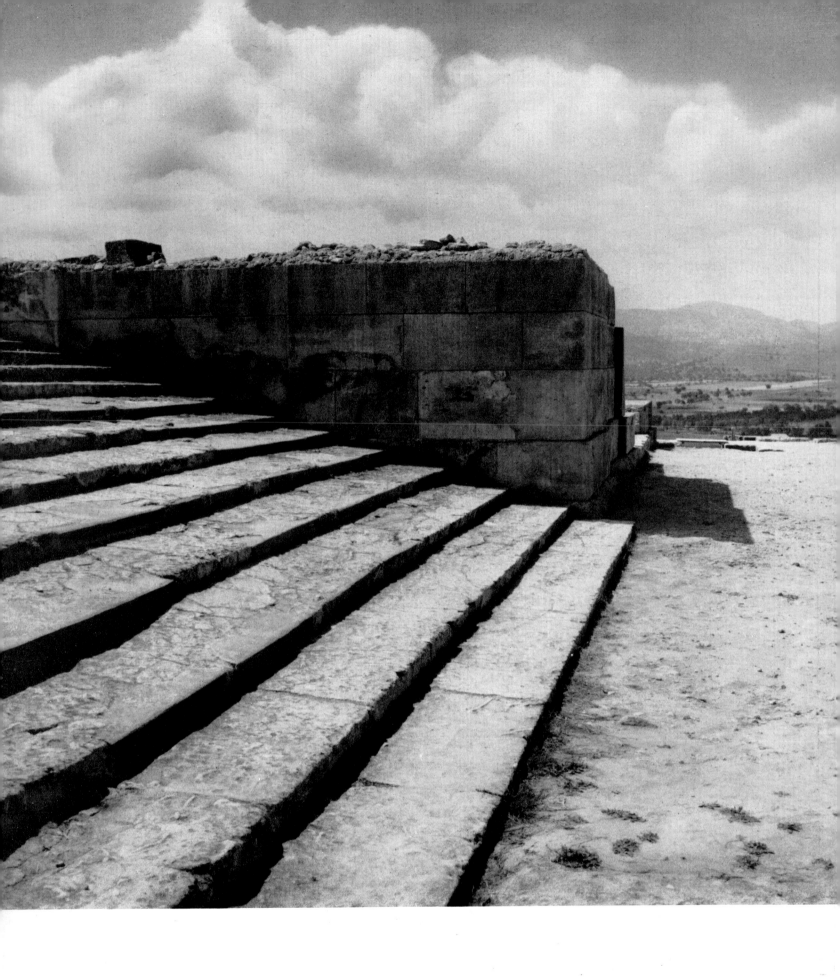

15 Steps for Display of Religious Rites at the Great Court of the Palace of Phaistos

16 *Inside the Minoan Village Settlement of Gurnia, Crete*

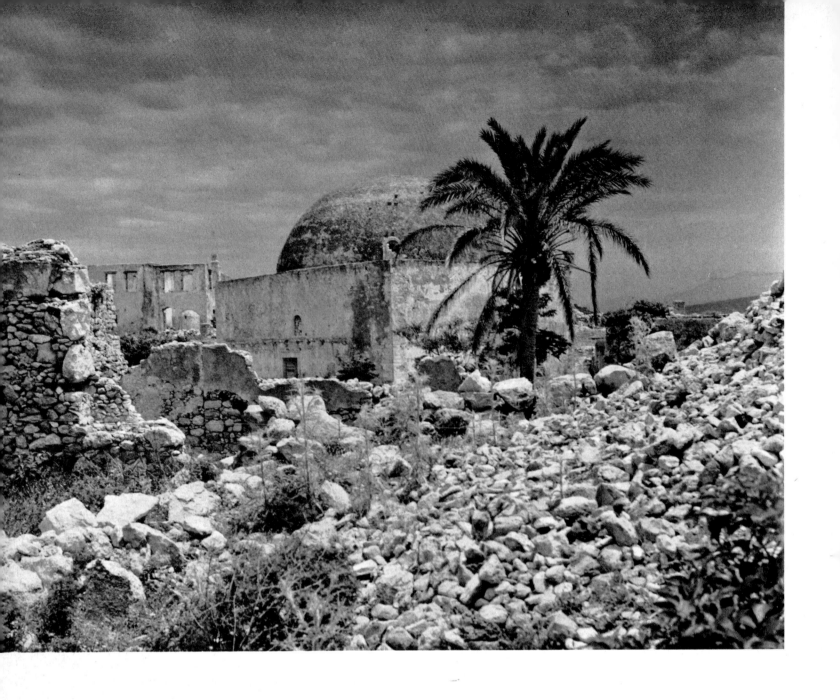

17 *The Great Mosque inside the Venetian Fortifications of Rethymno, Crete*

18 *Byzantine Chapel on Merabellos Bay, Crete*

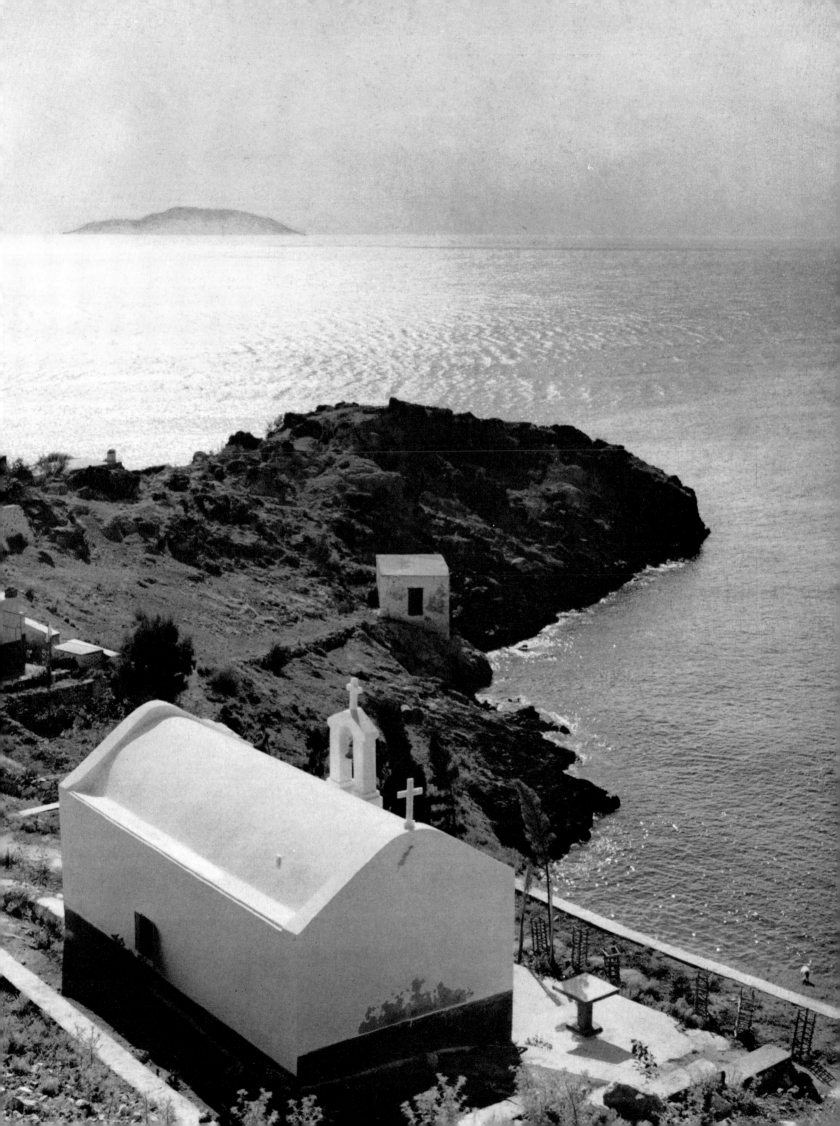

19 *Apsides of the Ancient Byzantine Church at Iraklion, Crete*

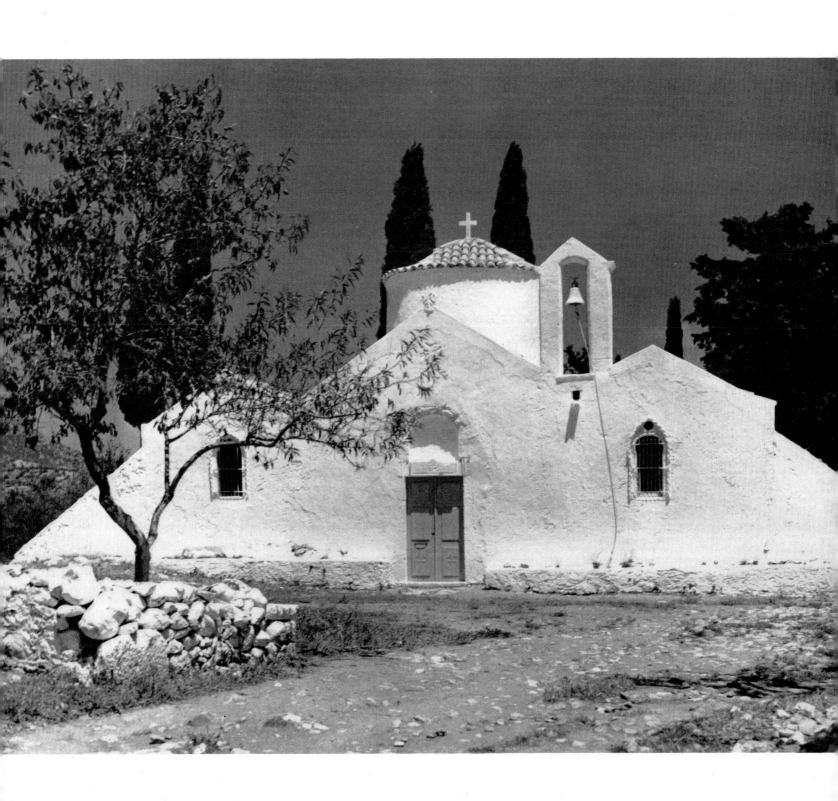

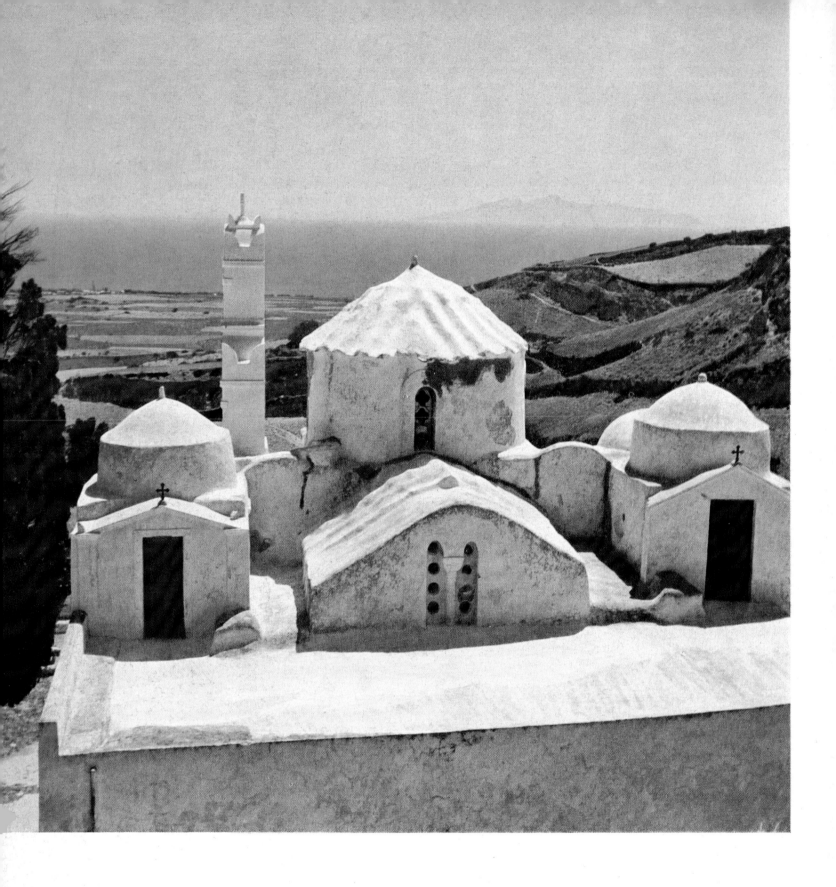

21 *The Byzantine Episcopi Church on the Island of Thira*

22 *Byzantine Episcopi Country Church, the only church untouched by the earthquake of 1956*

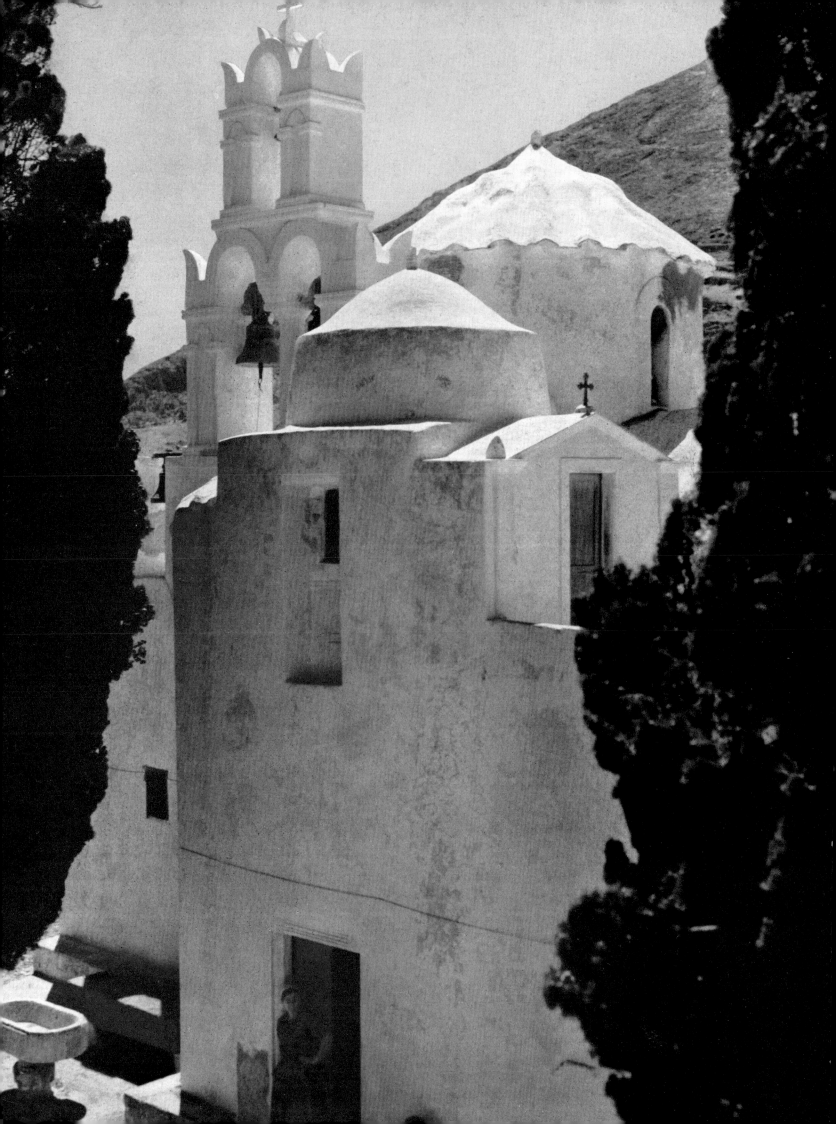

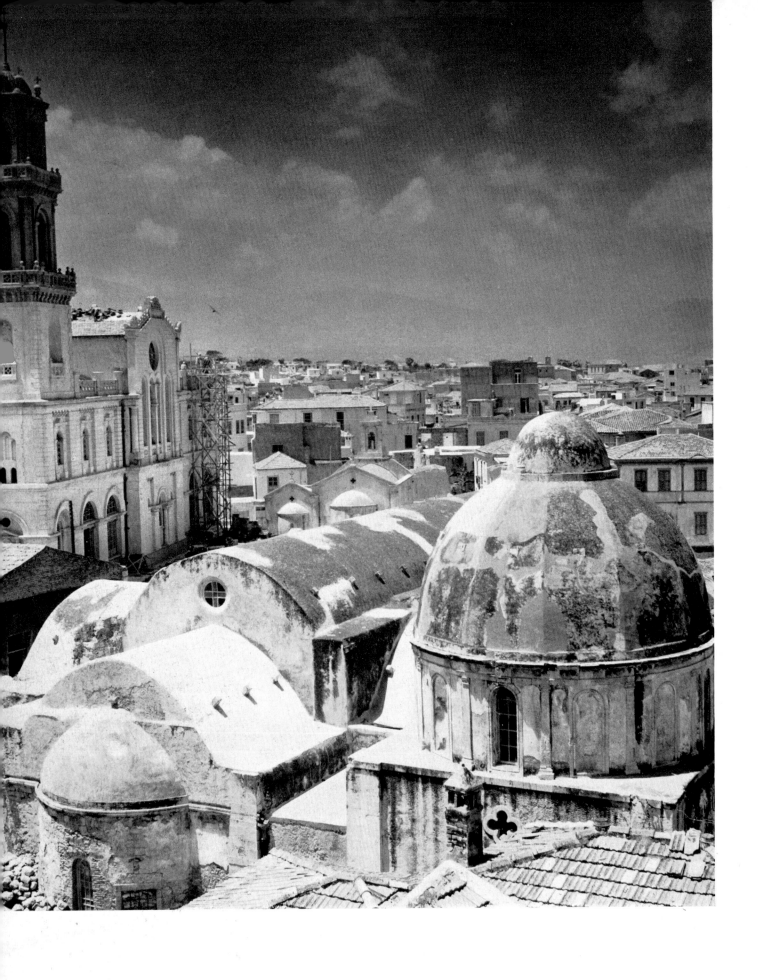

23 *View of Iraklion*

24 *The Morosini Well at Iraklion*

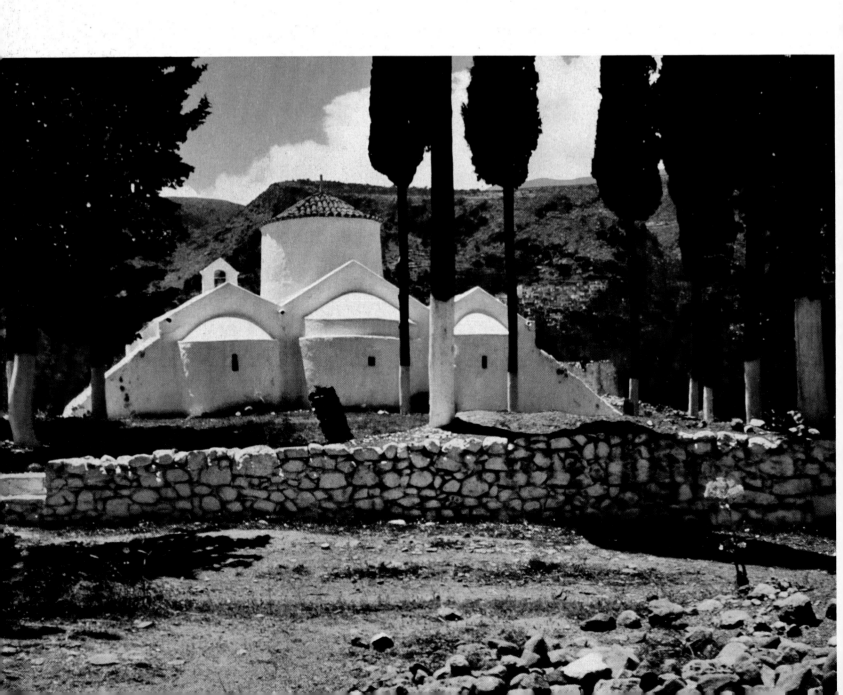

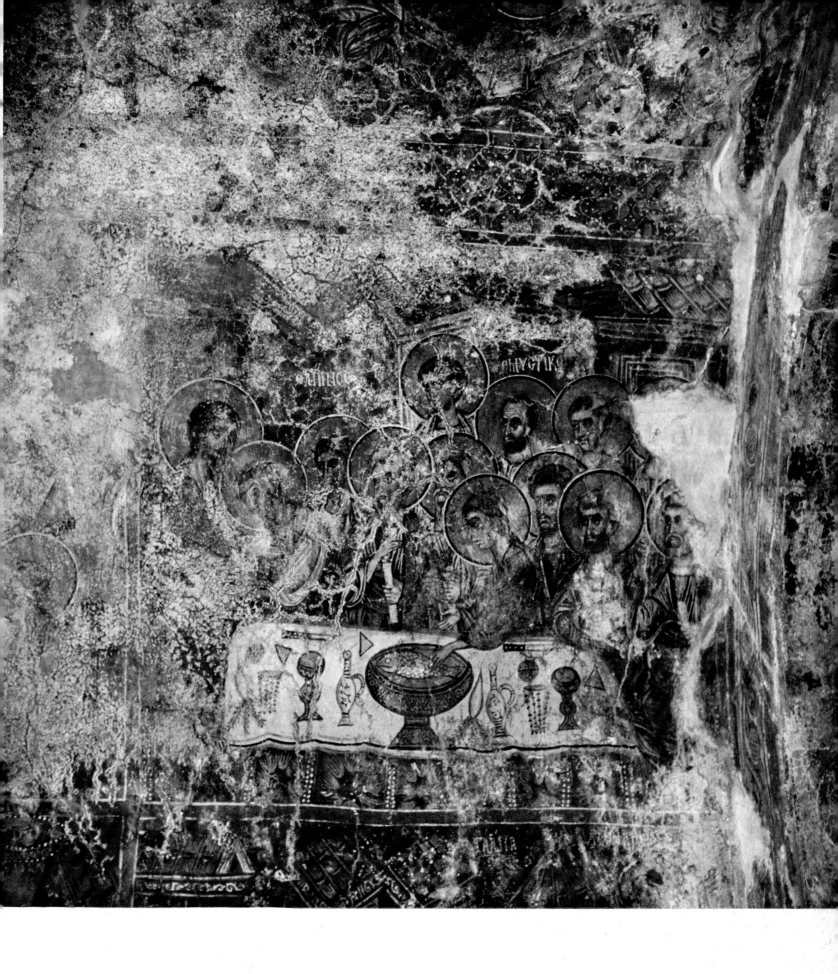

26 *Fresco in the Byzantine Country Church near Kritzas, Crete*

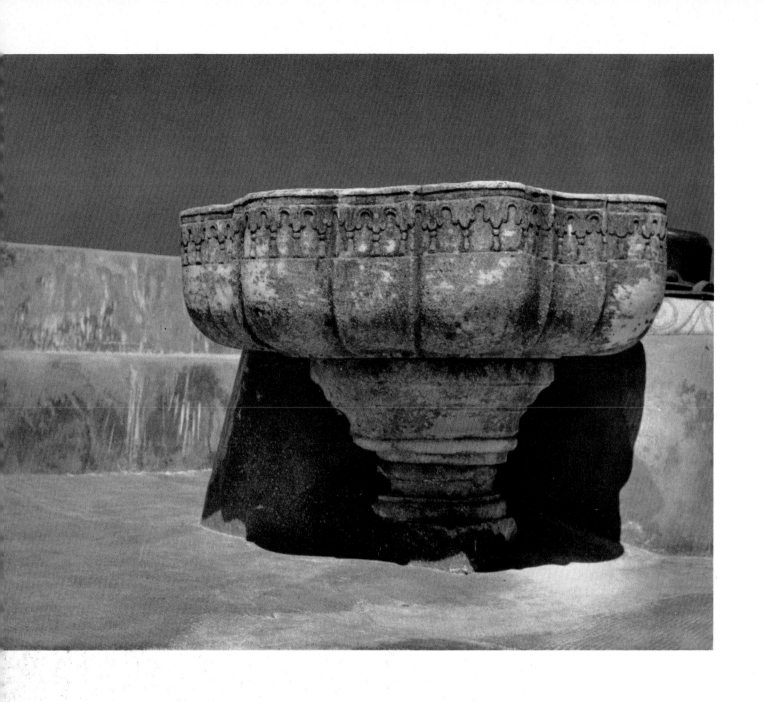

27 *Romanesque Basin in the Courtyard of "Ayios Elias" Mountain Monastery on the Island of Thira*

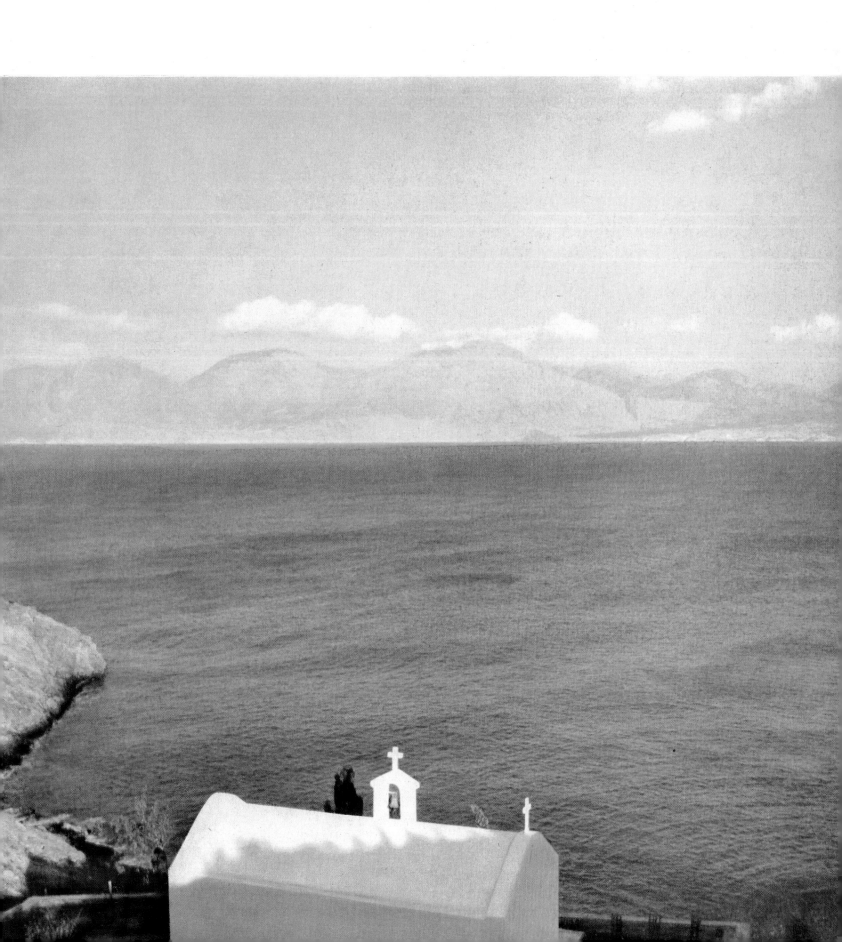

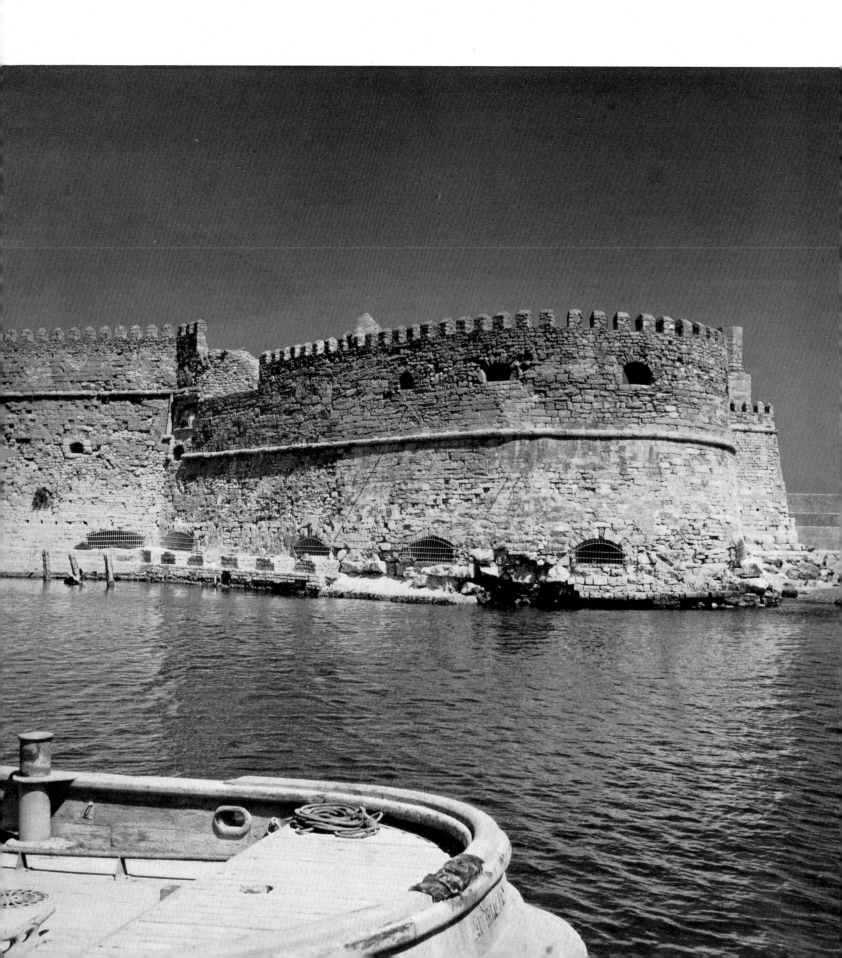

29 *Venetian Bastion, Port of Iraklion*

30 *New Building in the Working-Quarter of Iraklion*

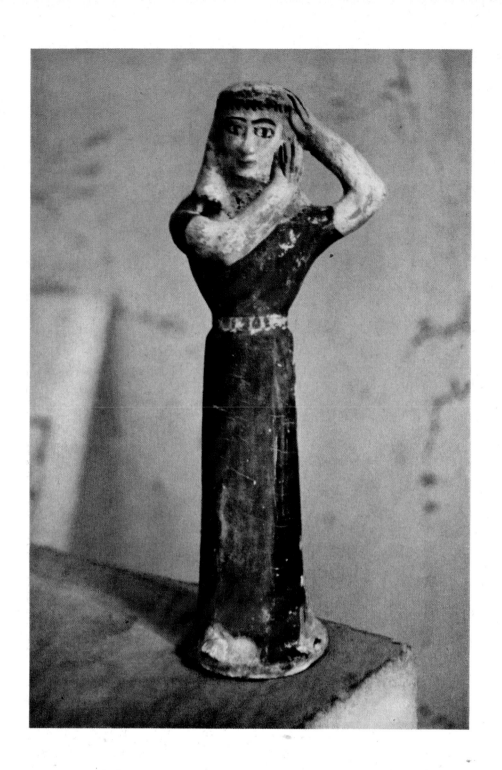

31 *Terra Cotta from Thira*

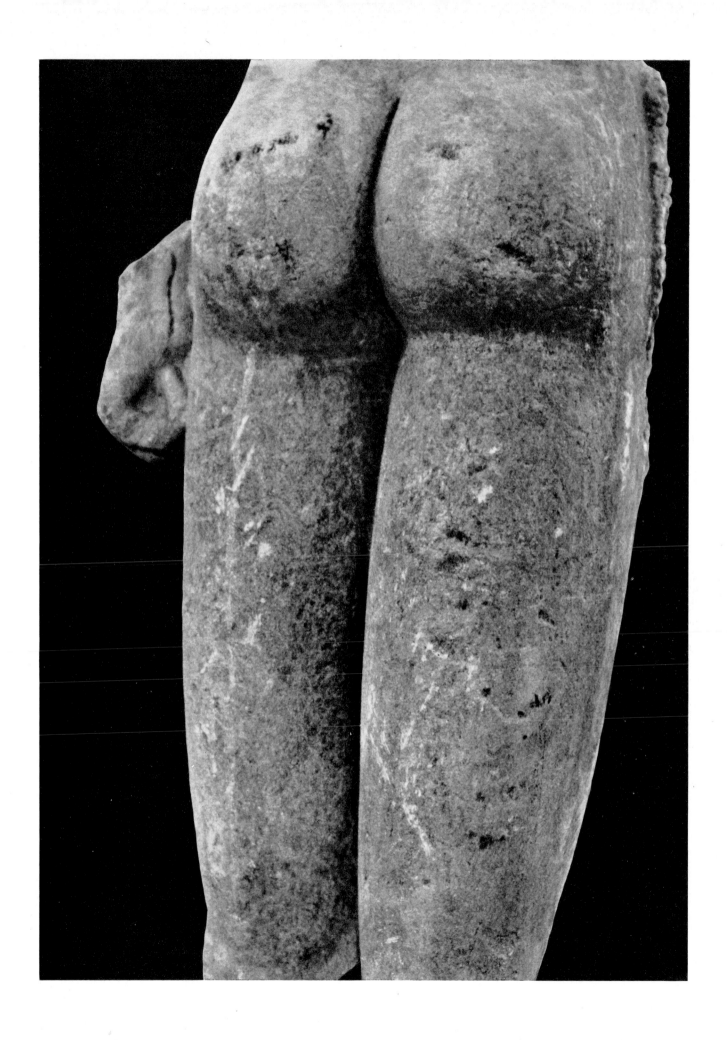

32 Torso of a Kouros; Museum, Thira

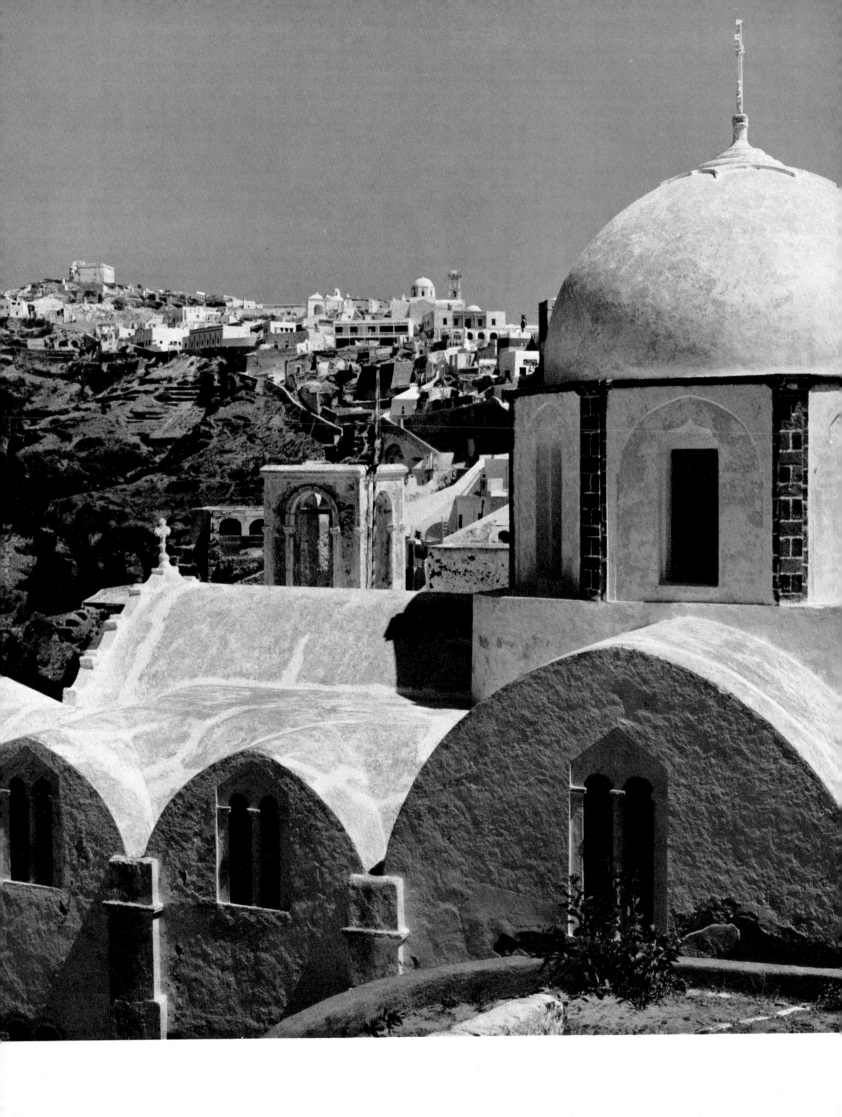

33 *Byzantine Church in the Town of Thira*
34 *Serpentine Road along the Crater Wall of the Island of Thira*

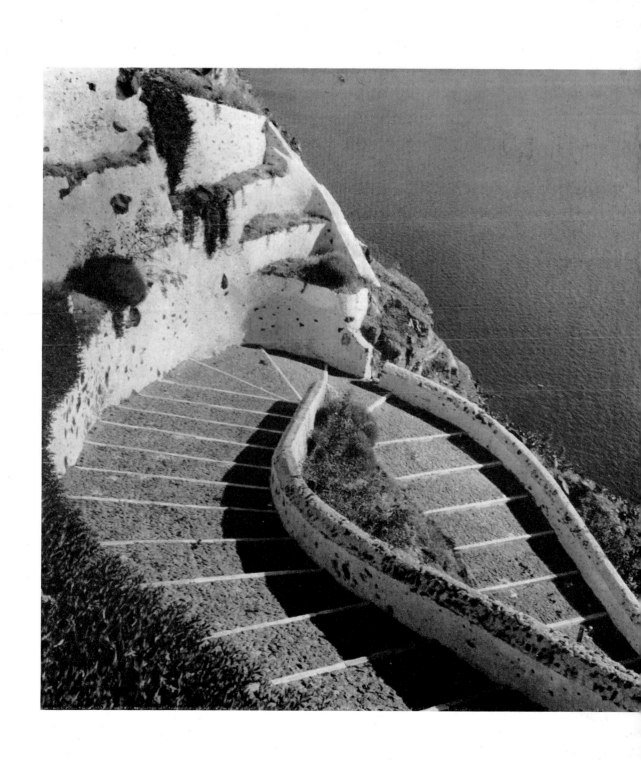

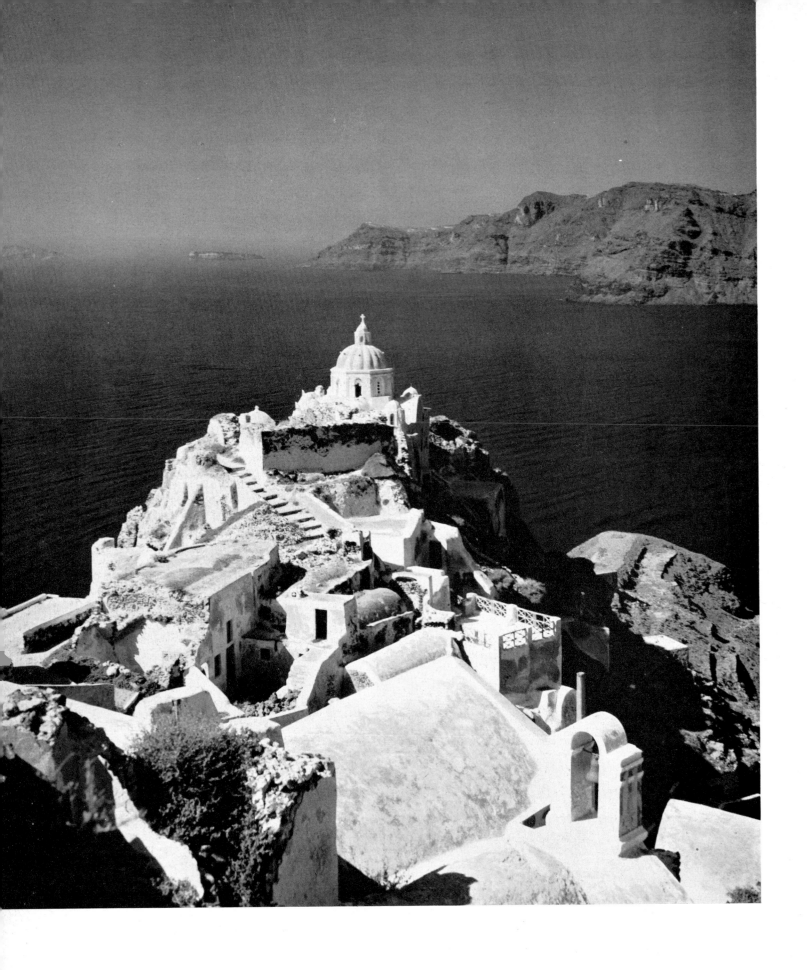

35 *Among the Seismic Ruins of Oia; in the background the island of Therasia*

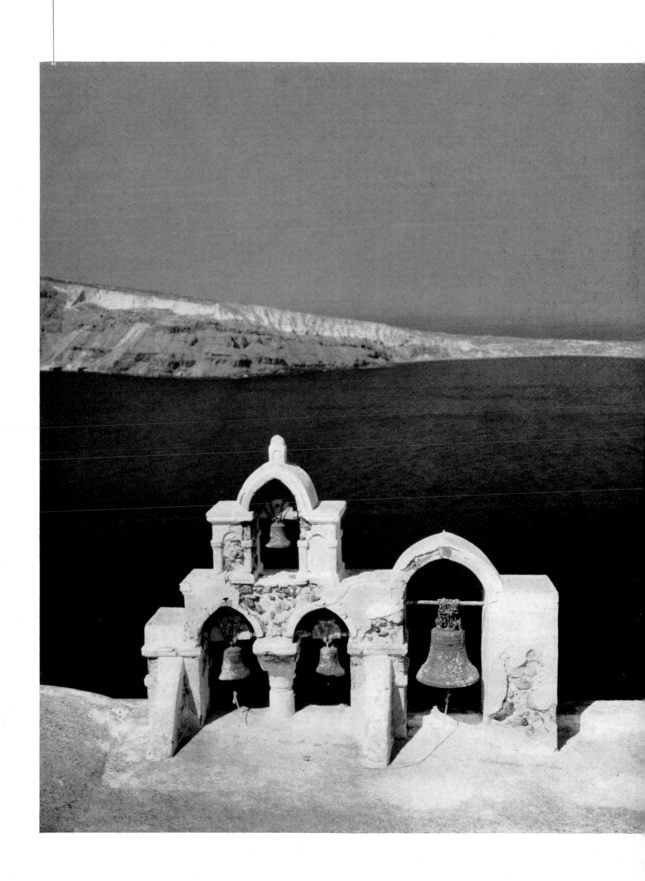

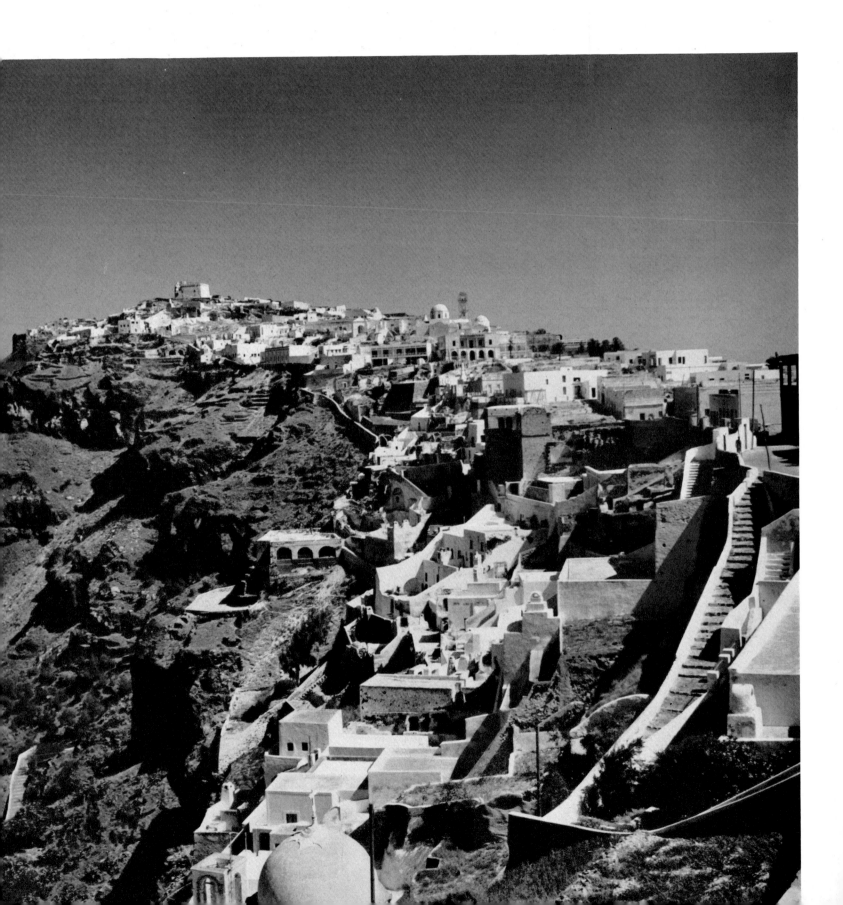

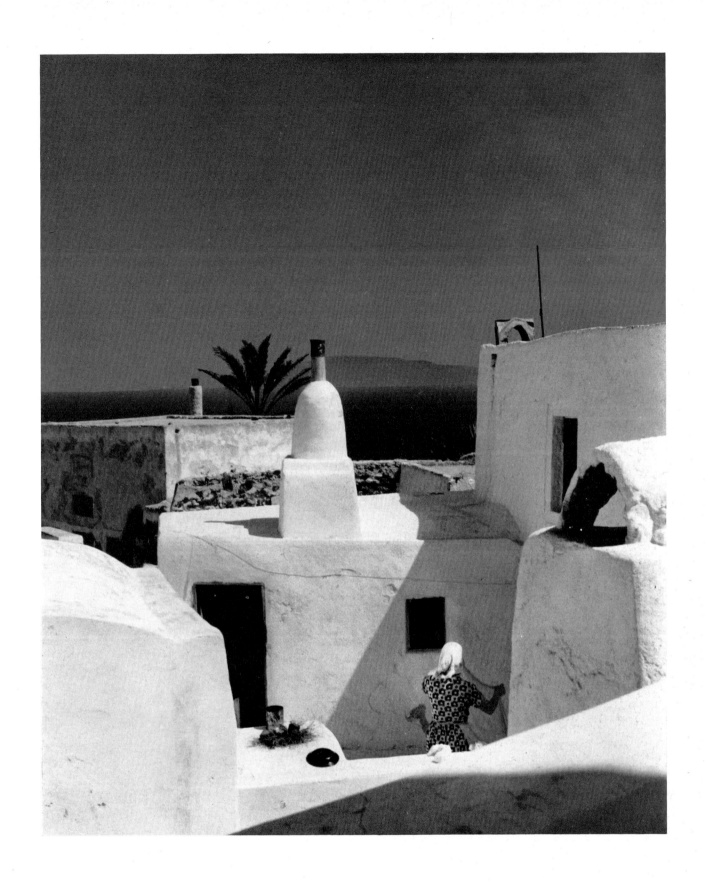

38 Dwelling-Houses at Oia

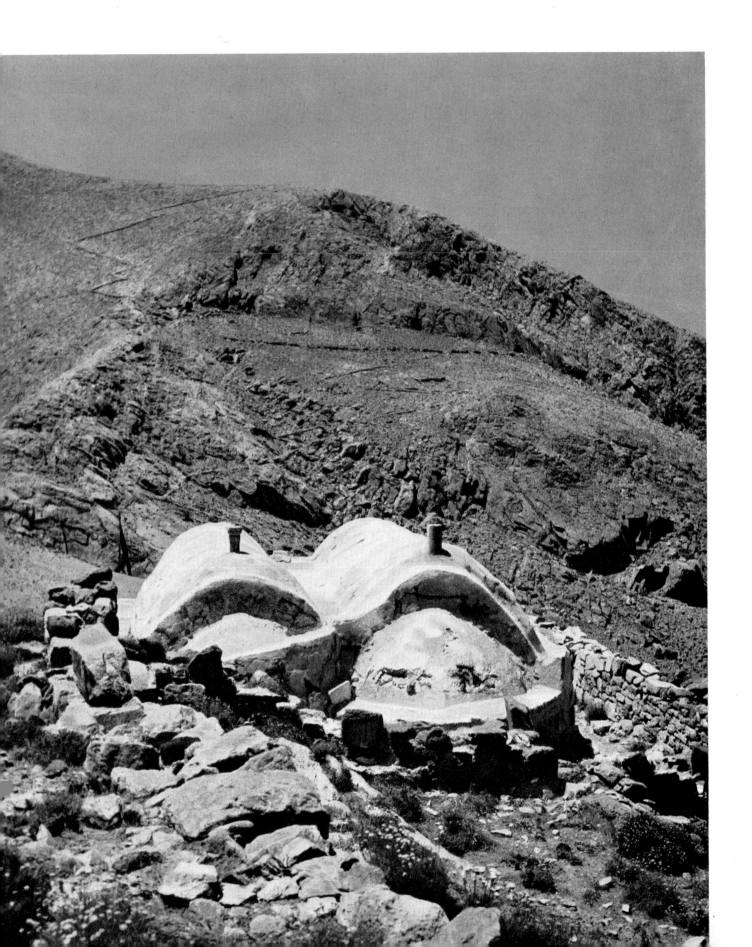

40 *Ruins of Stavros Church at Perissa, Thira*

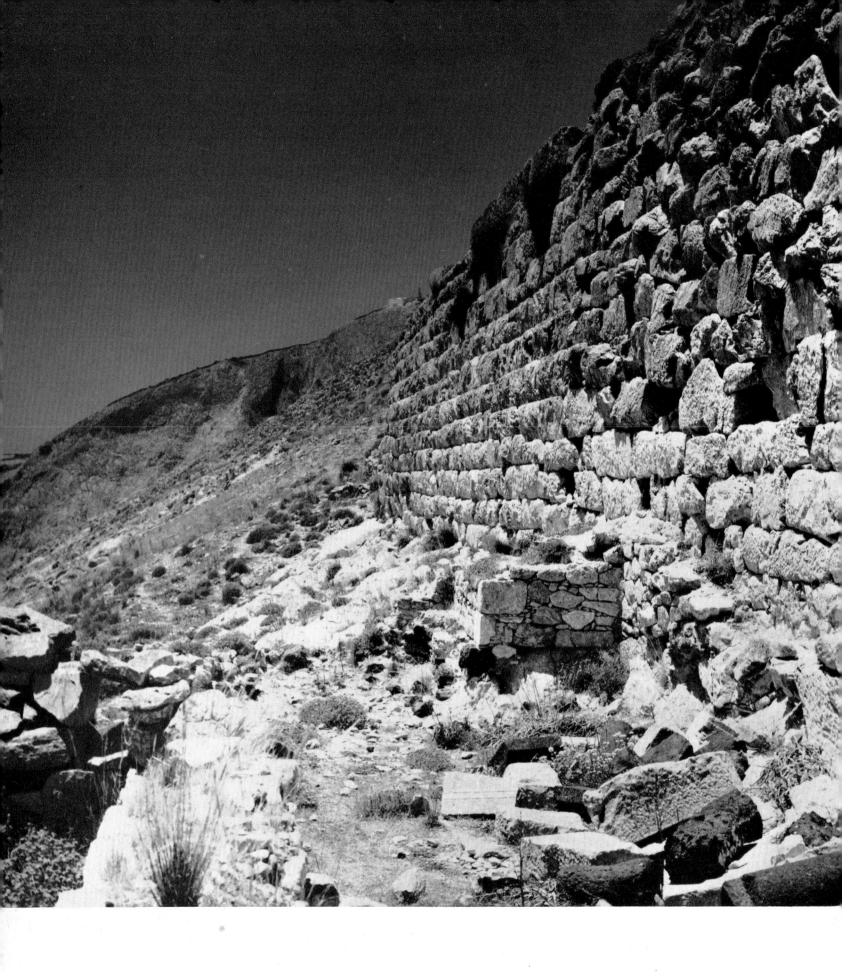

41 *Ancient Wall among the Ruins of the Town of Thira*

42 *Burial Stele in Shape of a Lion; Museum, Thira*

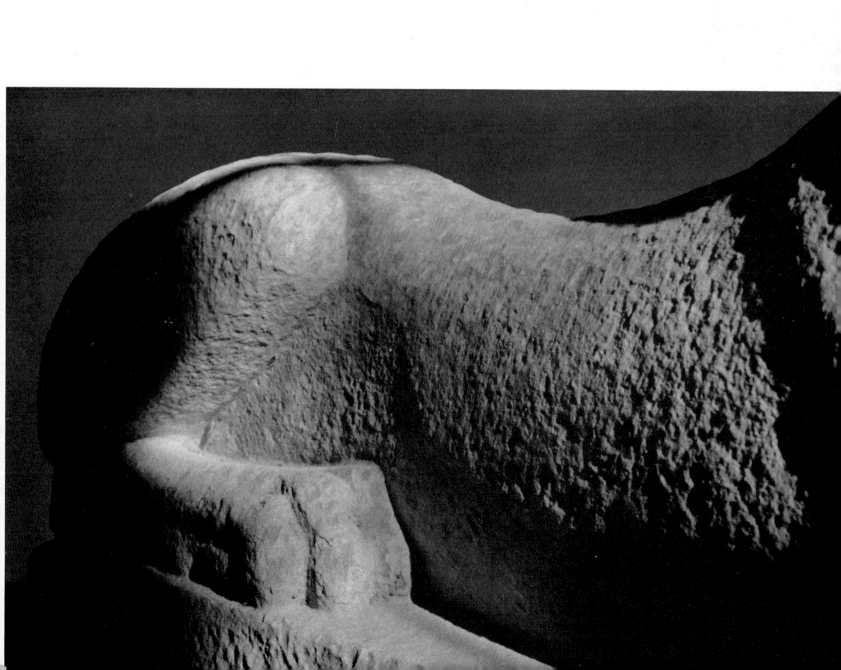

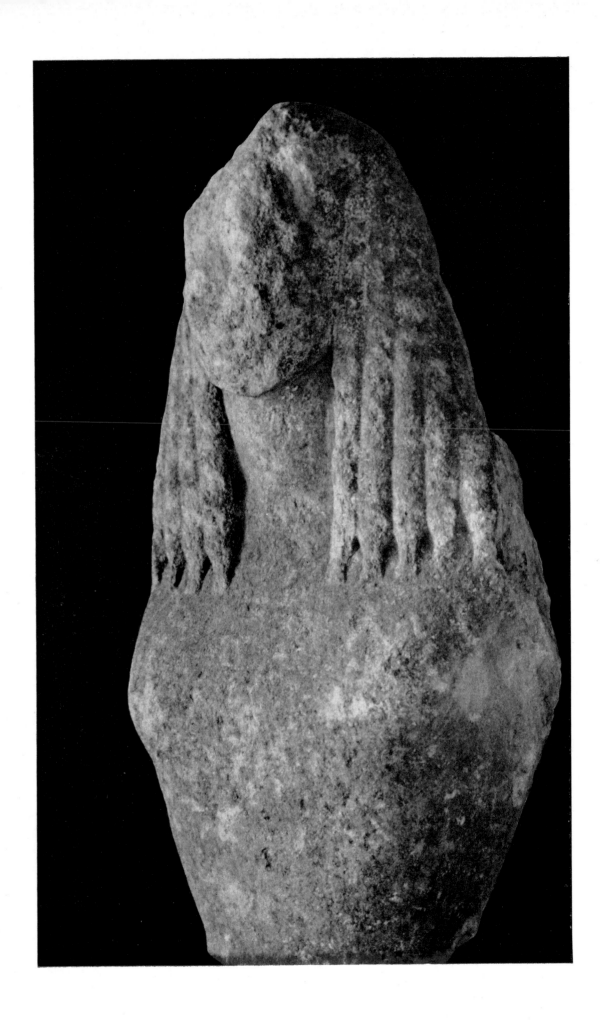

43 *Archaic Statue of a Woman; Museum, Thira*

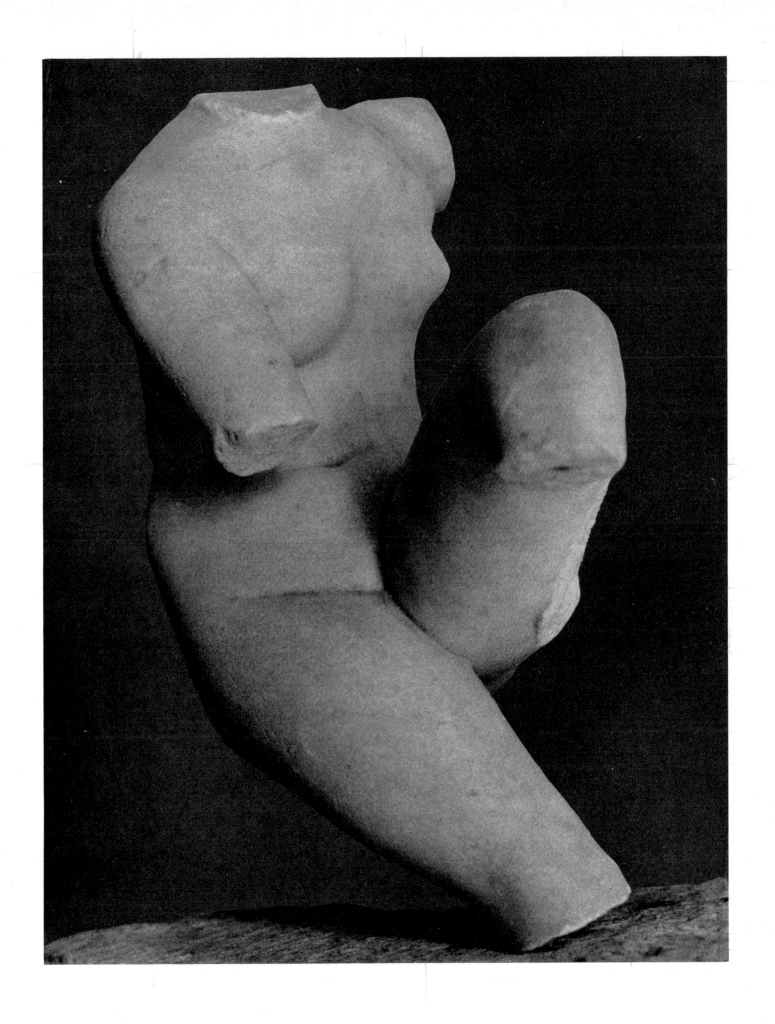

44 *Torso of an Aphrodite, Hellenistic; Museum, Thira*

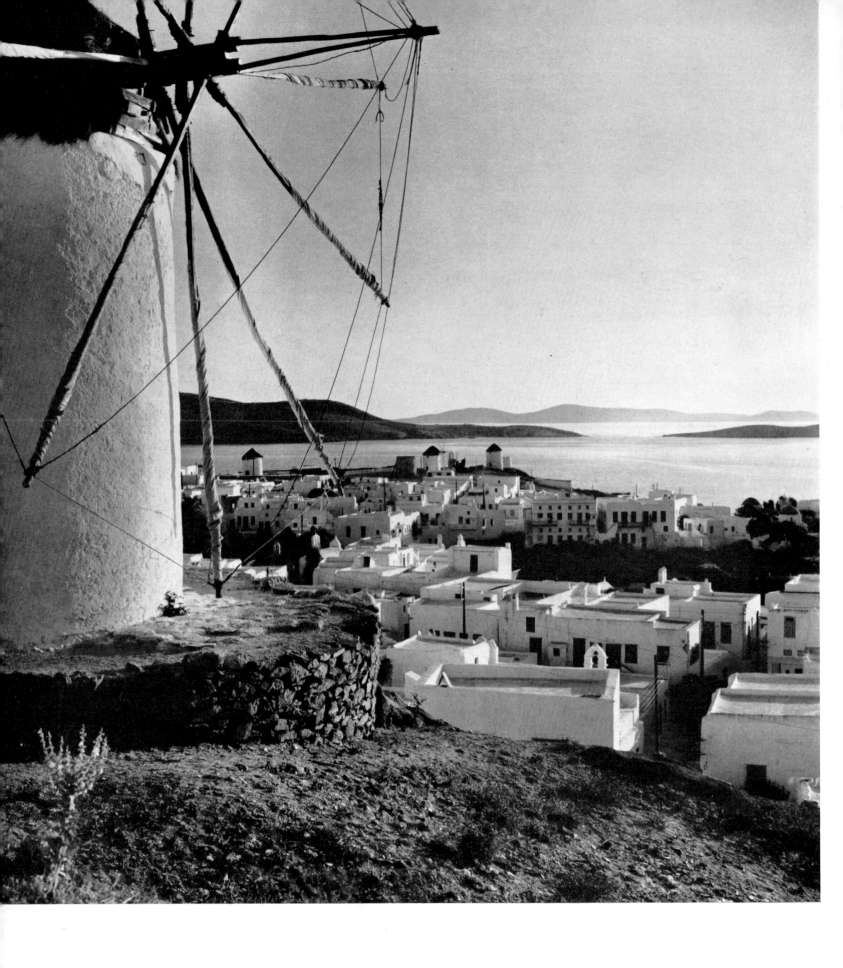

45 *The Town of Mykonos*

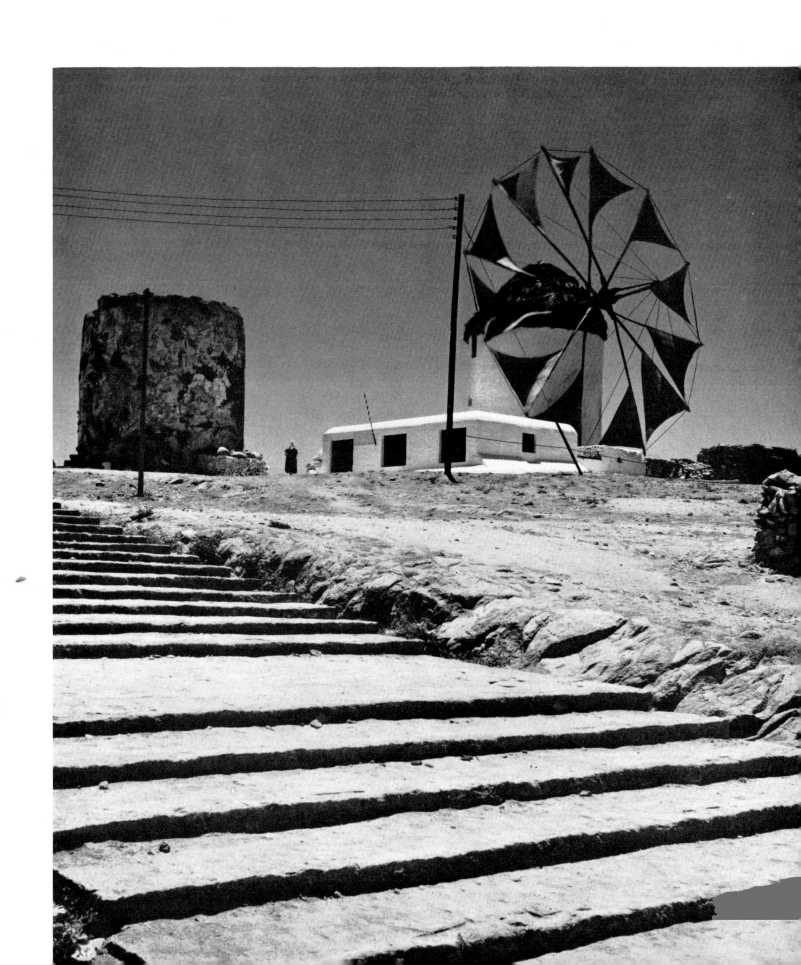

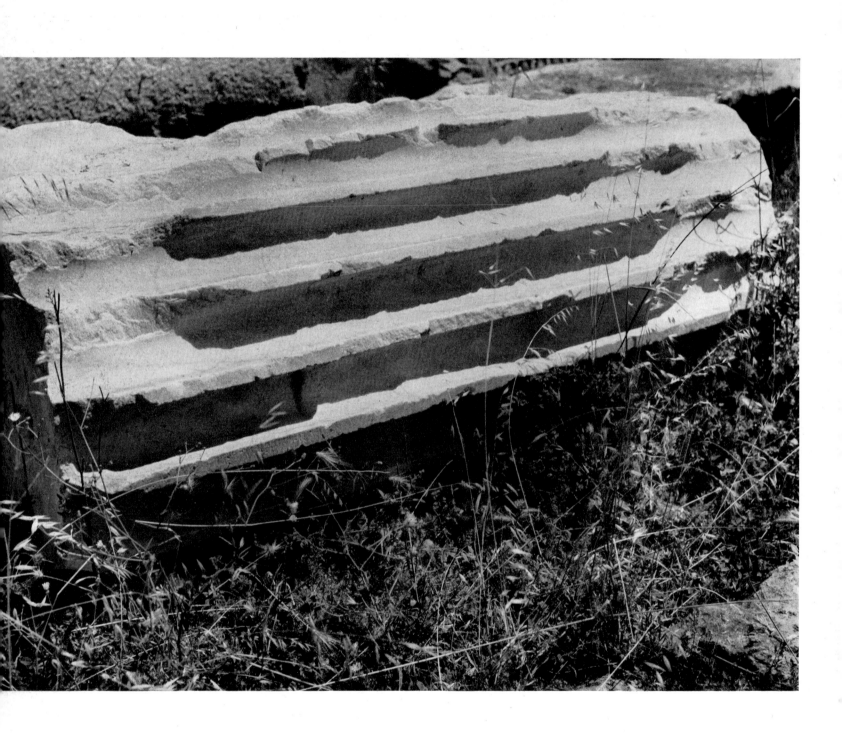

47 *Column Torso*

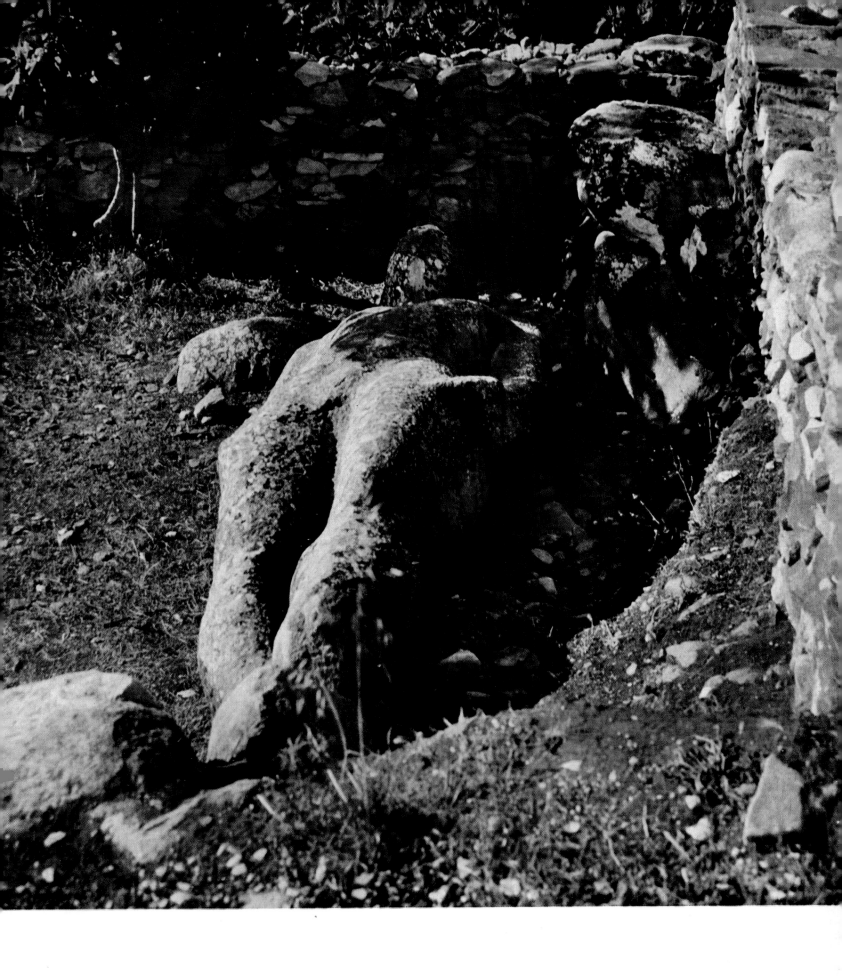

48 *Unfinished Kouros in the Ancient Marble Quarries on the Island of Naxos*

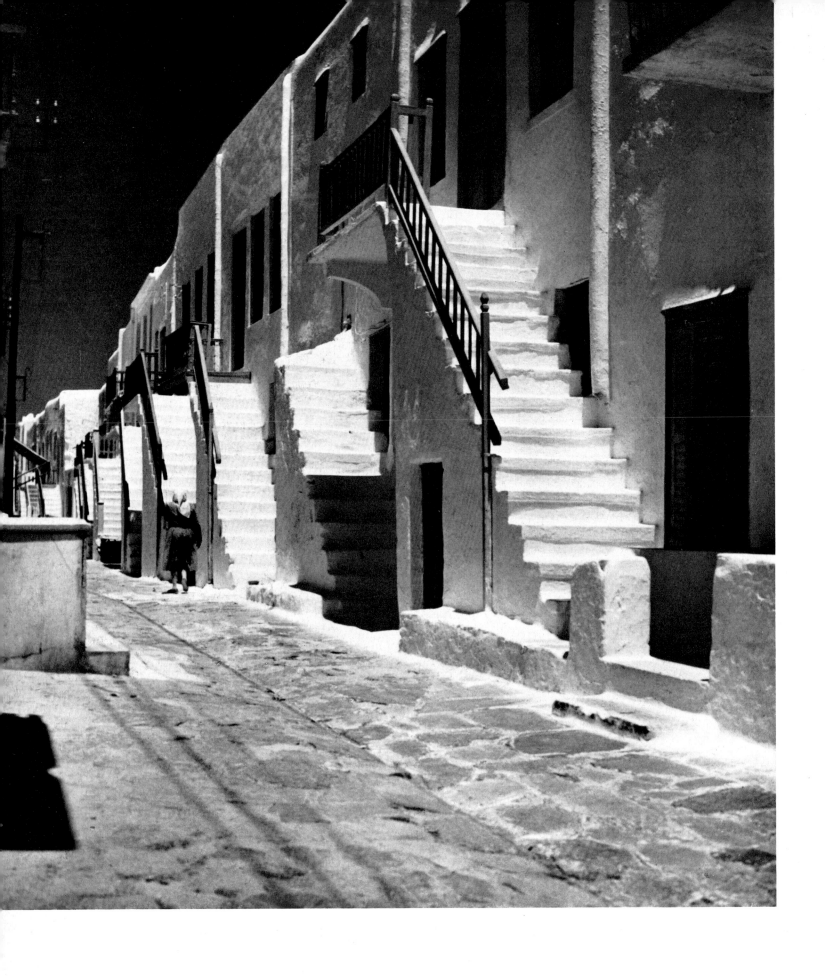

49 *Street at Mykonos*

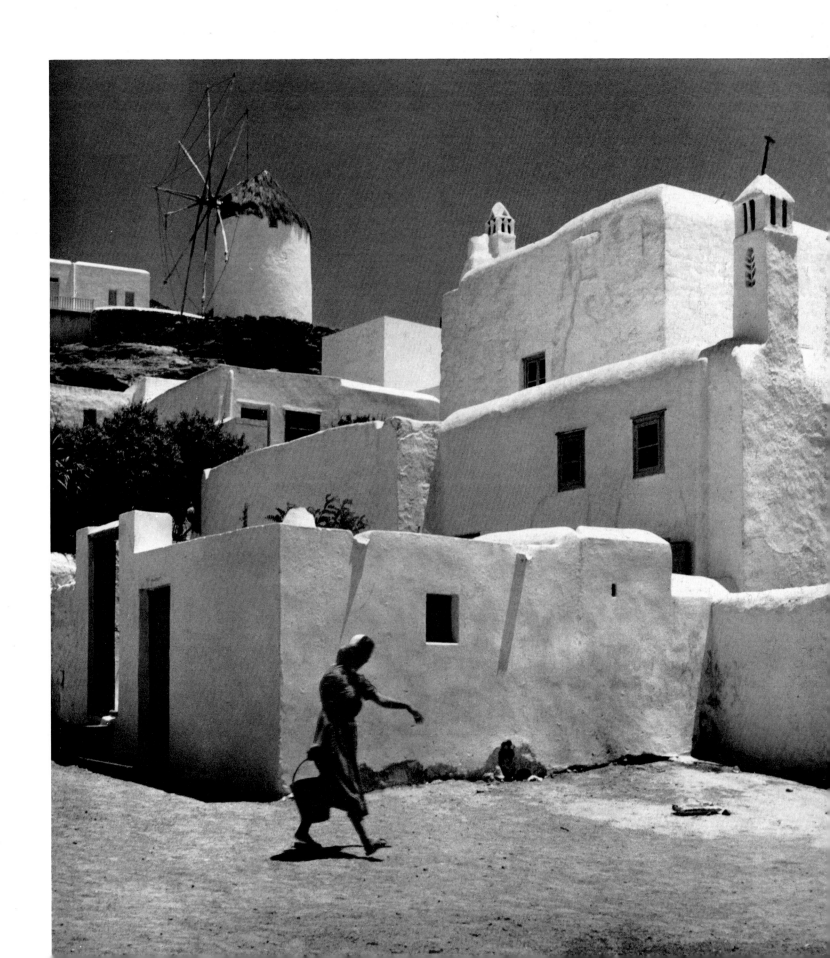

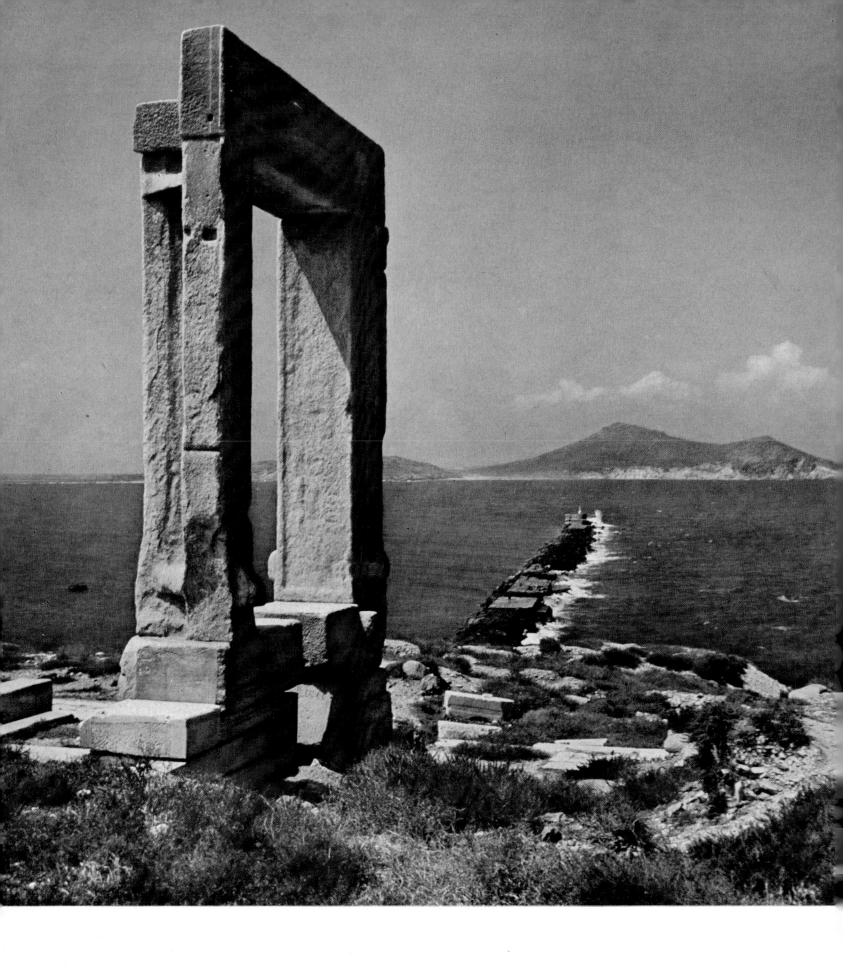

51 Unfinished "Gate of the Winds" Temple Portal on the Island of Naxos

52 *Greek Amphora in the Courtyard of a Dwelling-House in Naxos*

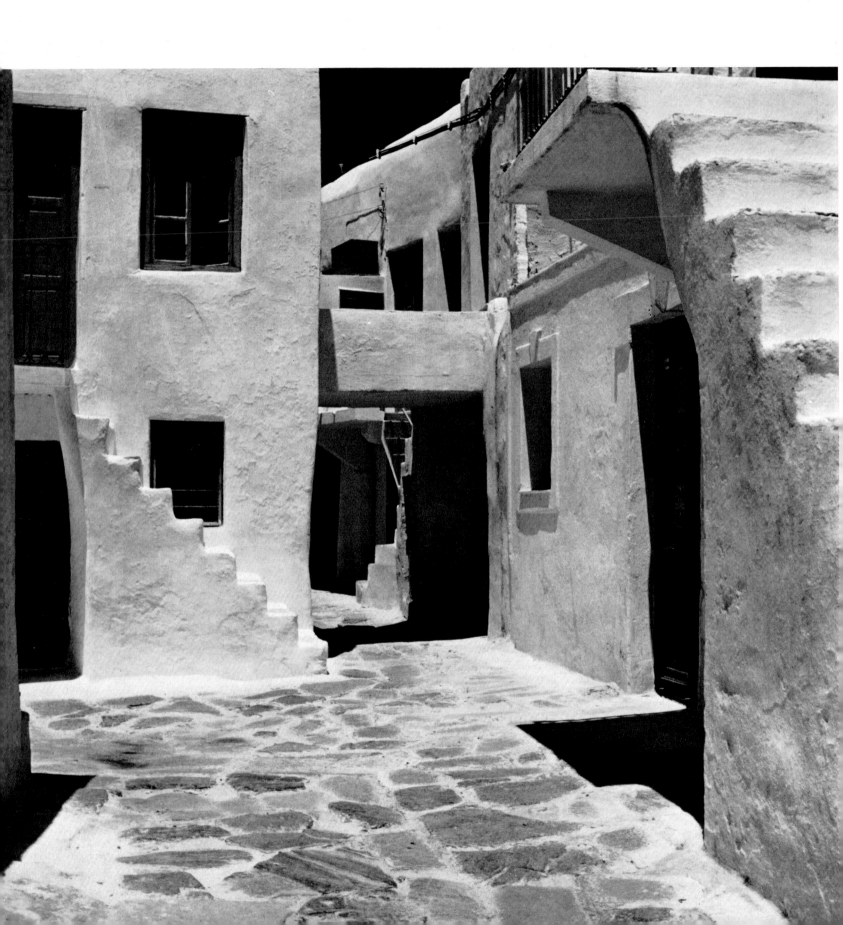

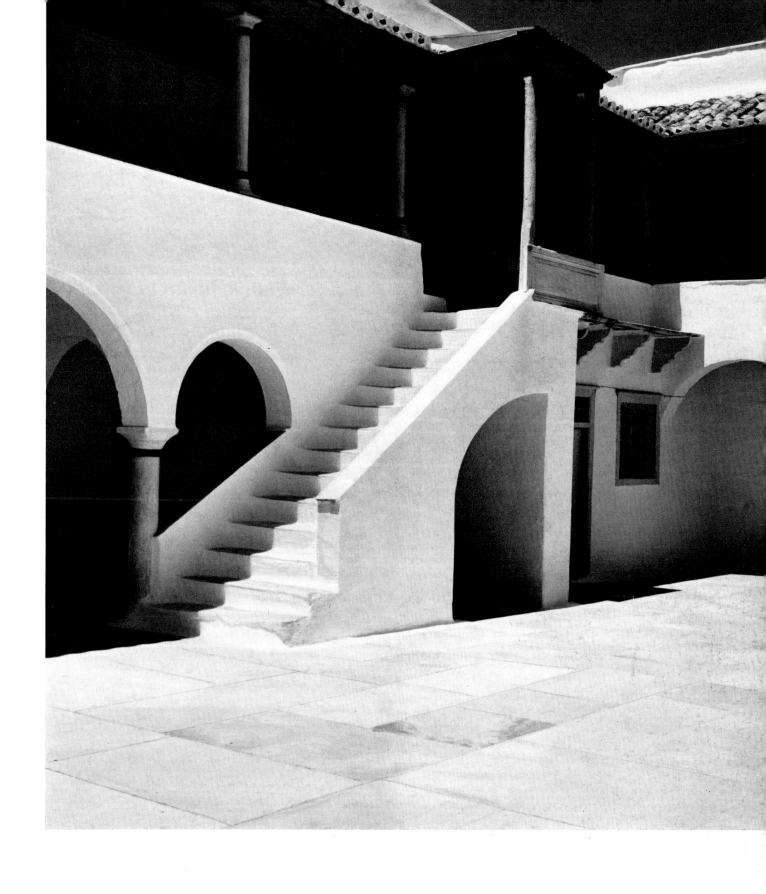

54 *Turliani Quadrangle, Mykonos*

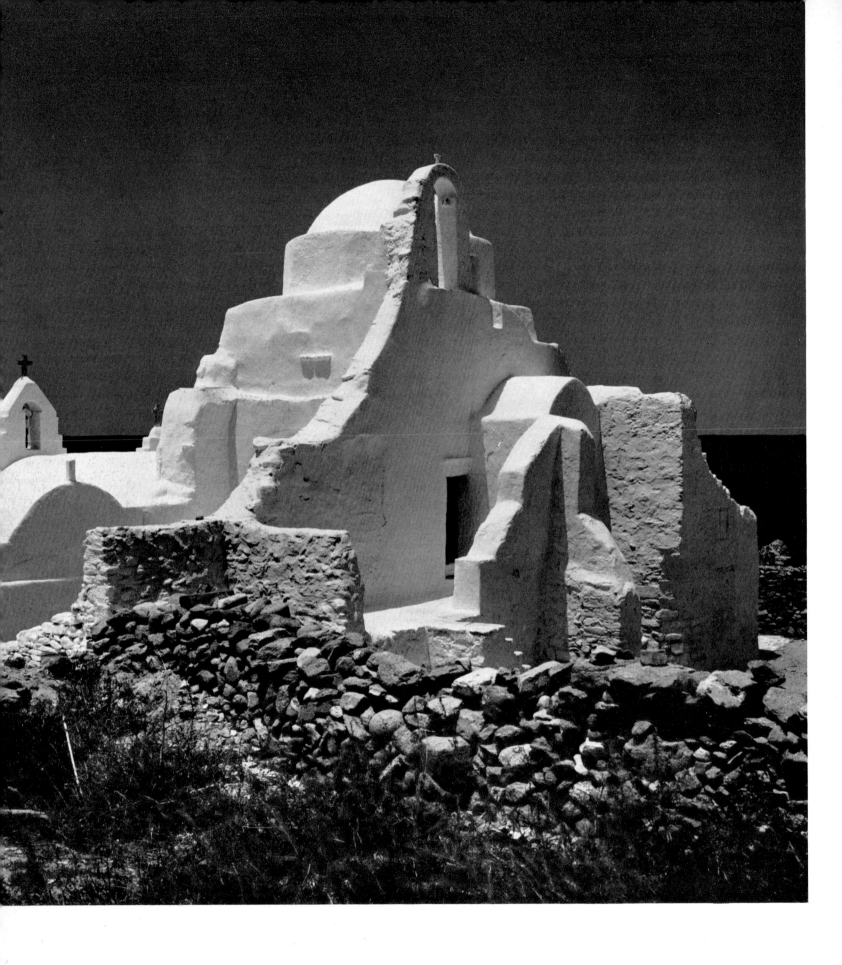

55 *The Sea Church of Mykonos*

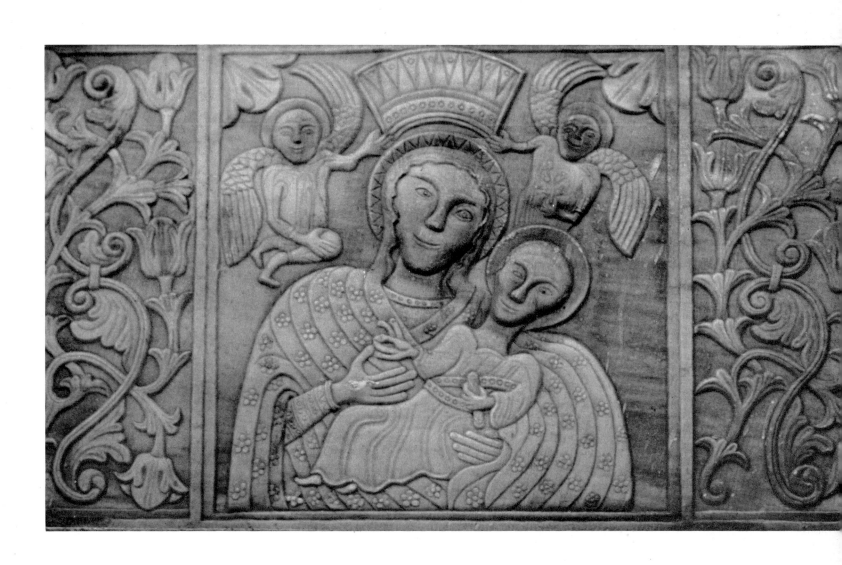

56 Relief by an Early Venetian Master in the Turliani Quadrangle, Mykonos

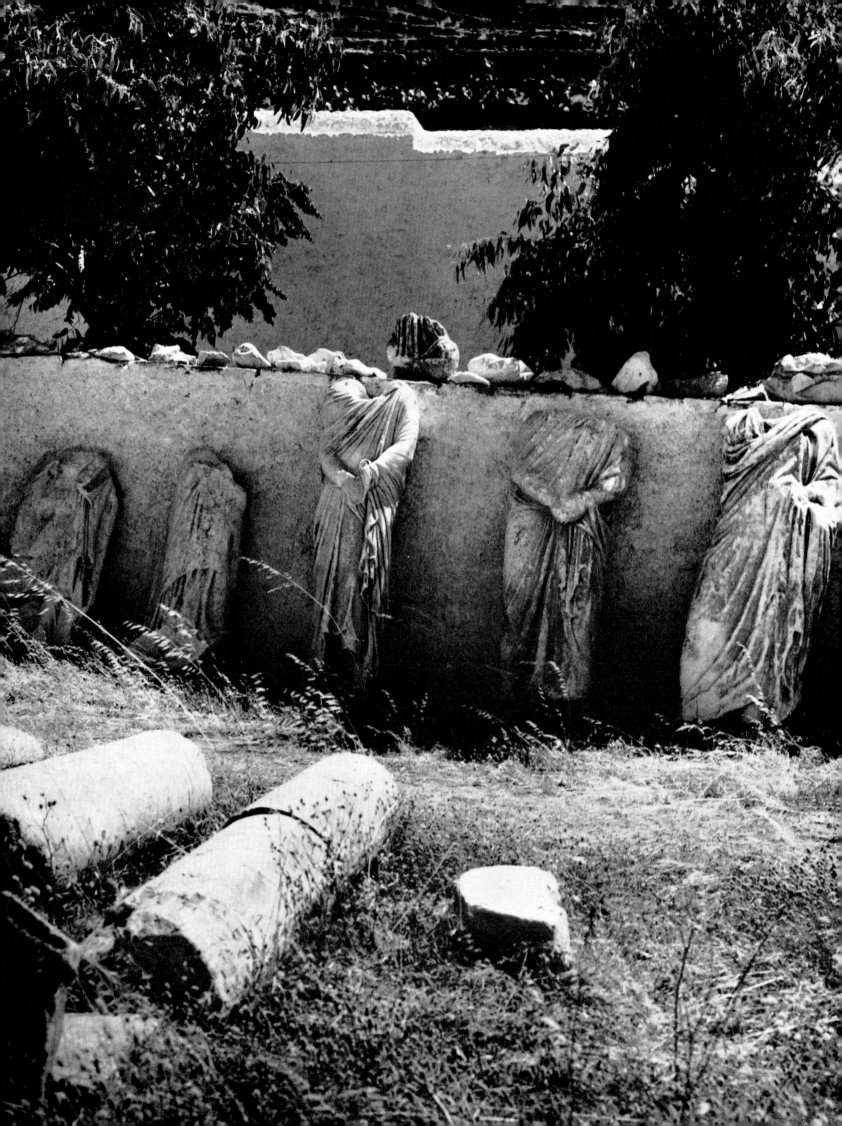

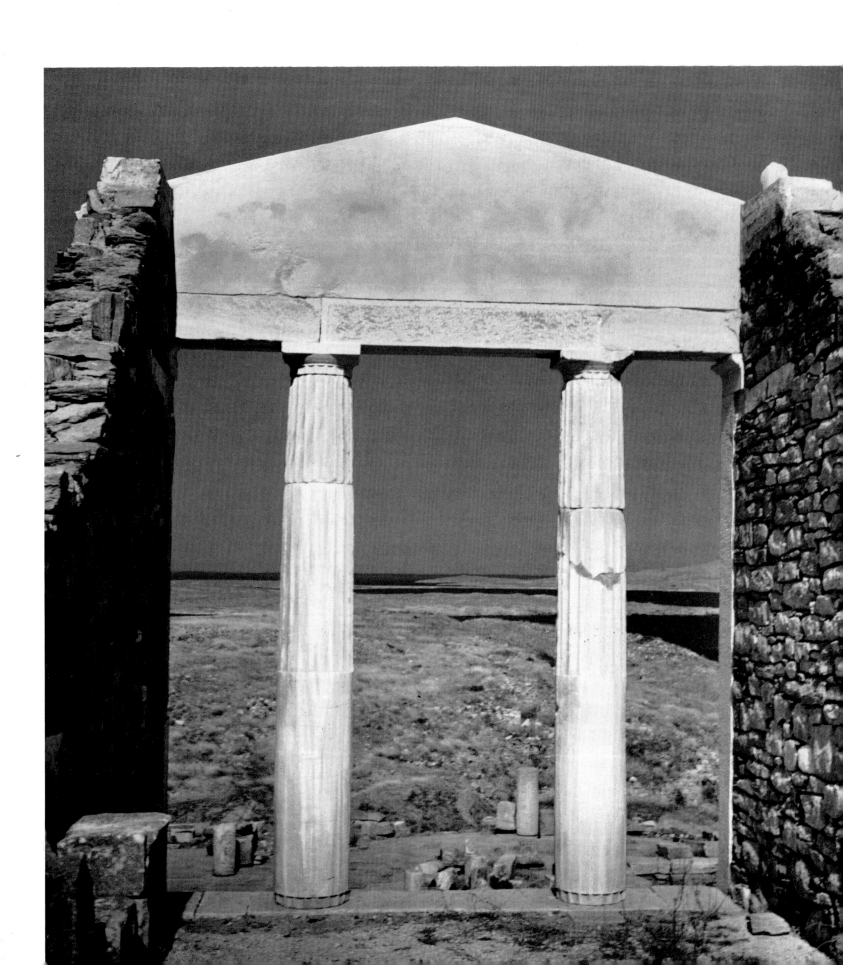

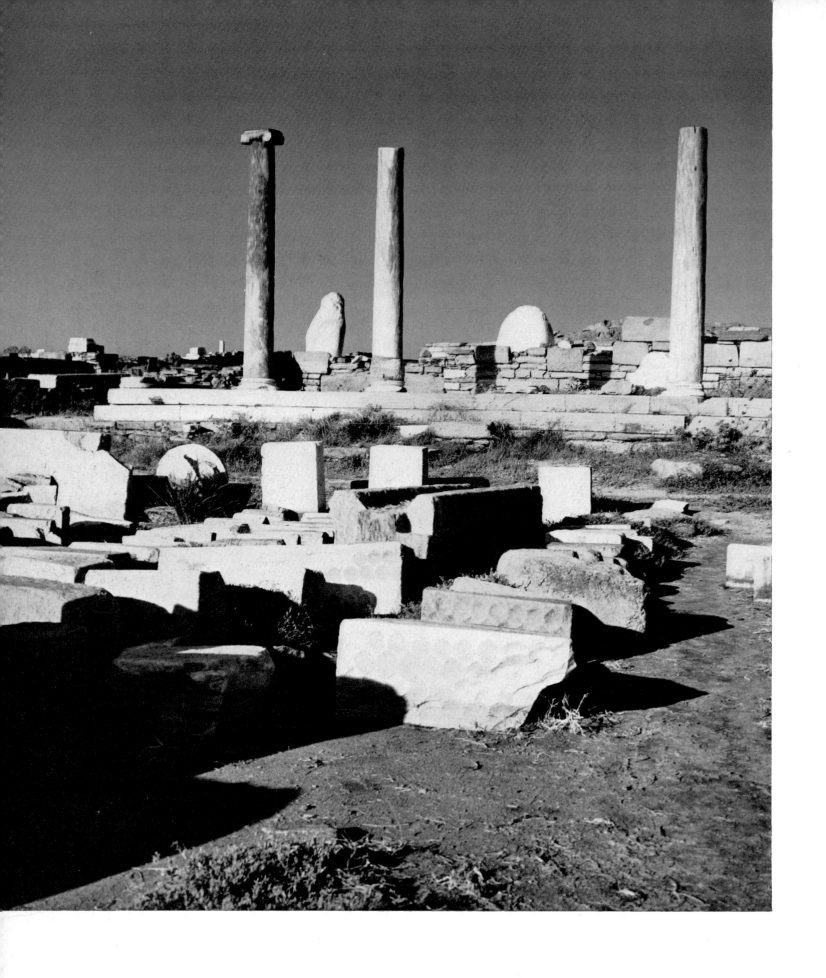

59 *Columns, Ionic Order, in the Shrine of Apollo with Torsos of the Colossus*
 of the Naxians on the Island of Delos
60 *Late Hellenistic Statue of Isis and the Temple of Serapis, Delos*

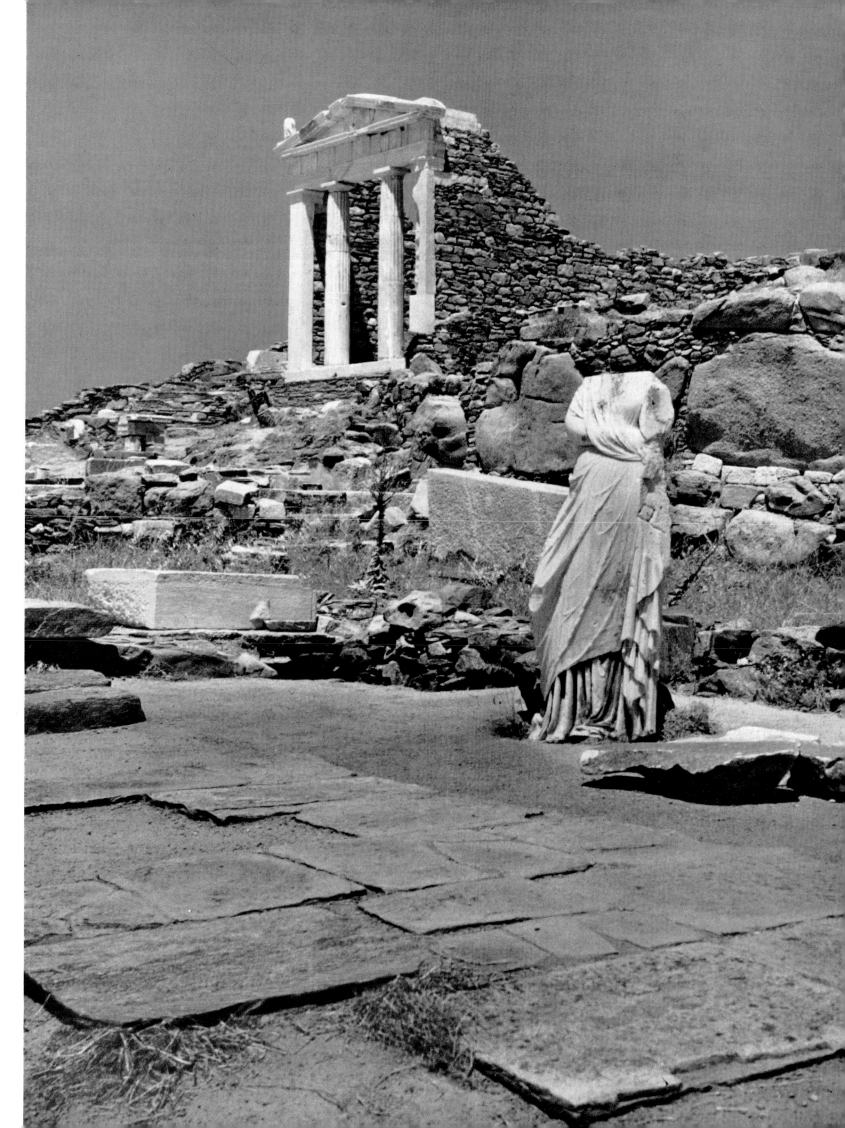

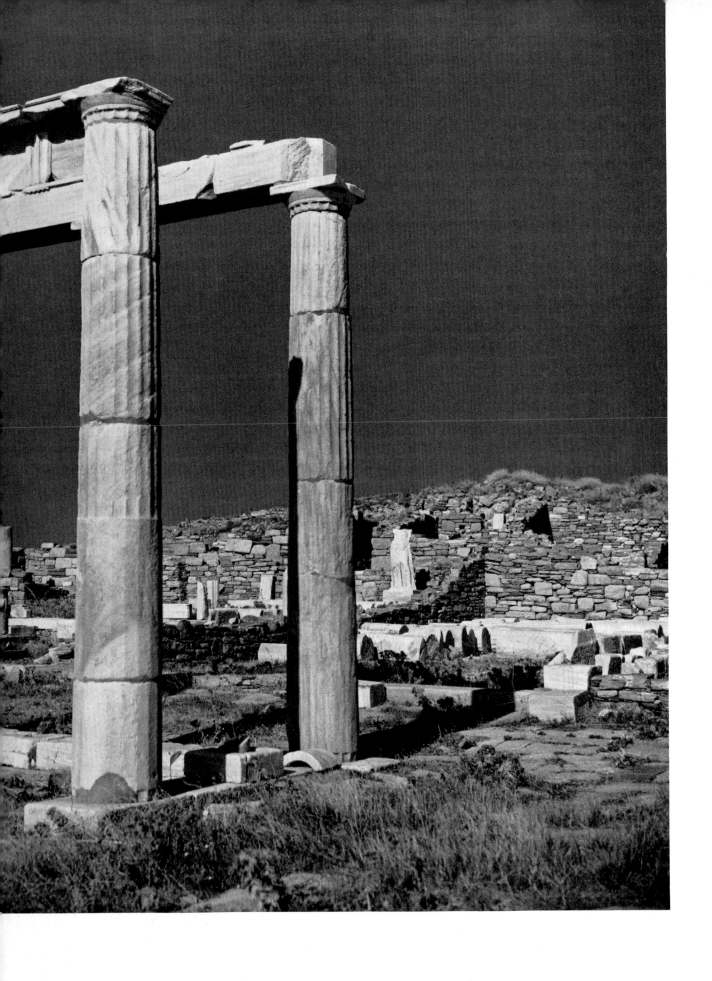

61 *Propylaea of the Italic Agora, Delos*

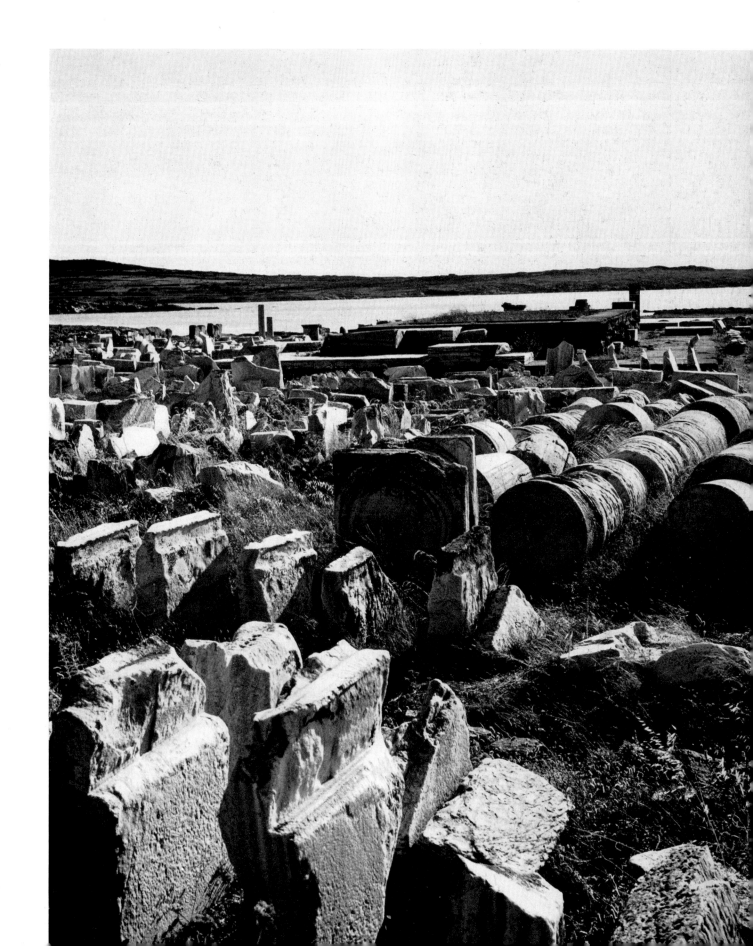

63 *Cistern in the Shrine of Apollo, Delos*

64 *Dionysian Phallic Monument, Delos; Offering,* 1st *half of* 3rd *century* B. C.

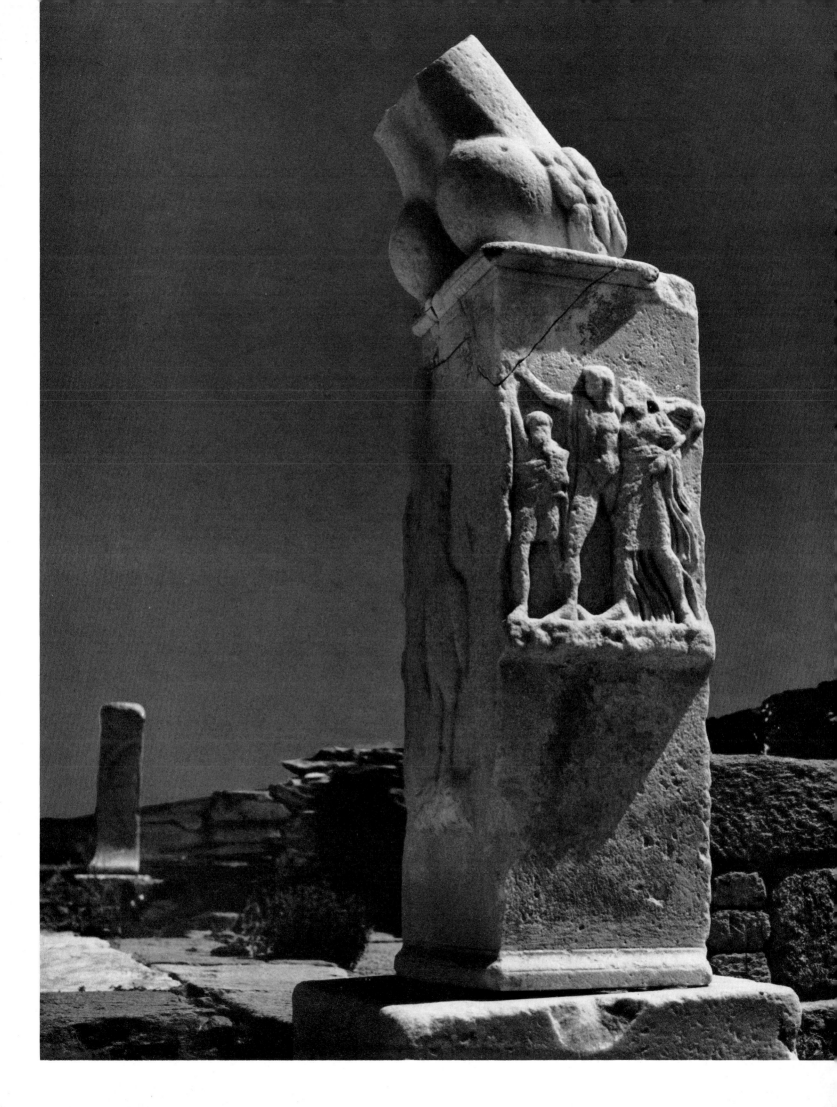

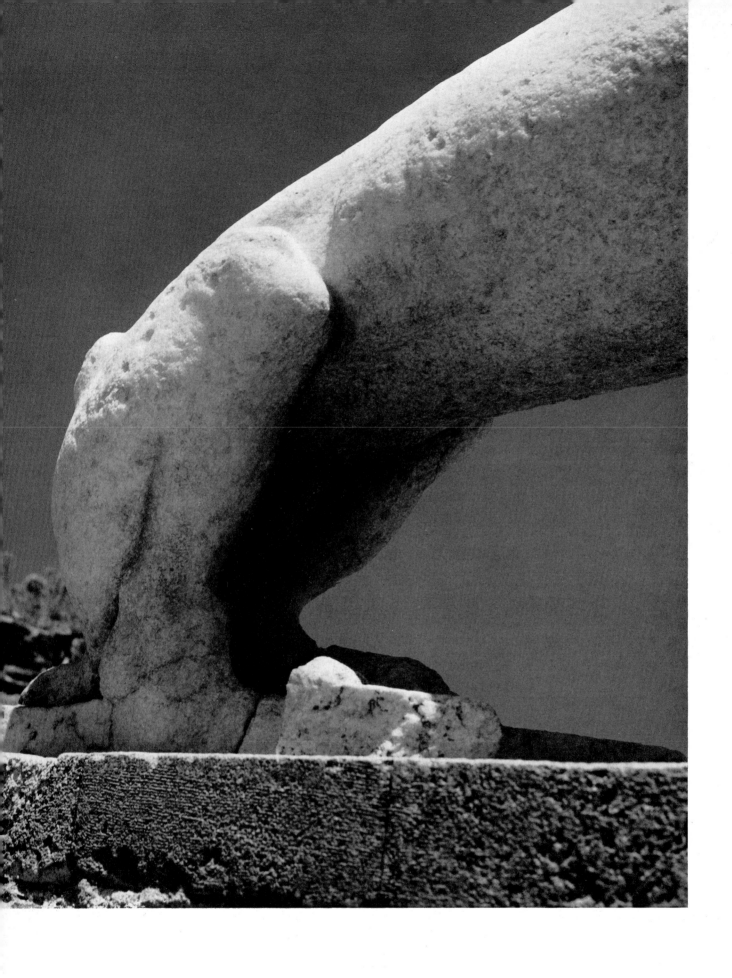

65 Detail of one of the Delian Lions

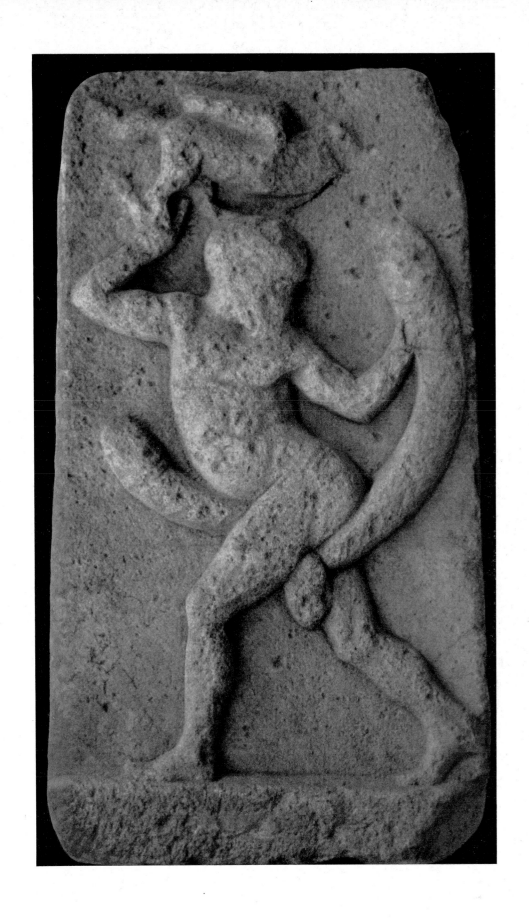

66 Satyr; Museum, Delos

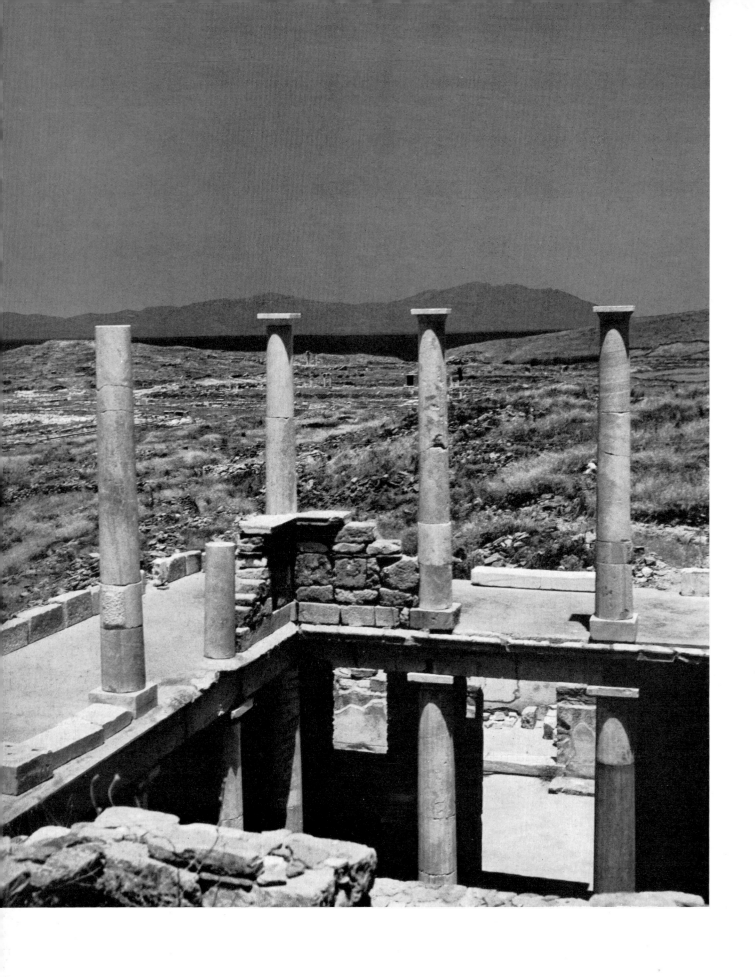

67 The House of Hermes on the Slope of Kynthos Hill, Delos

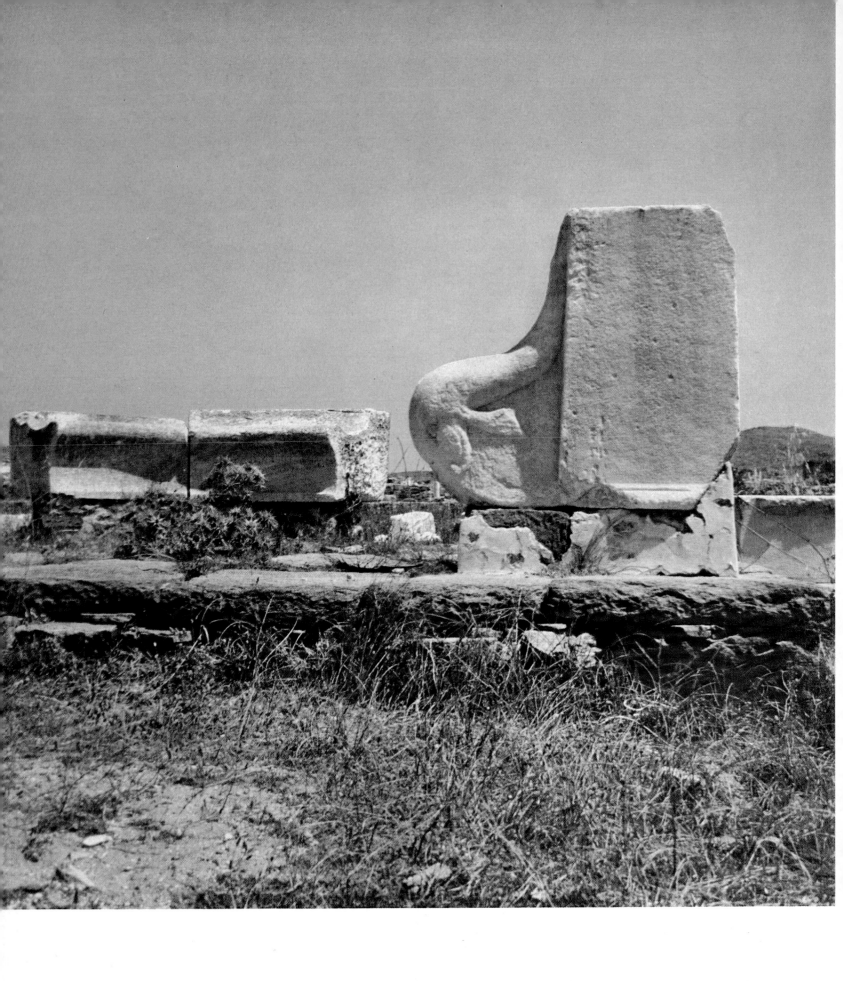

69 Fragment of a Relief Frieze in the Shrine of Apollo, Delos

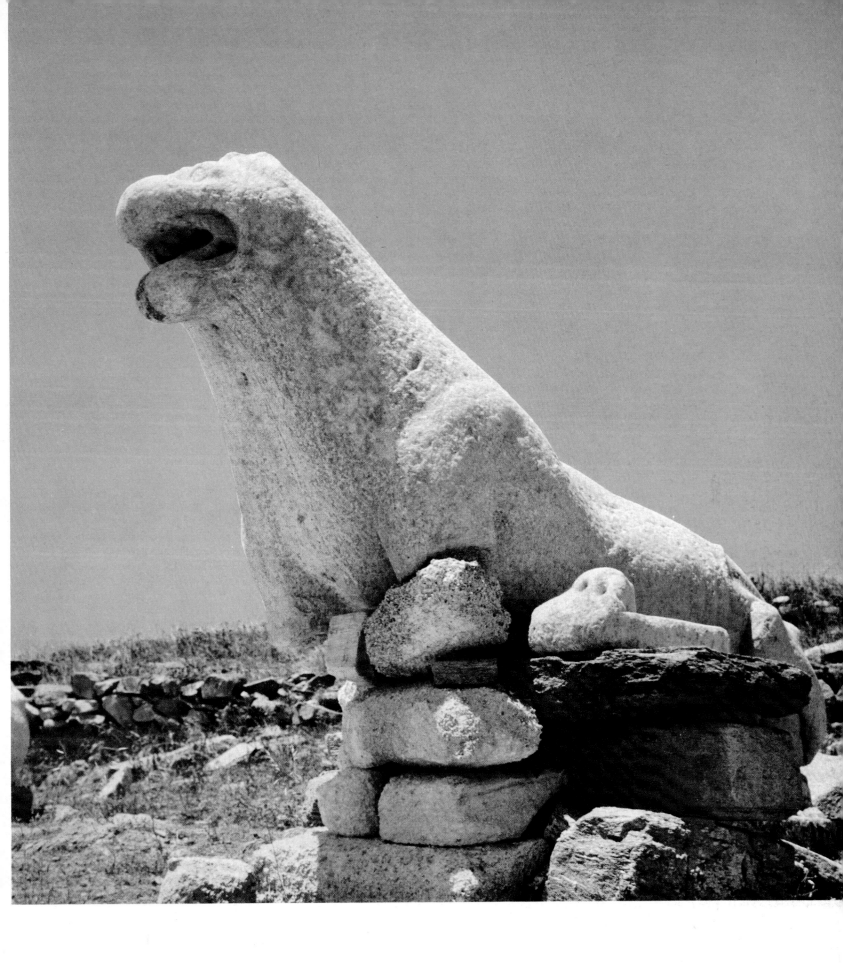

70 *Archaic Lions near the Sacred Lake of Delos*

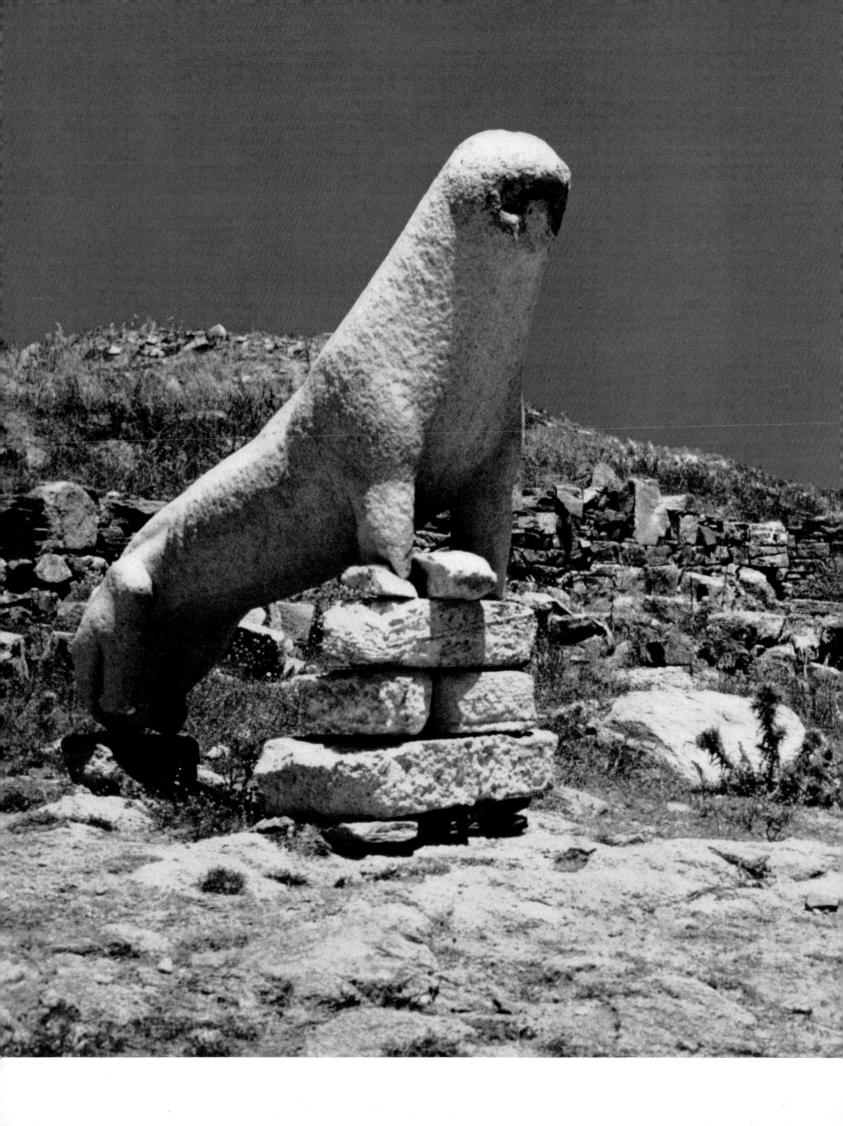

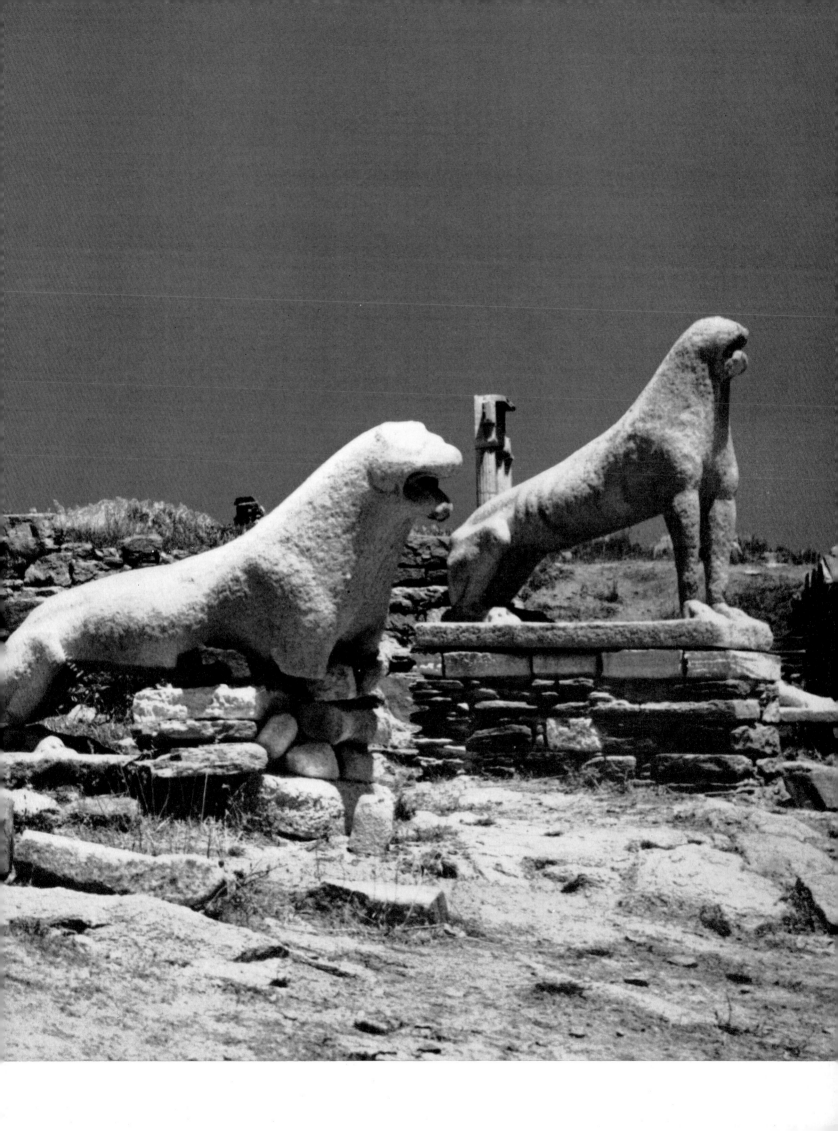

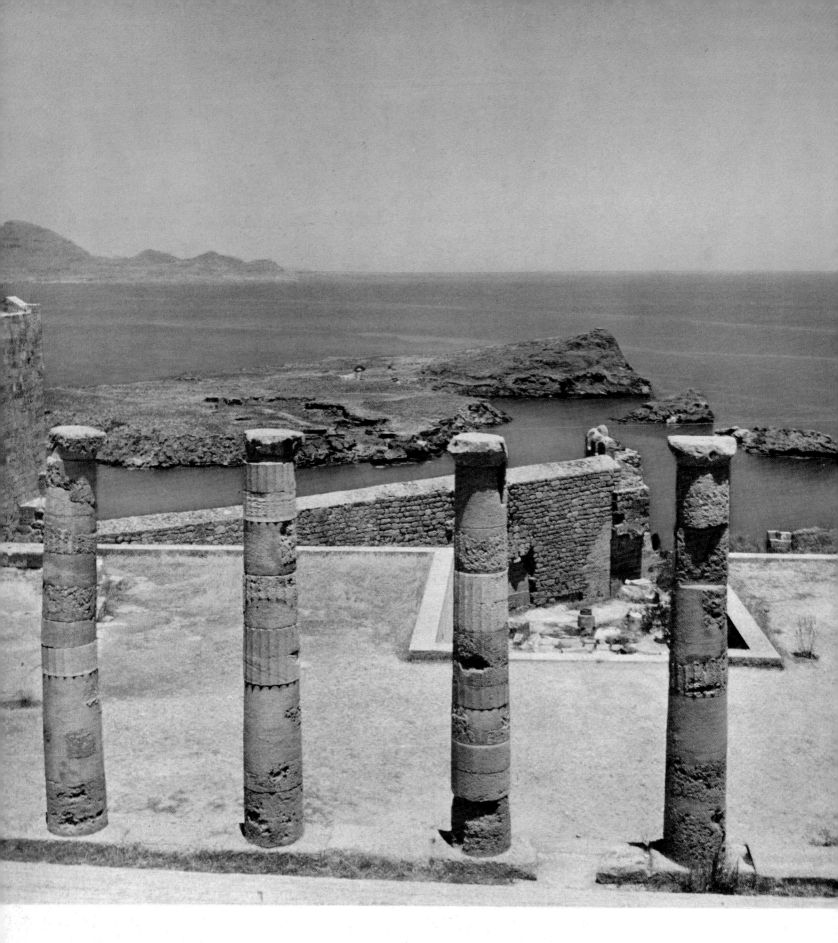

On the preceding pages:

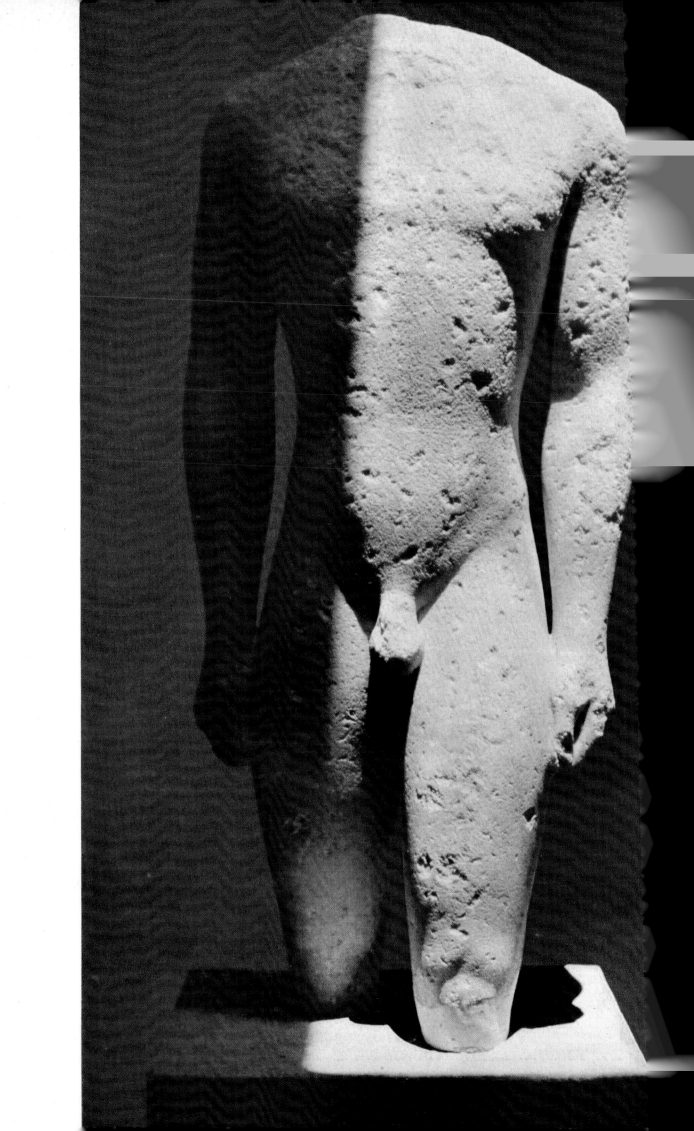

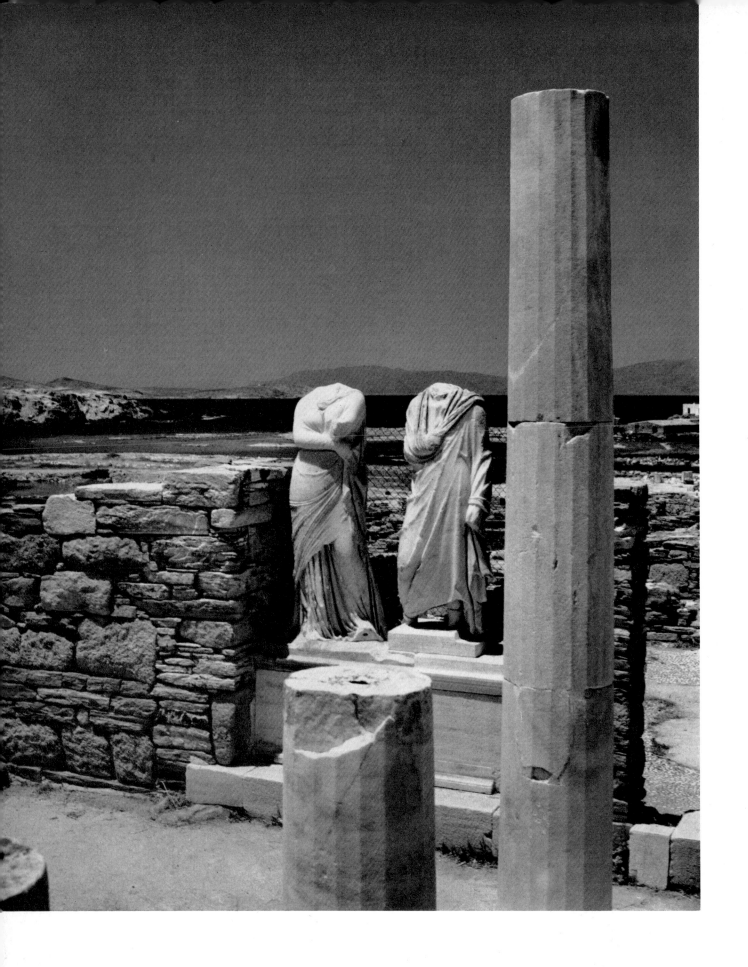

74 *Interior View of the House of the Athenian Cleopatra with her own Statue*
 and that of her Husband Dioscourides, Delos

75 *Mosaic of a Roman House, Delos*

76 *Mosaic in "Trident House", Delos*

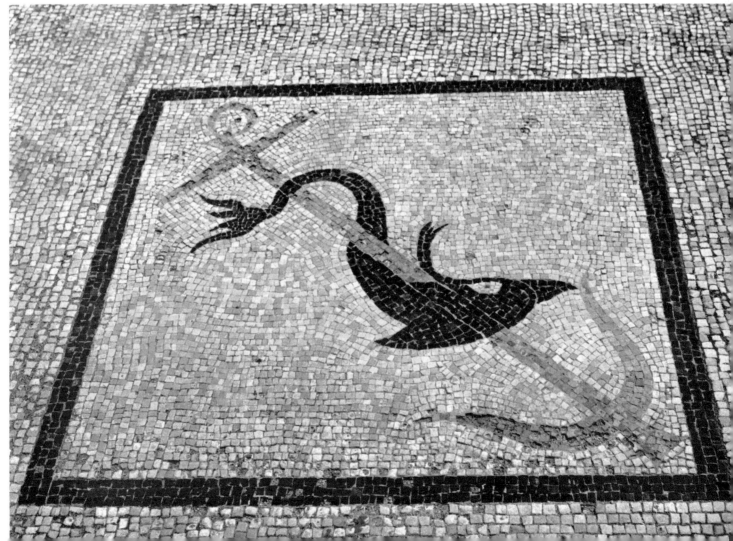

77 *Abduction of Oreithyia by Boreas, from the Athenian Temple on the Island of*
Delos, 5th century B. C.; *Museum, Delos*
78 *Archaic Terra Cotta, 6th century* B. C.; *Museum, Delos*

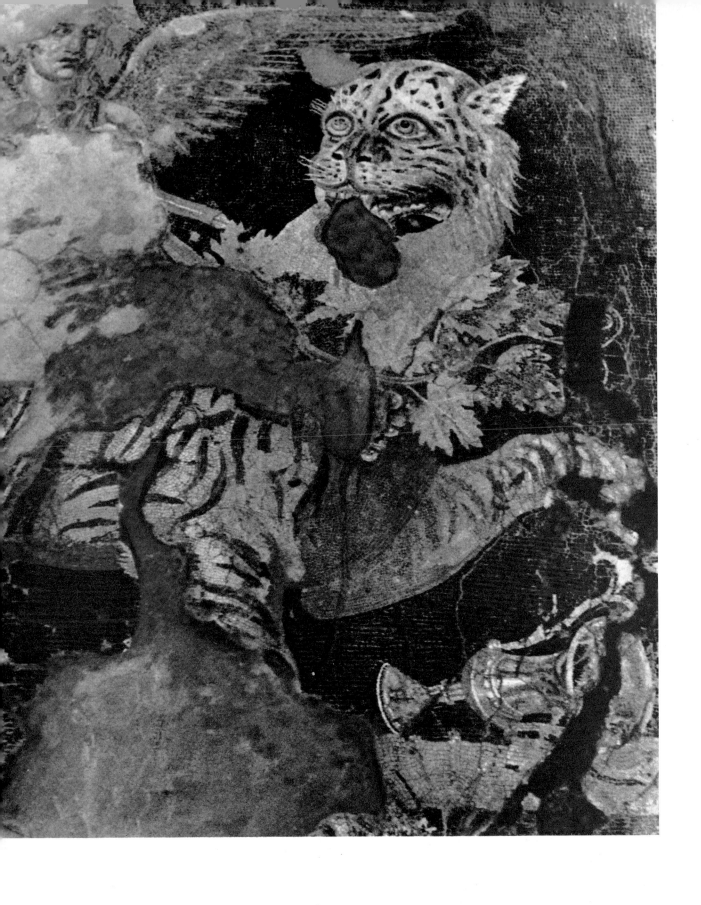

79 *Mosaic in the House of Dionysos*

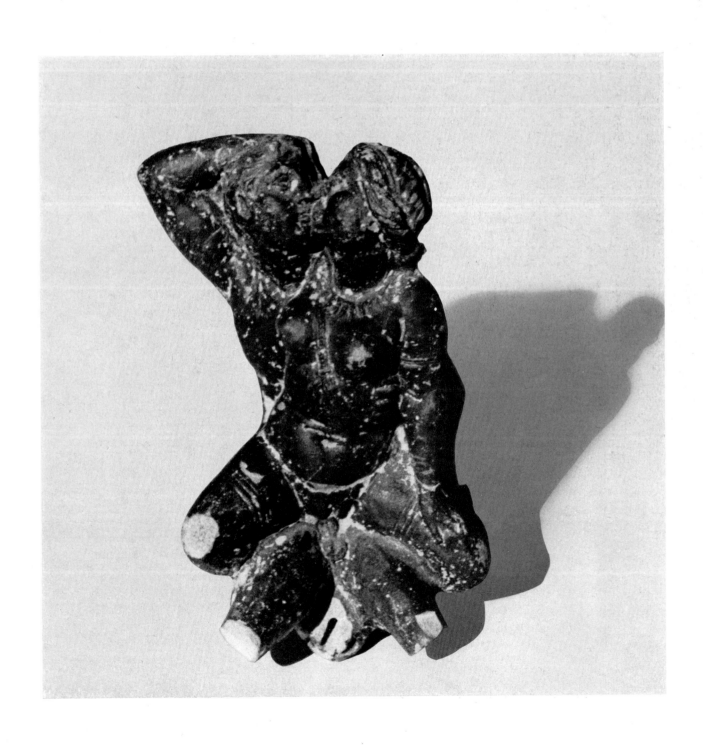

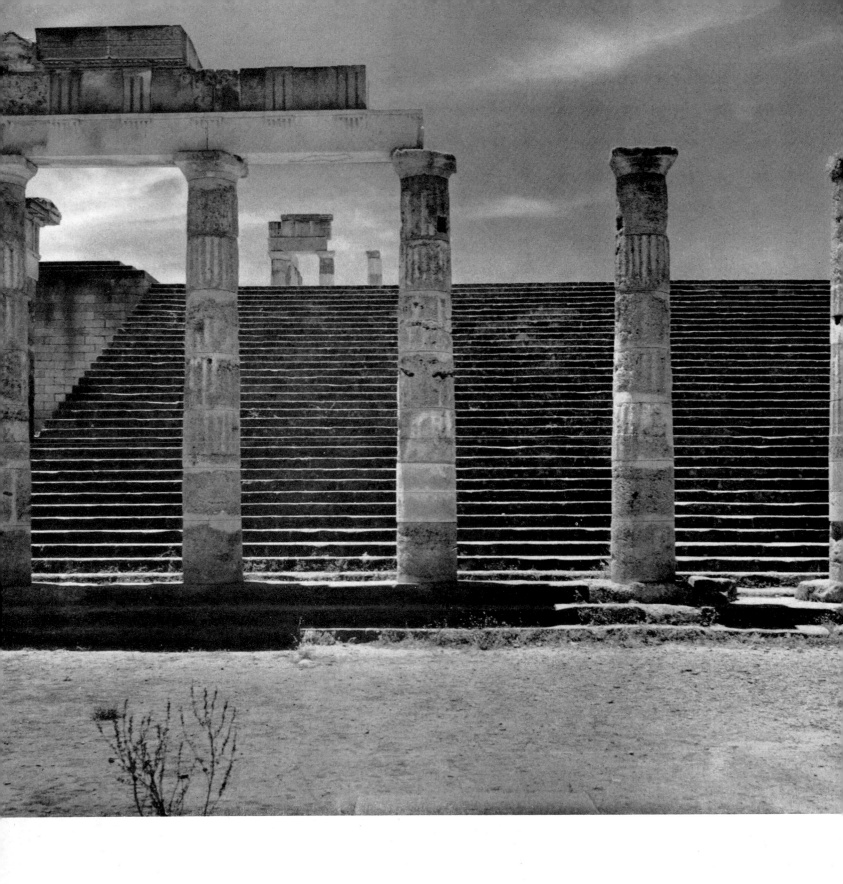

81 Propylaea of Lindos Acropolis, Rhodes

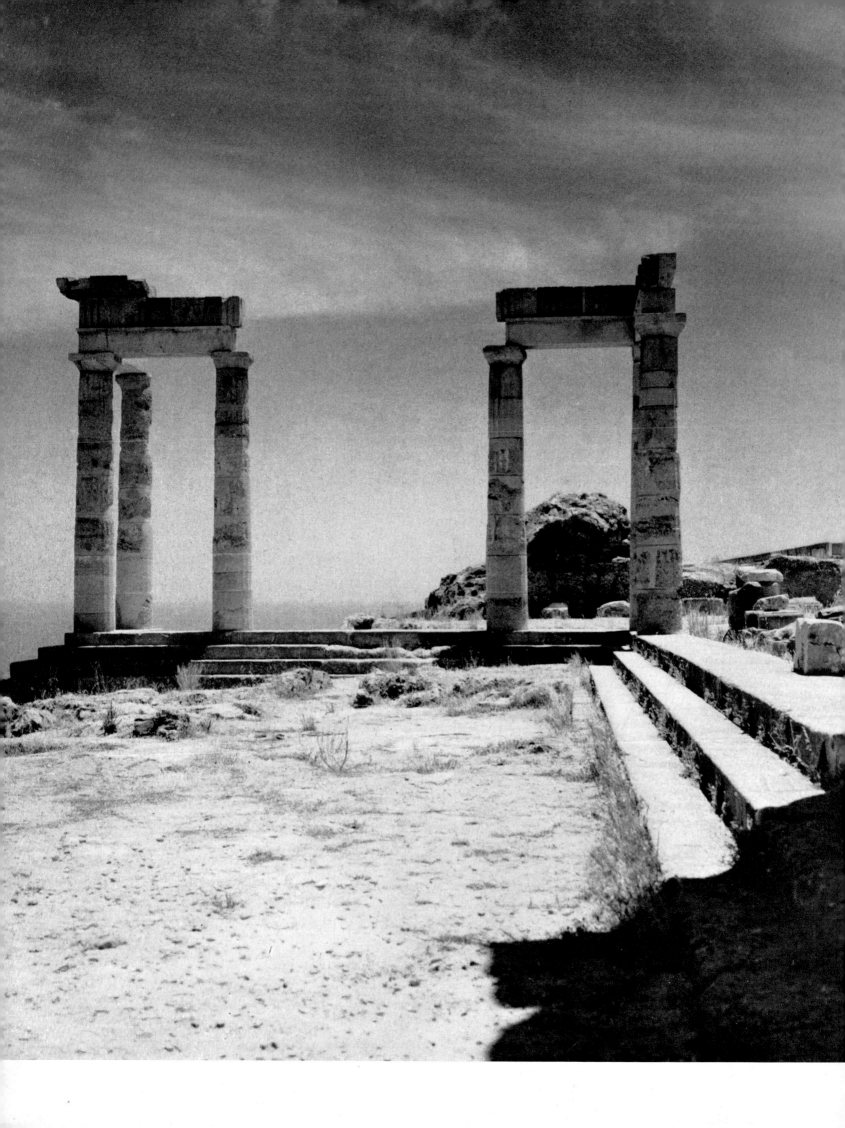

83 *Remains of the Ancient Pillared Hall in Lindos Acropolis*
84 *Ancient High Relief of a Ship at the Ascent leading to Lindos Acropolis, Rhodes*

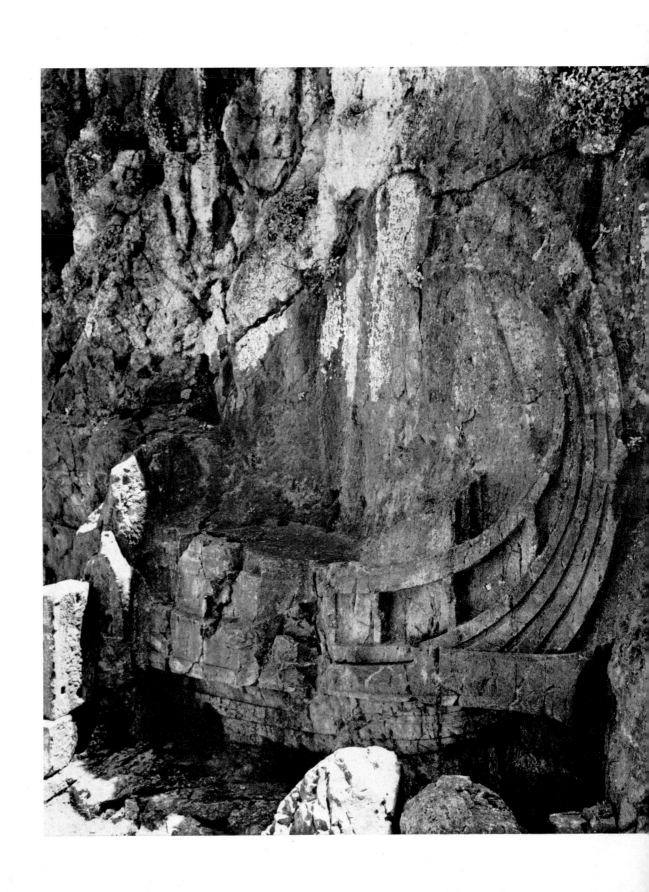

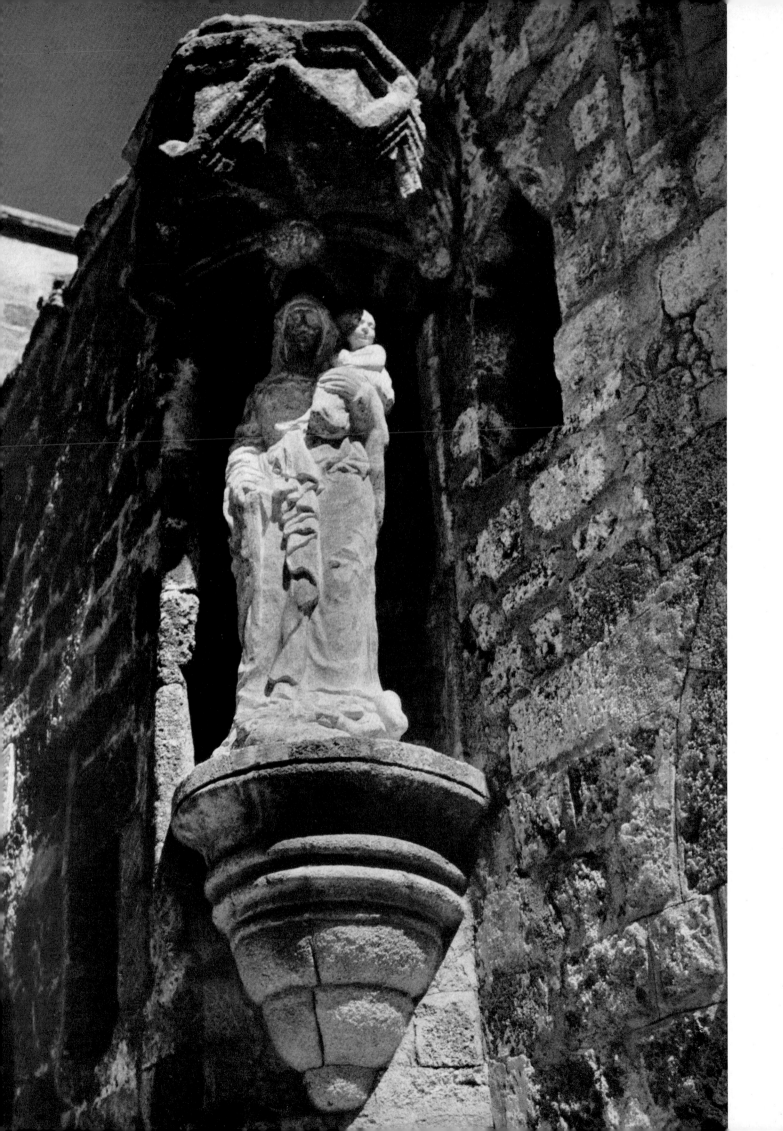

85 *Gothic Madonna, 14th century, in "Knights of the Order" Street, Town of Rhodes*
86 *The Koskinon, Gate of the Town-Wall of Rhodes*

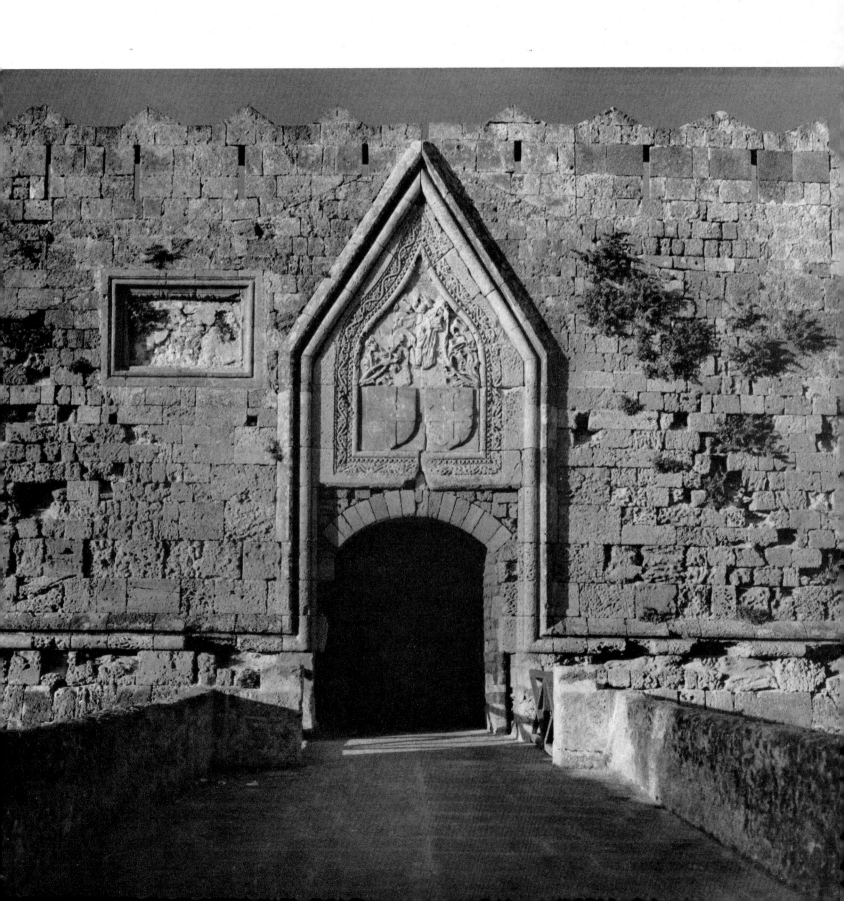

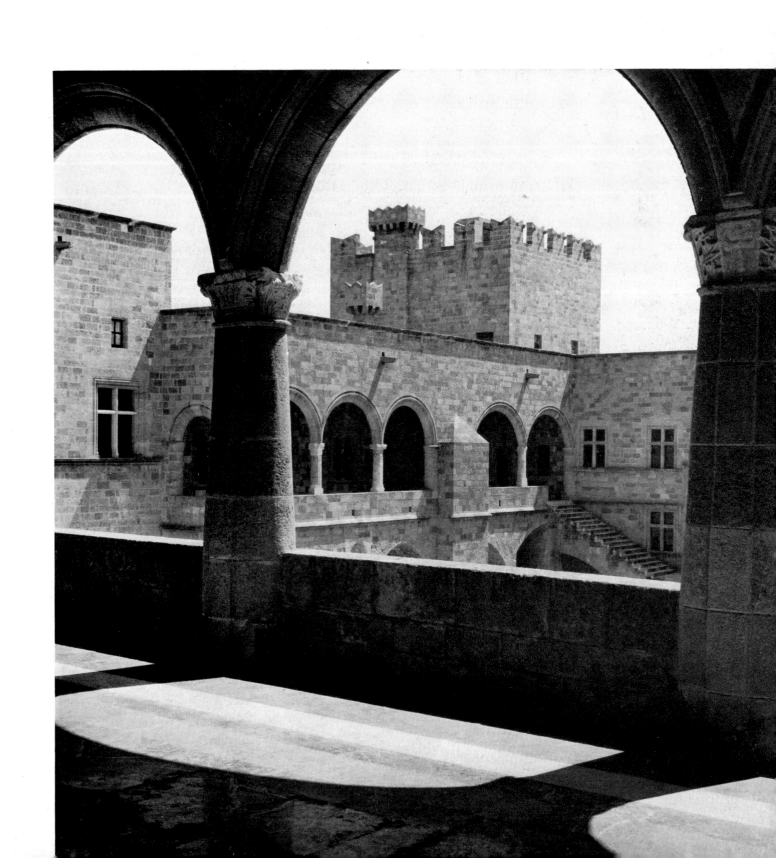

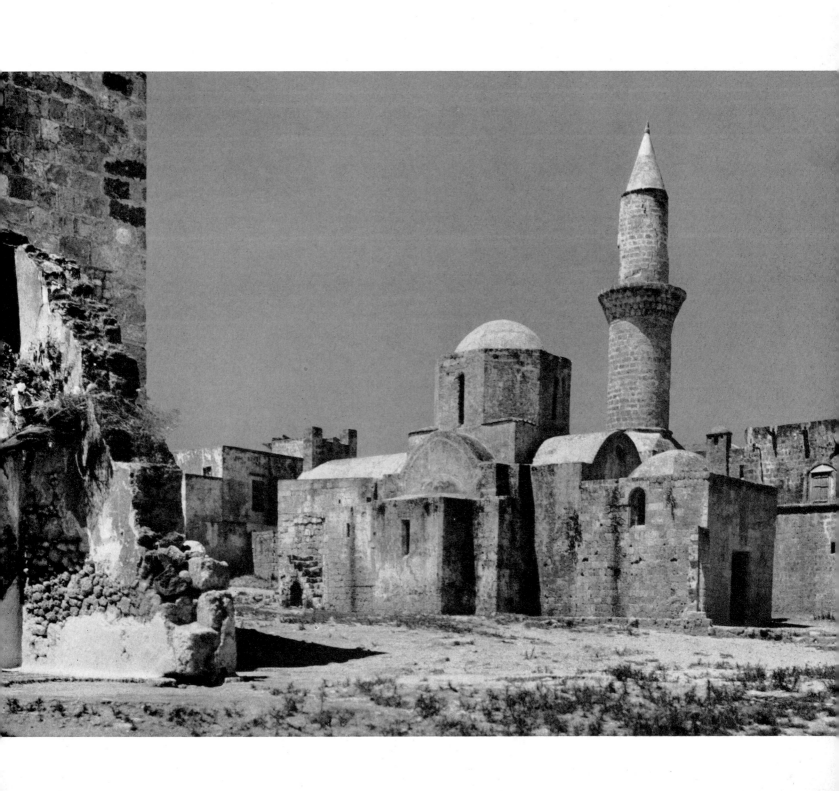

91 *New Minaret of the Turkish Cemetery, Rhodes*

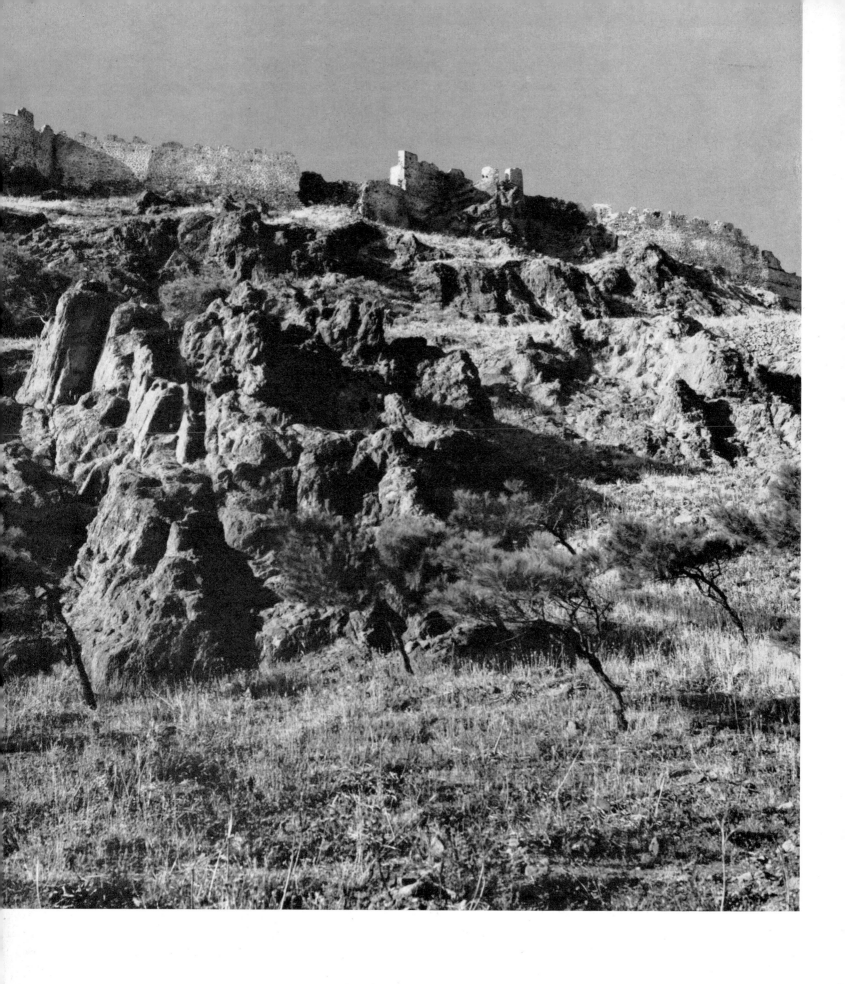

93 *The Venetian Fortifications, Lemnos*

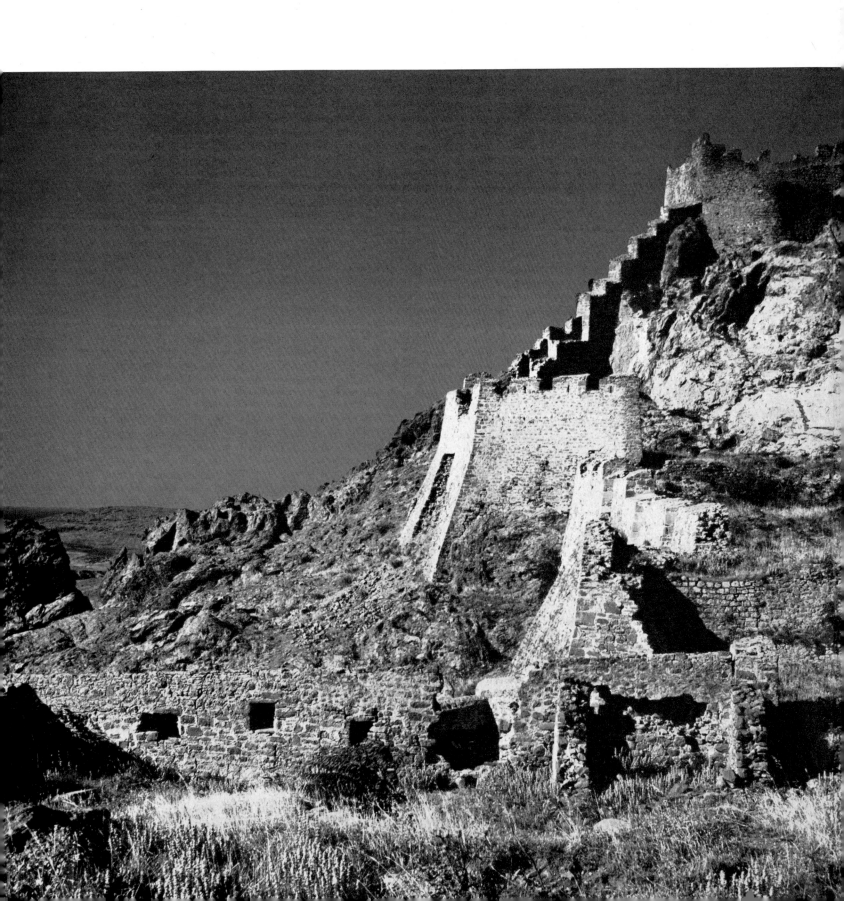

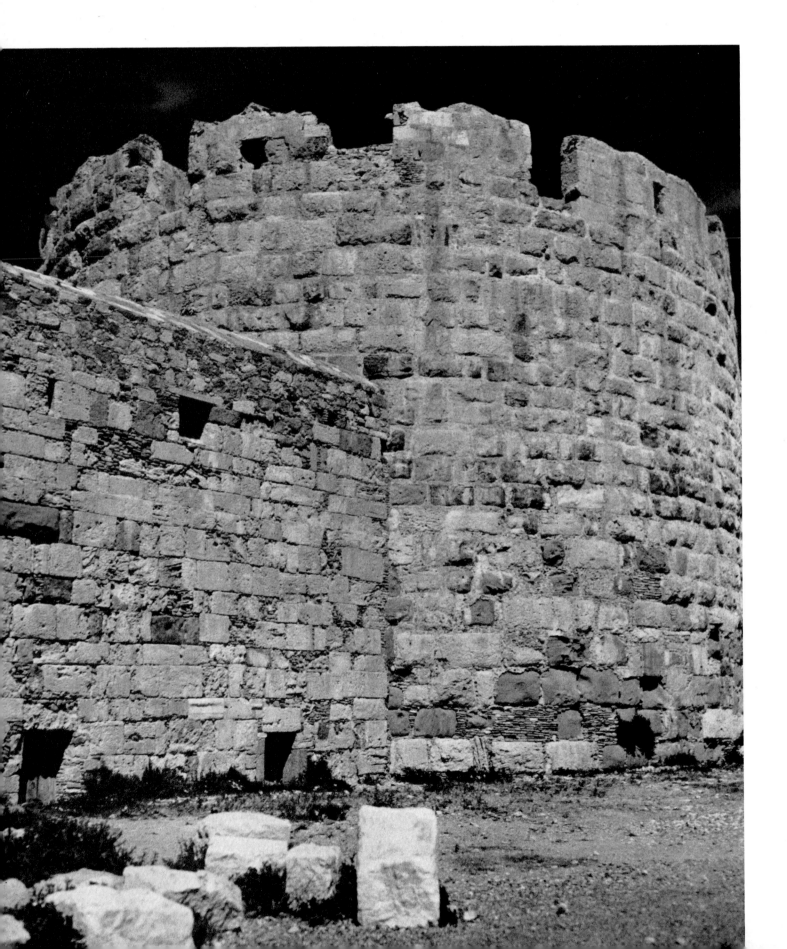

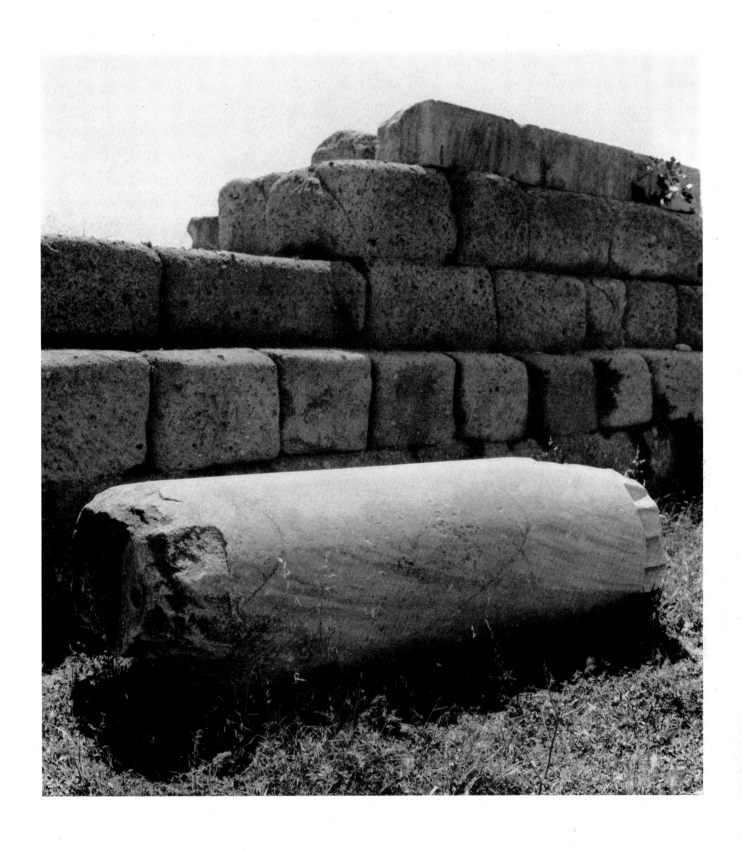

96 Ruins of the Ancient Town of Cos

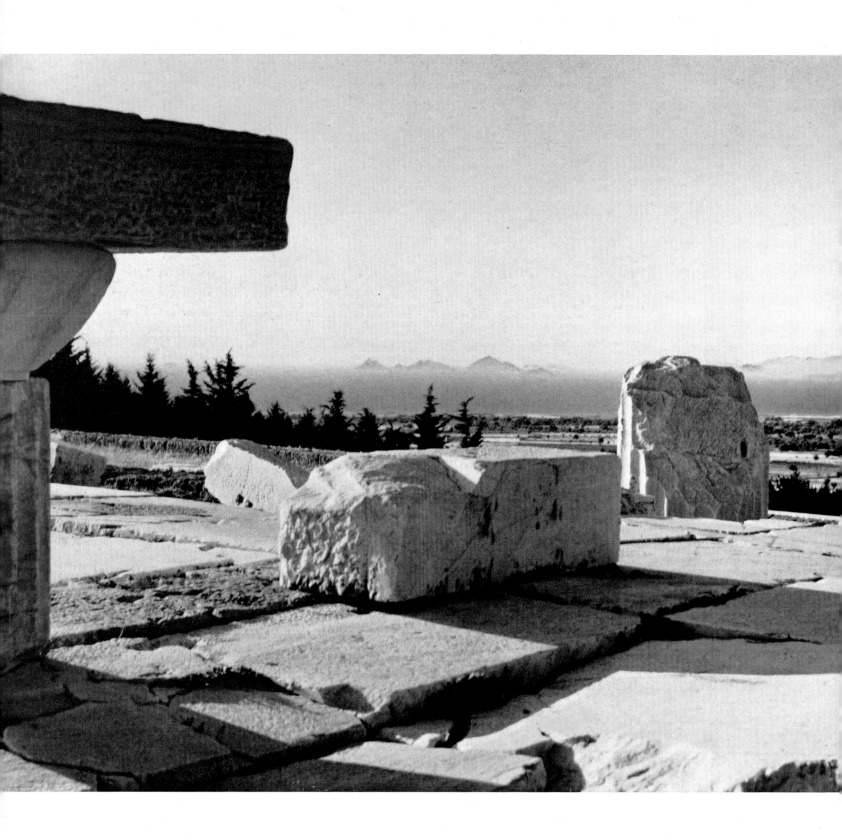

97 *View from the Cos Asclepieion towards the Sporades*

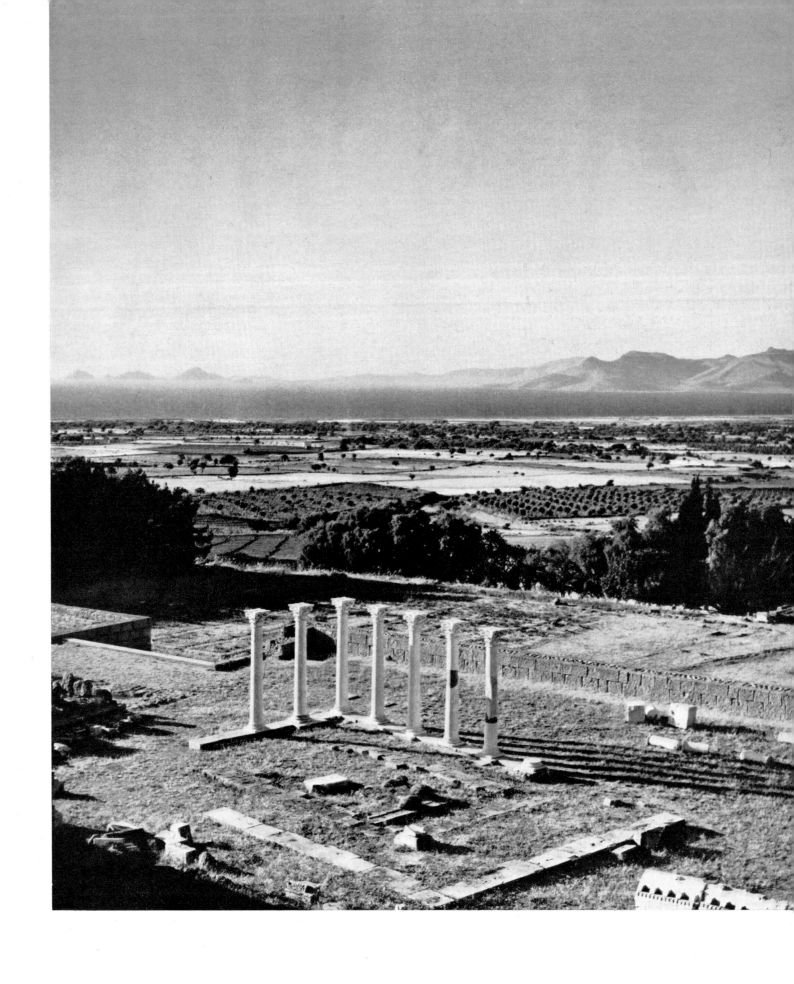

98 *Peripteral Temple with Columns of the Corinthian Order in the Asclepieion of Cos*

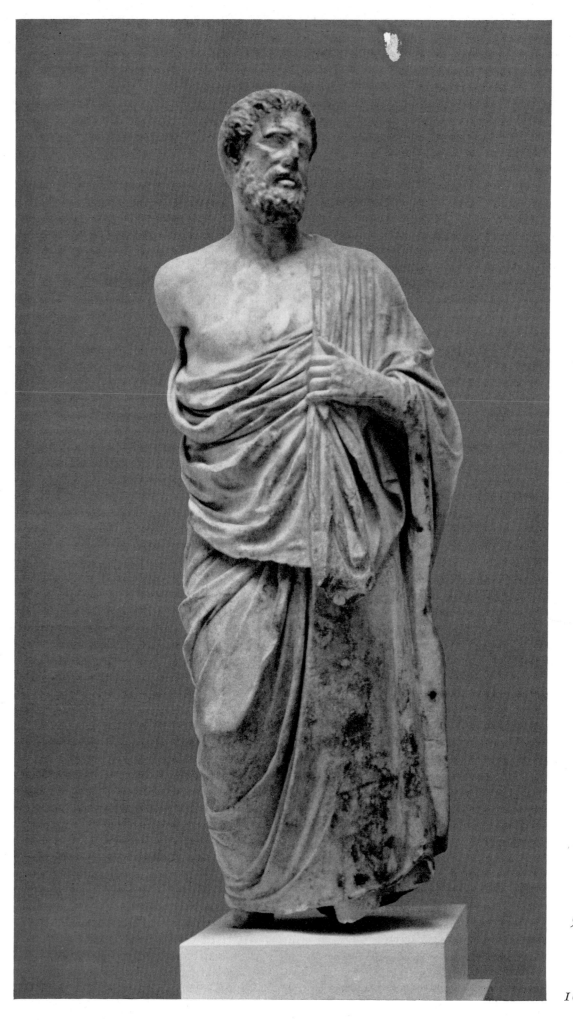

99 *Statue of Hippocrates,*
3rd century B. C.*;*
Museum, Cos

100 *Coin with Staff of Aesculap*

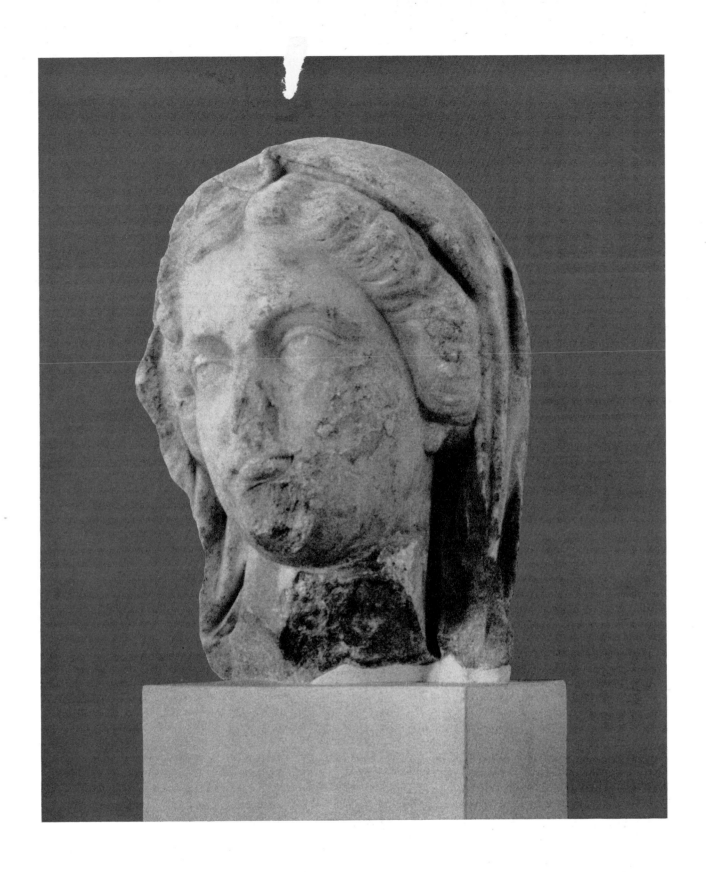

101 Roman Sculptured Head, 2nd century; Museum, Cos

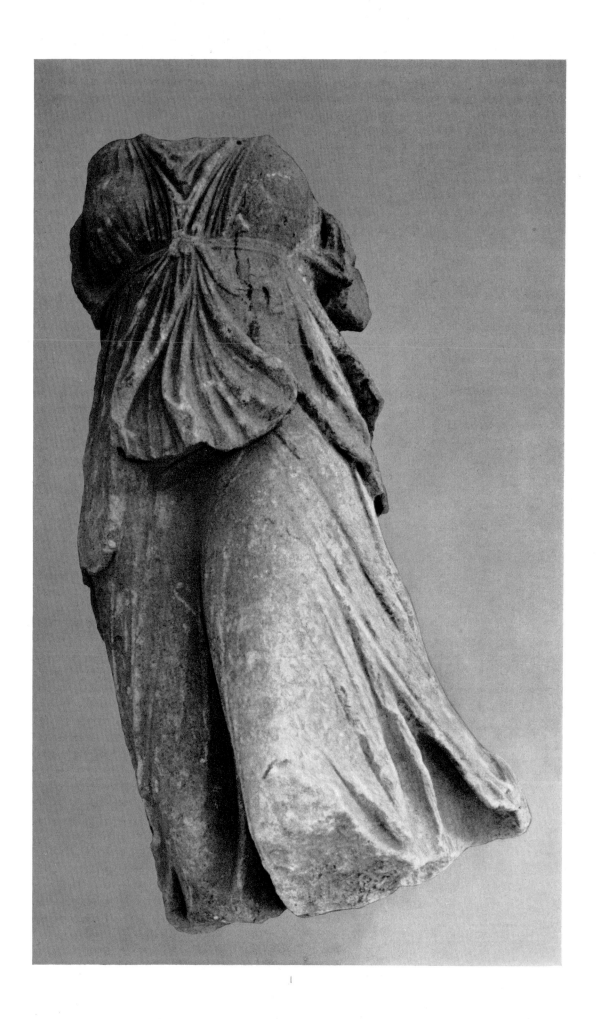

*103 Ephesian Statue of Artemis, Hellenistic-Roman Style;
Museum, Cos*

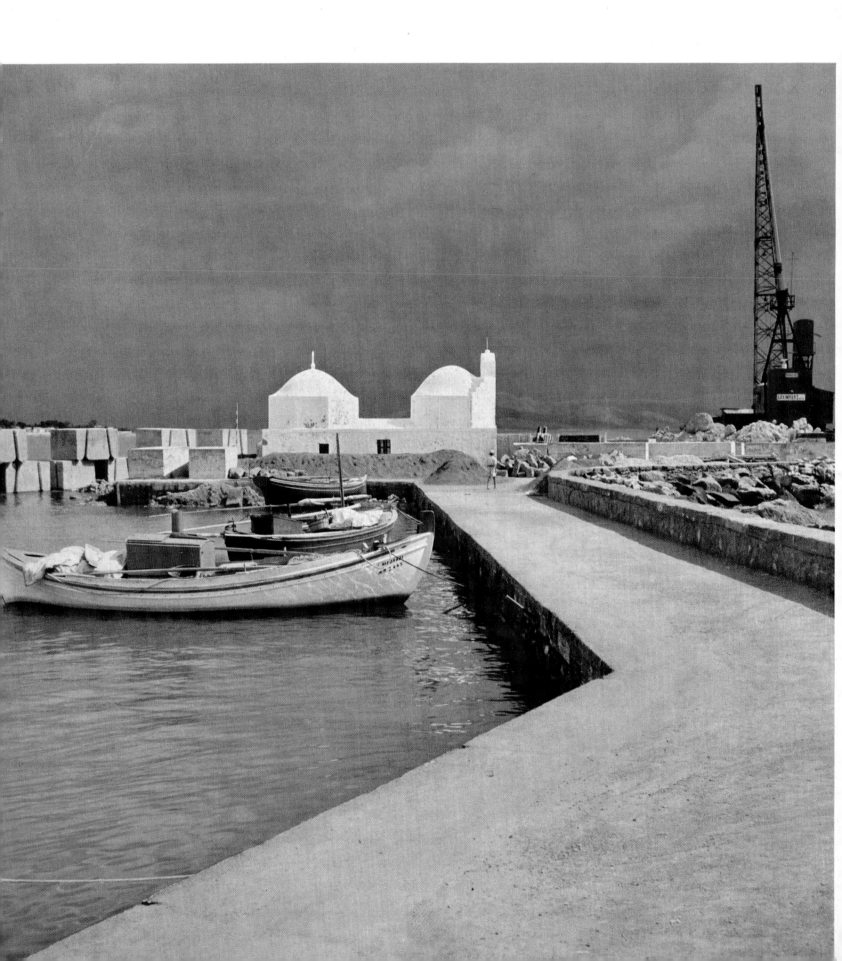

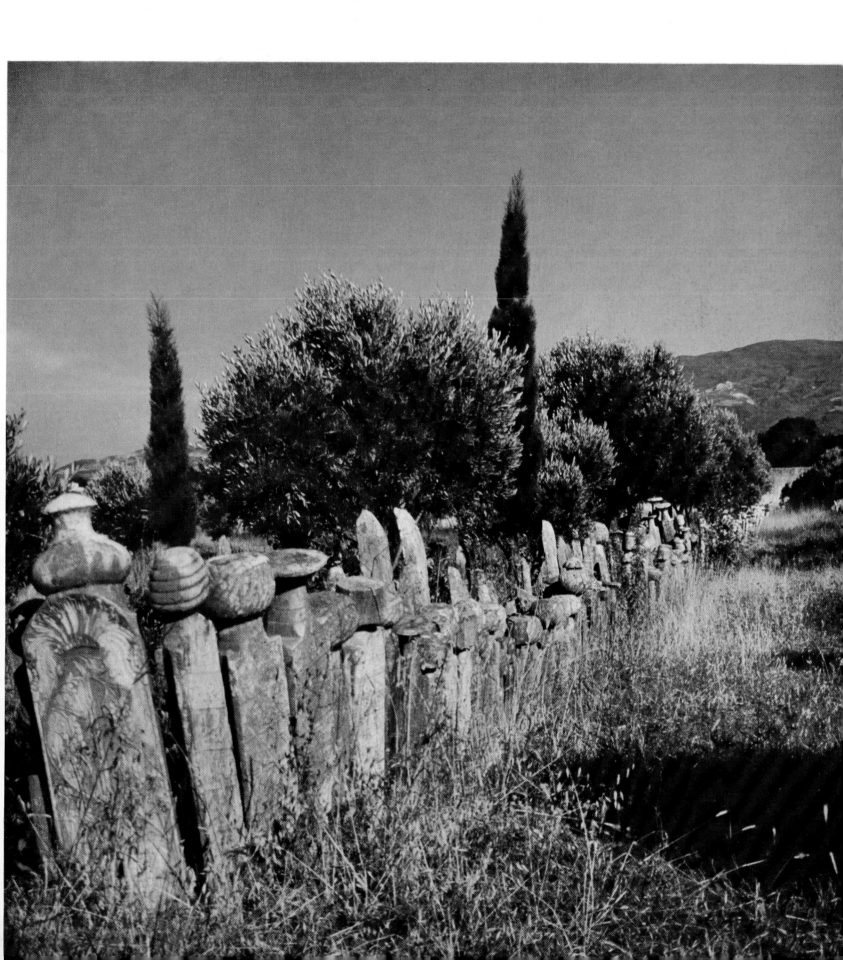

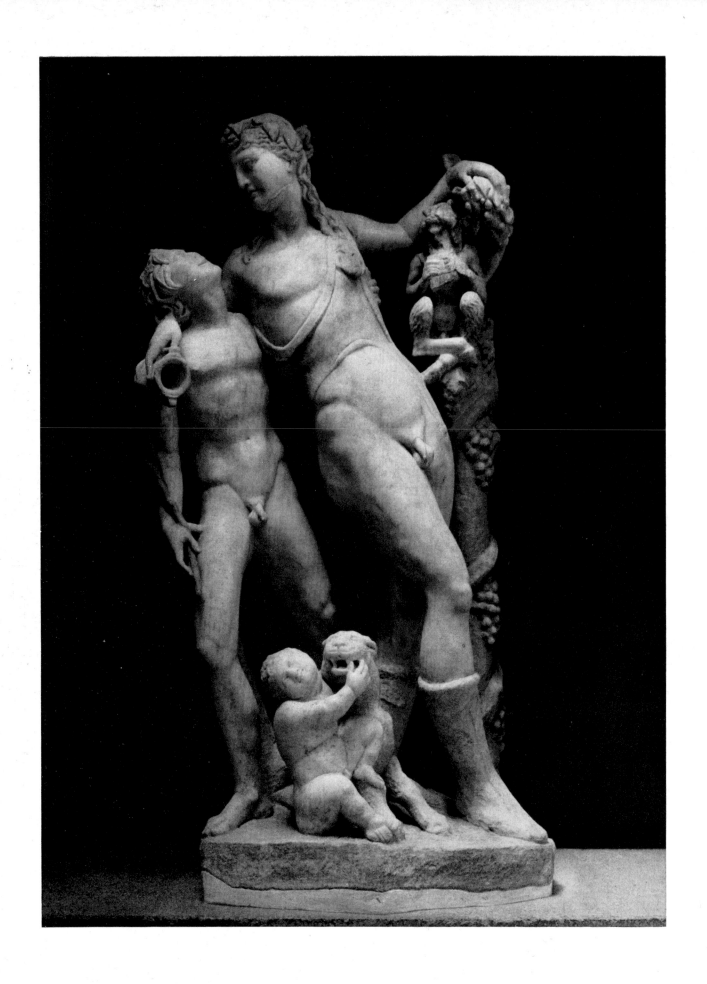

106 *Hellenistic Dionysos, 2nd century; Museum, Cos*
107 *Hellenistic Dionysos, Detail*

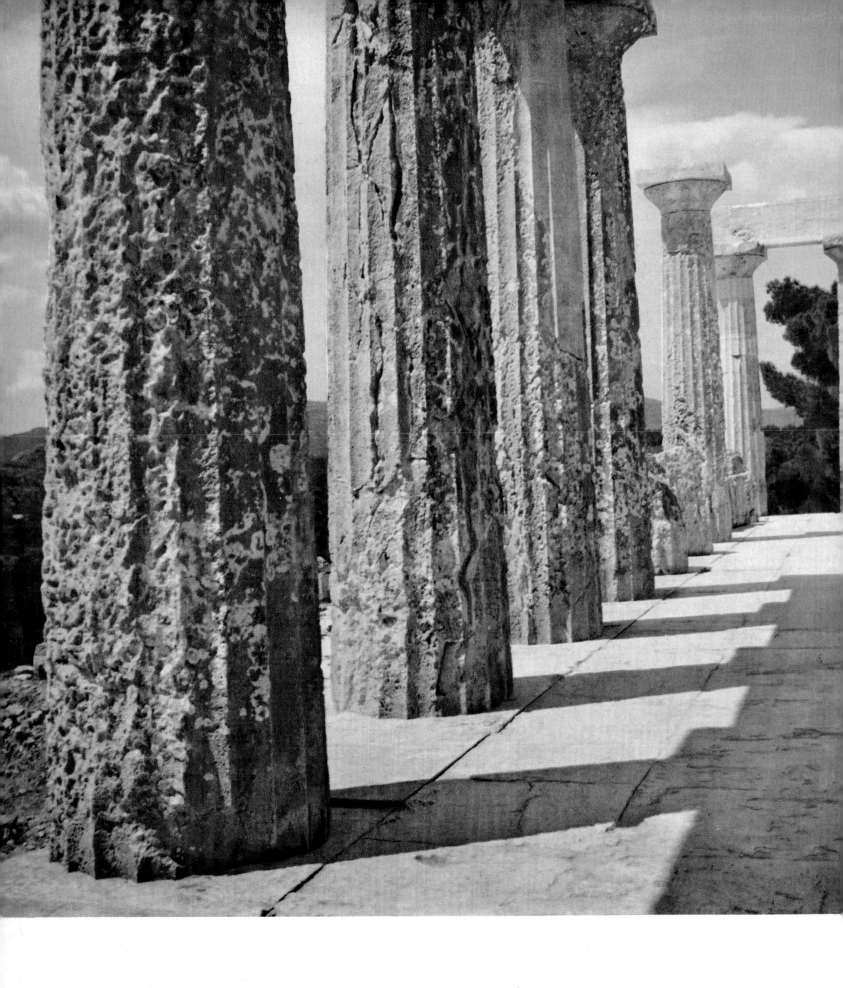

108 *Flight of Columns of the Aegina Temple of Athene*

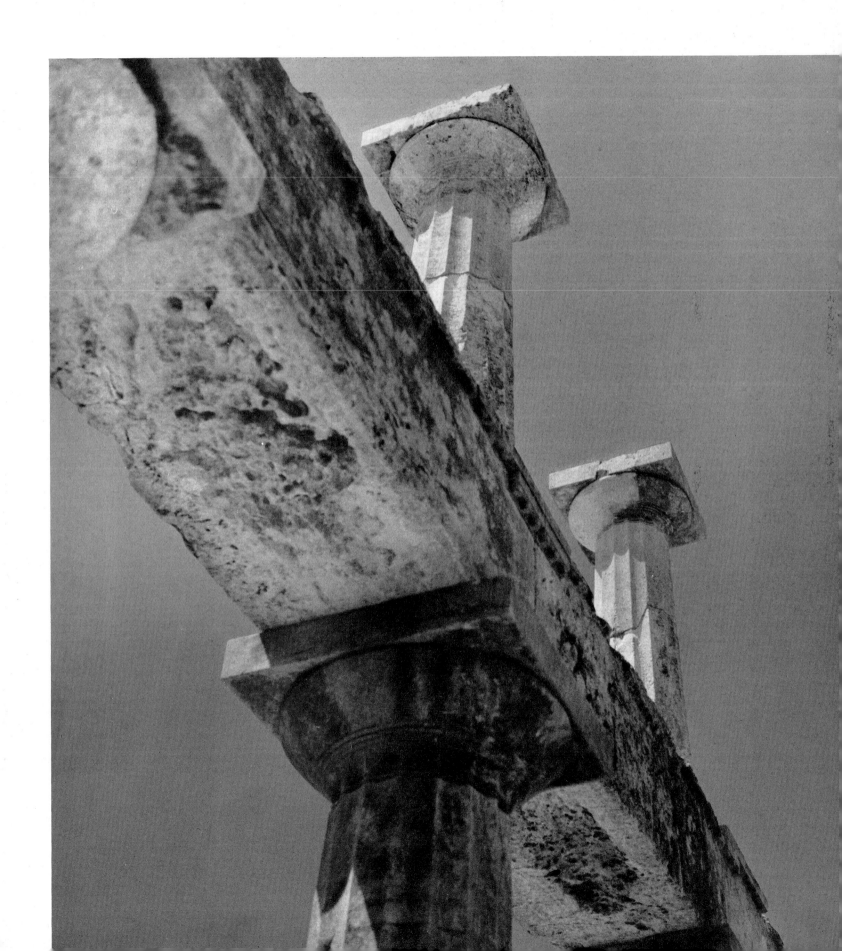

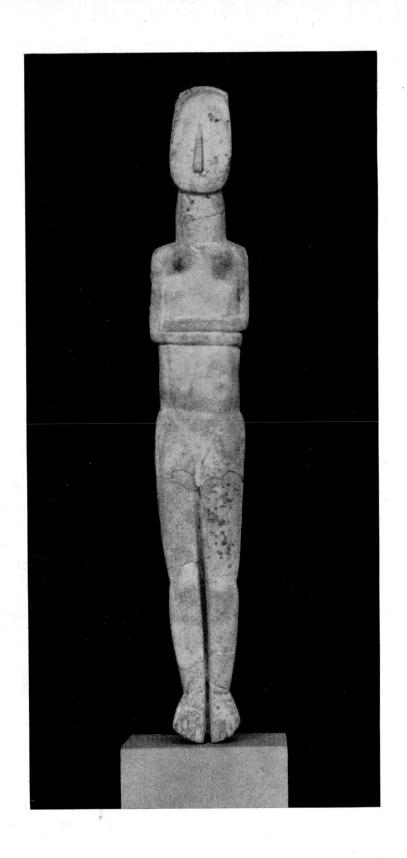

110 *The Great Goddess of the Cyclades from Paros,*
2200 B.C.; National Museum, Athens

111 *Kouros of Melos, 530 B.C.;*
National Museum, Athens

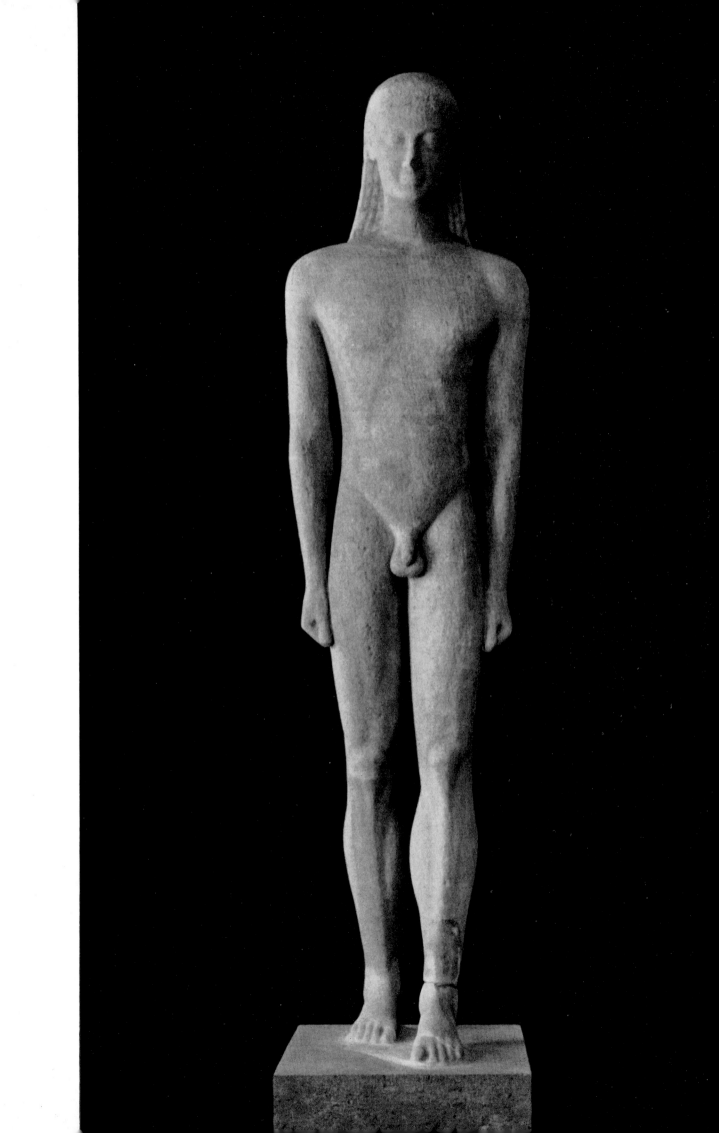

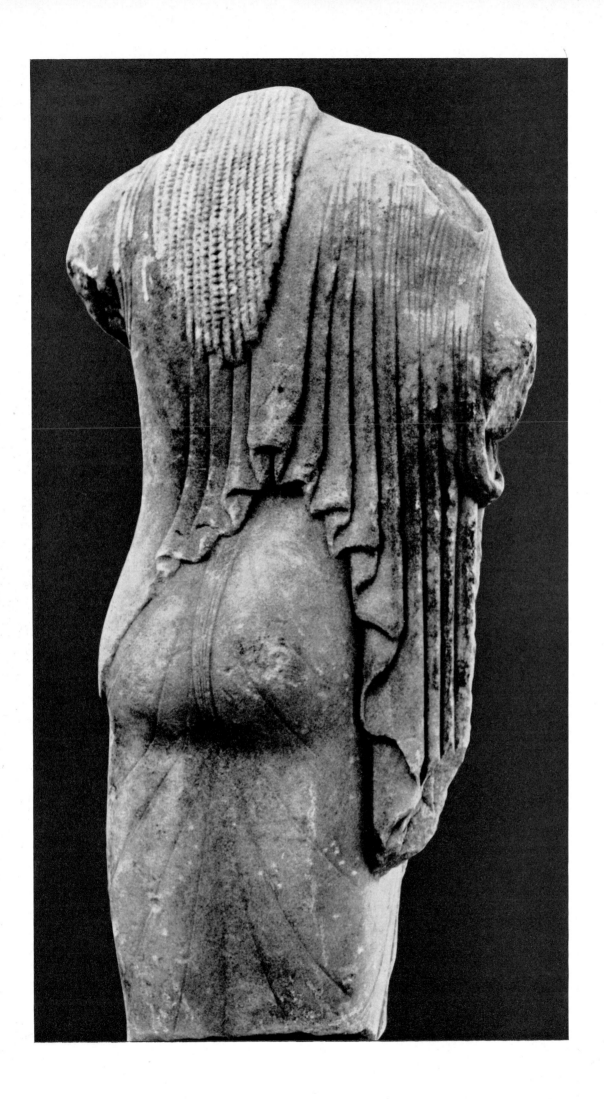

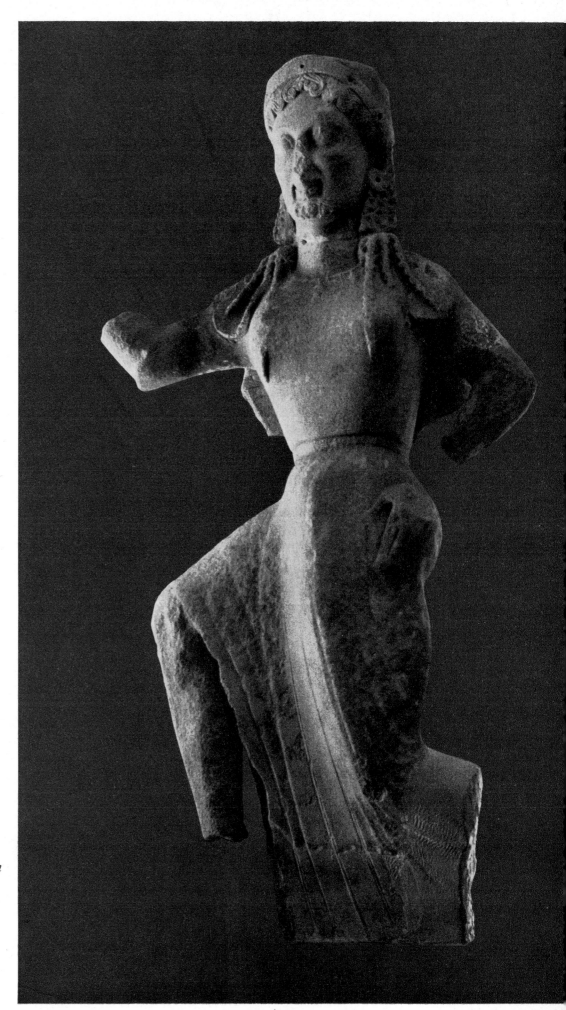

112 *Back View of an Insular-Ionian*
Kore on Delos; Offering,
1st half of 3rd century B.C.

113 *Nike from the Delian*
Shrine of Apollo, 550 B.C.;
National Museum, Athens

114 *The Town of Vathí, Samos*

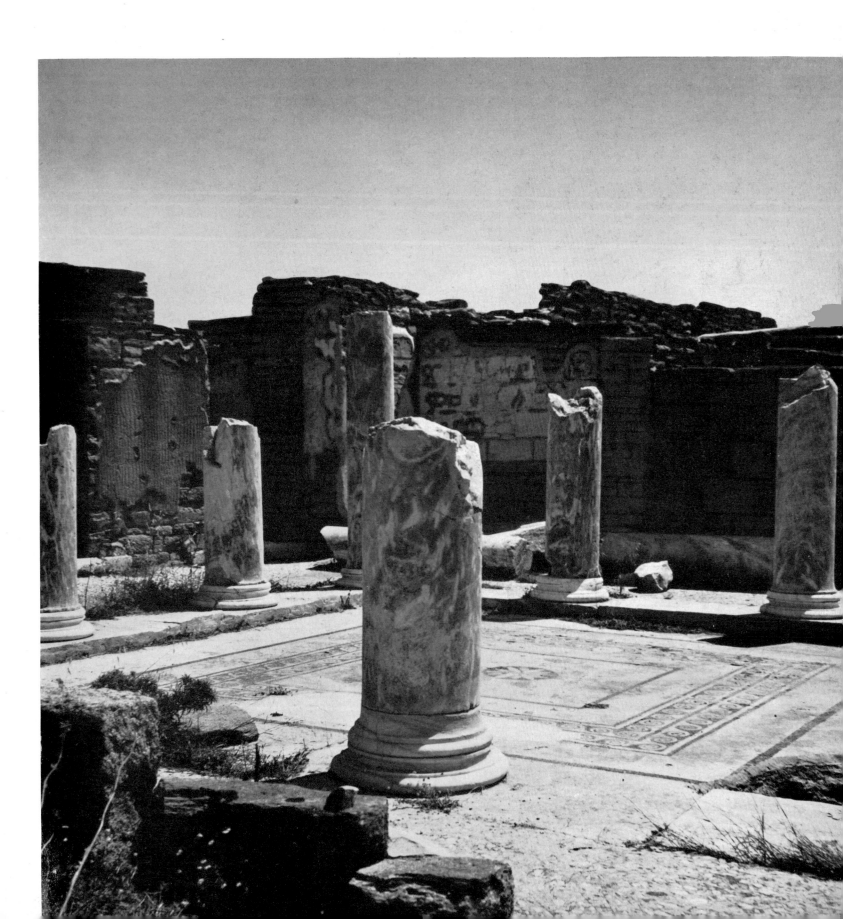

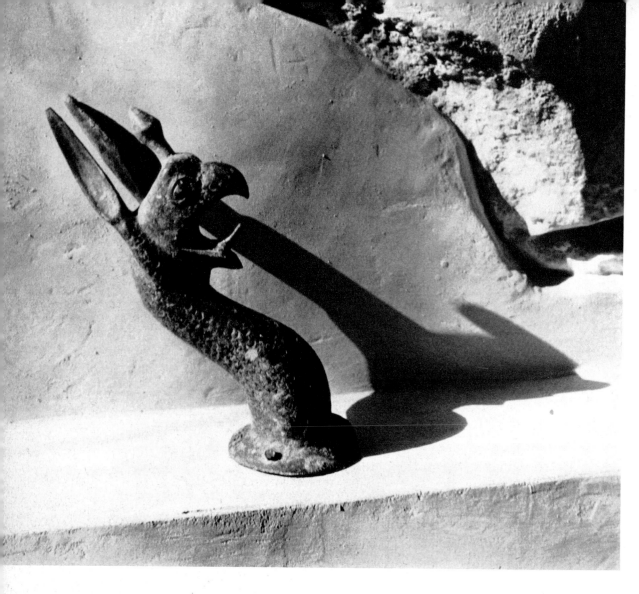

116 *Bronze Griffin Head from an Archaic Font; Museum, Samos*
117 *Winged Buck, Archaic Idol, 7th century* B. C.; *Museum, Samos*
118 *In the Shrine of Hera near Tigana, Samos*

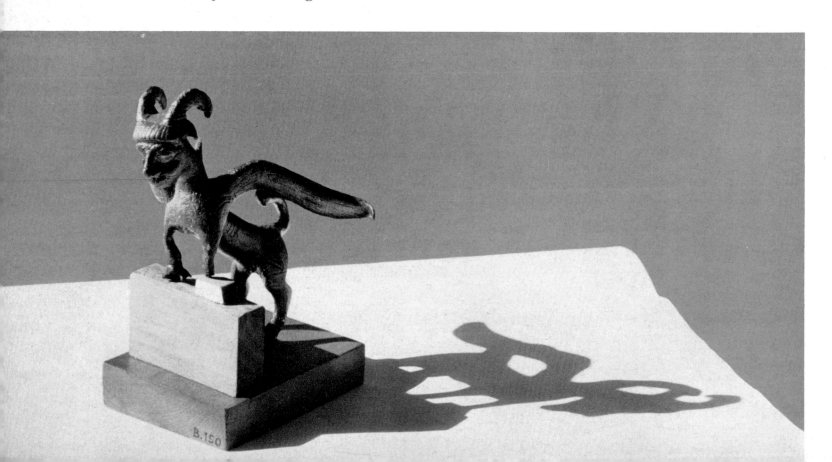

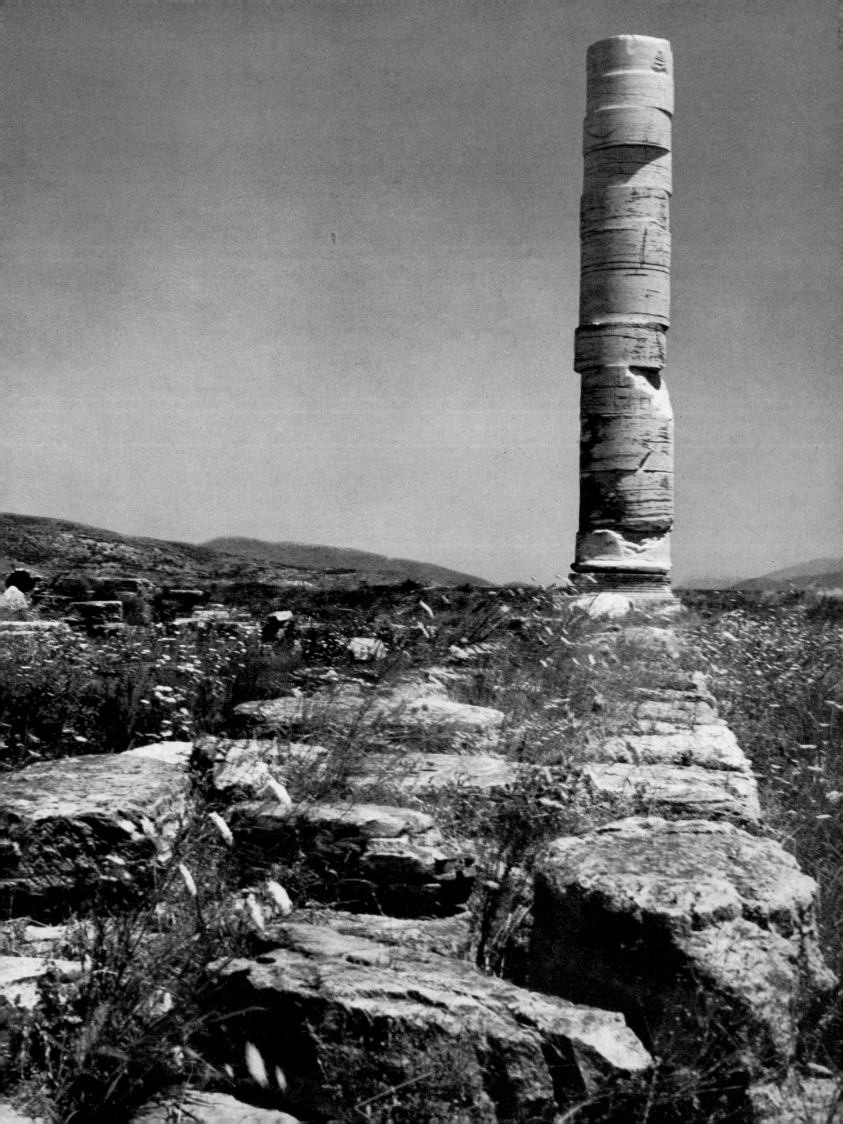

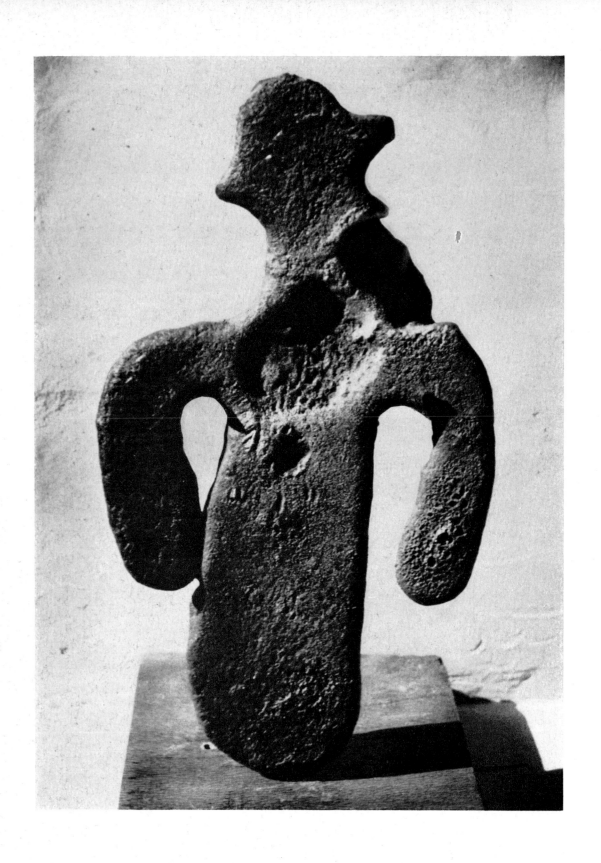

119 *Geometric Bronze Statue from the Early Greek Workshops*
 on Samos; Museum, Samos
120 *The "Philippe", Archaic Offering to Hera; Museum, Samos*

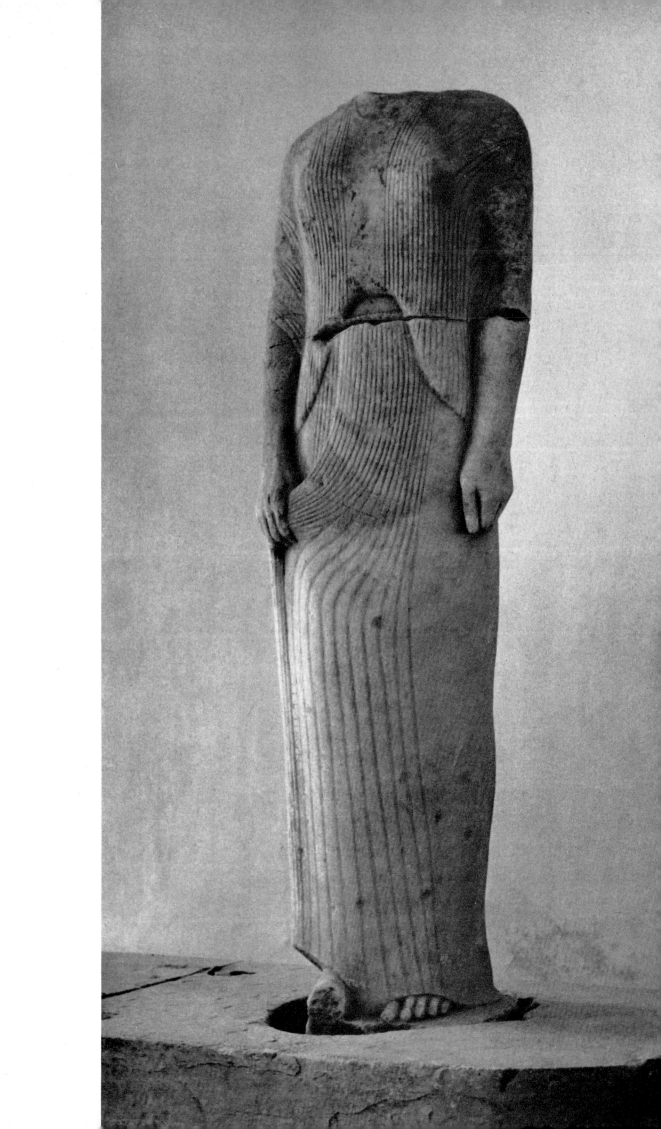

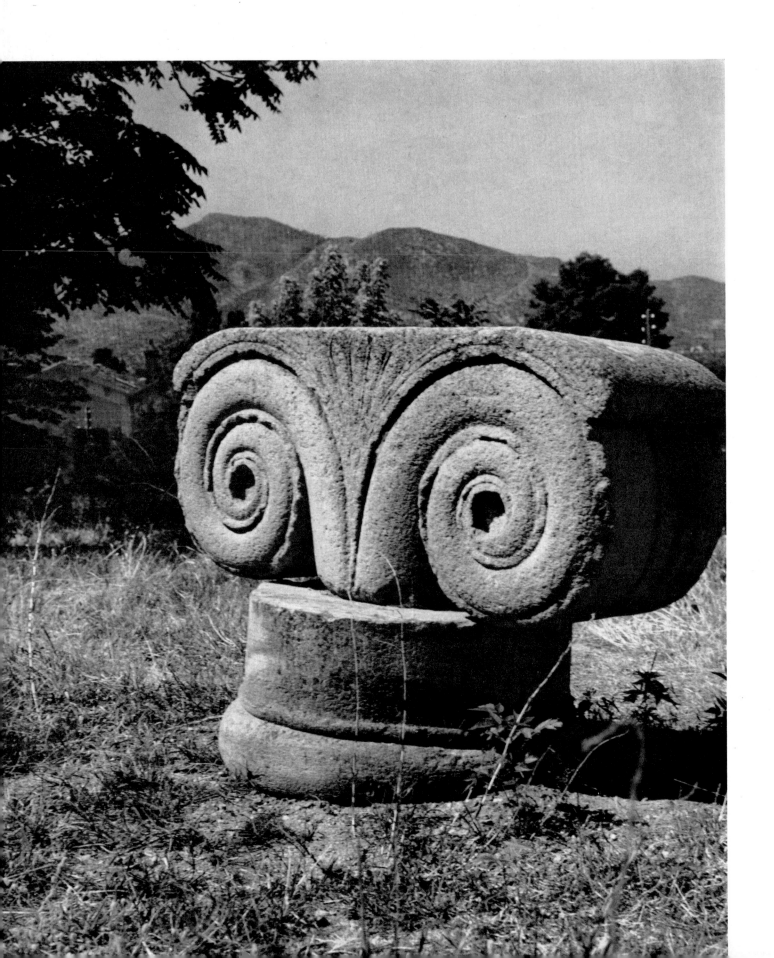

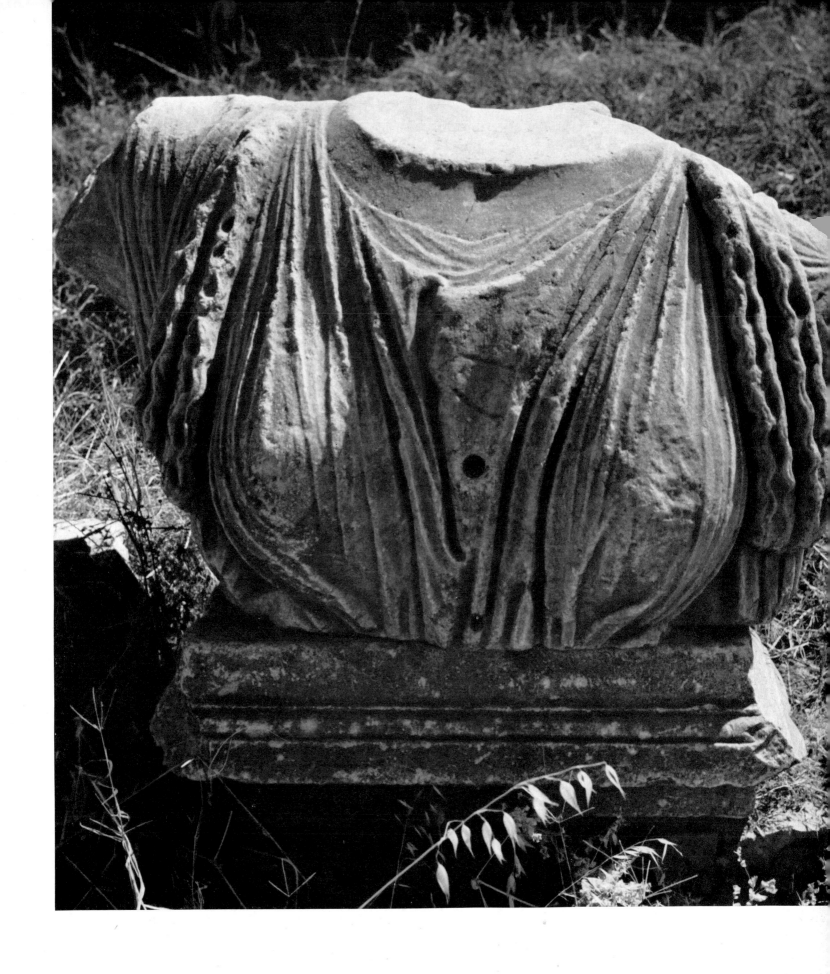

122 *Roman Bust of a Woman; Museum, Mytilene*

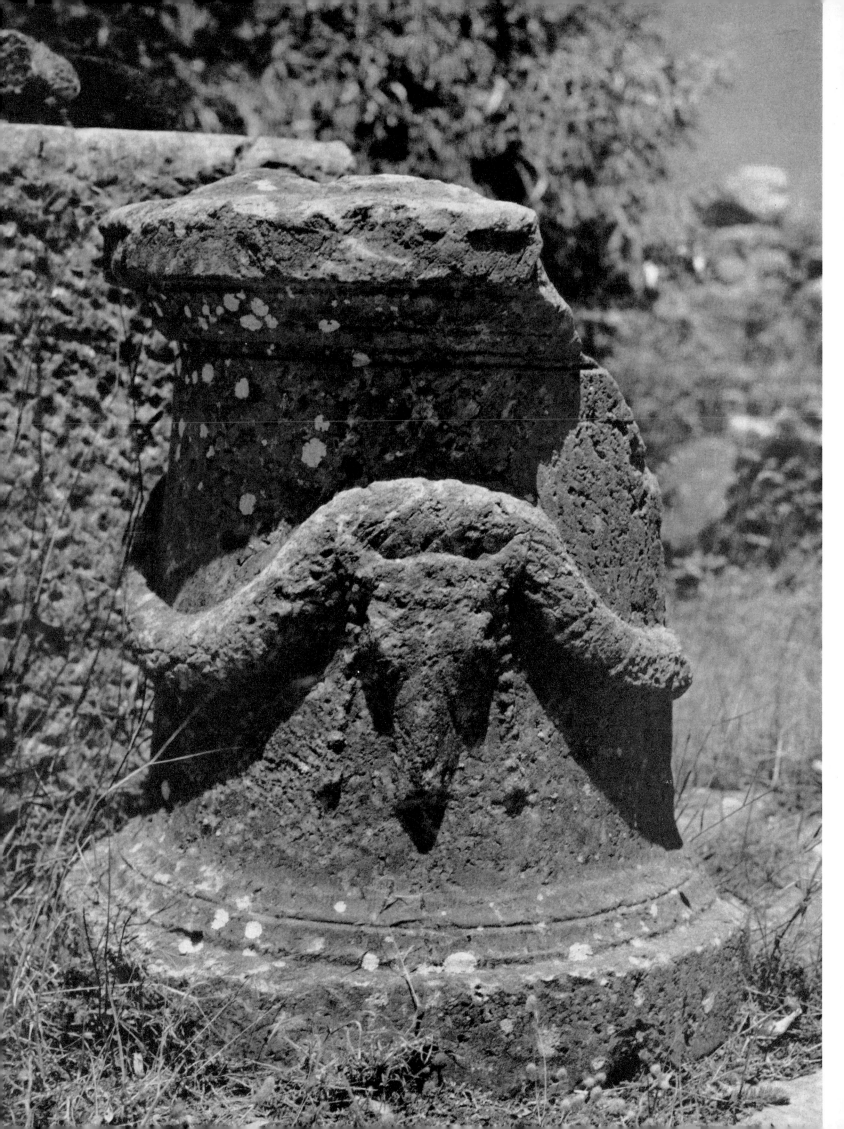

123 *Hellenistic Sacrificial Altar with Bucranion in the Genoese Castle of Mytilene, Lesbos*
124 *View of the Bay of Mytilene from the Genoese Castle*

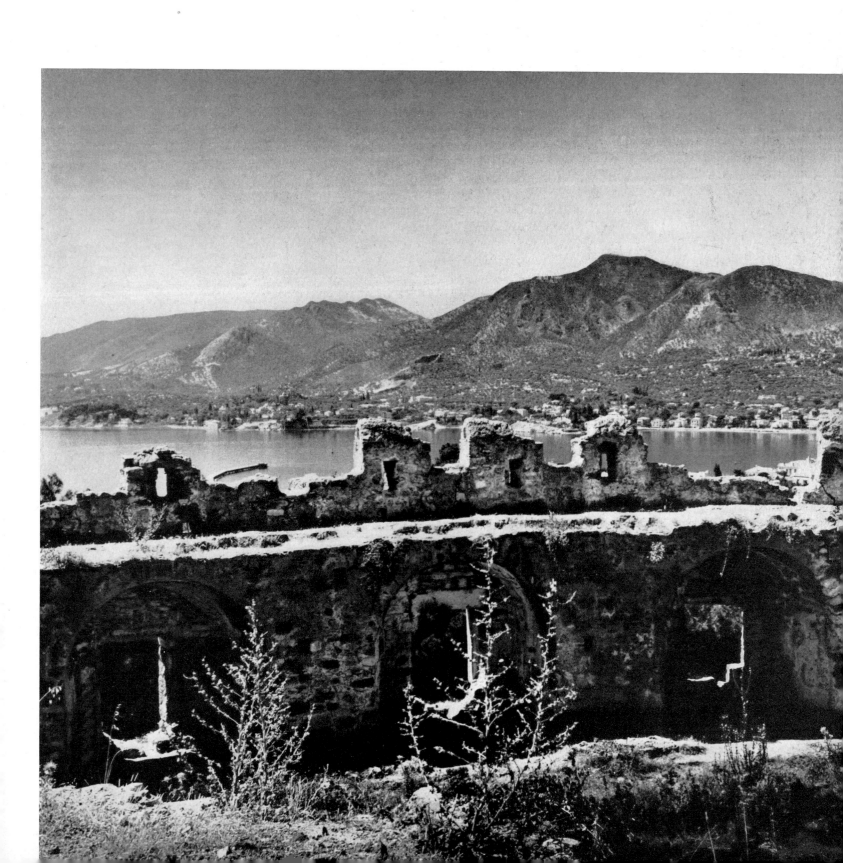

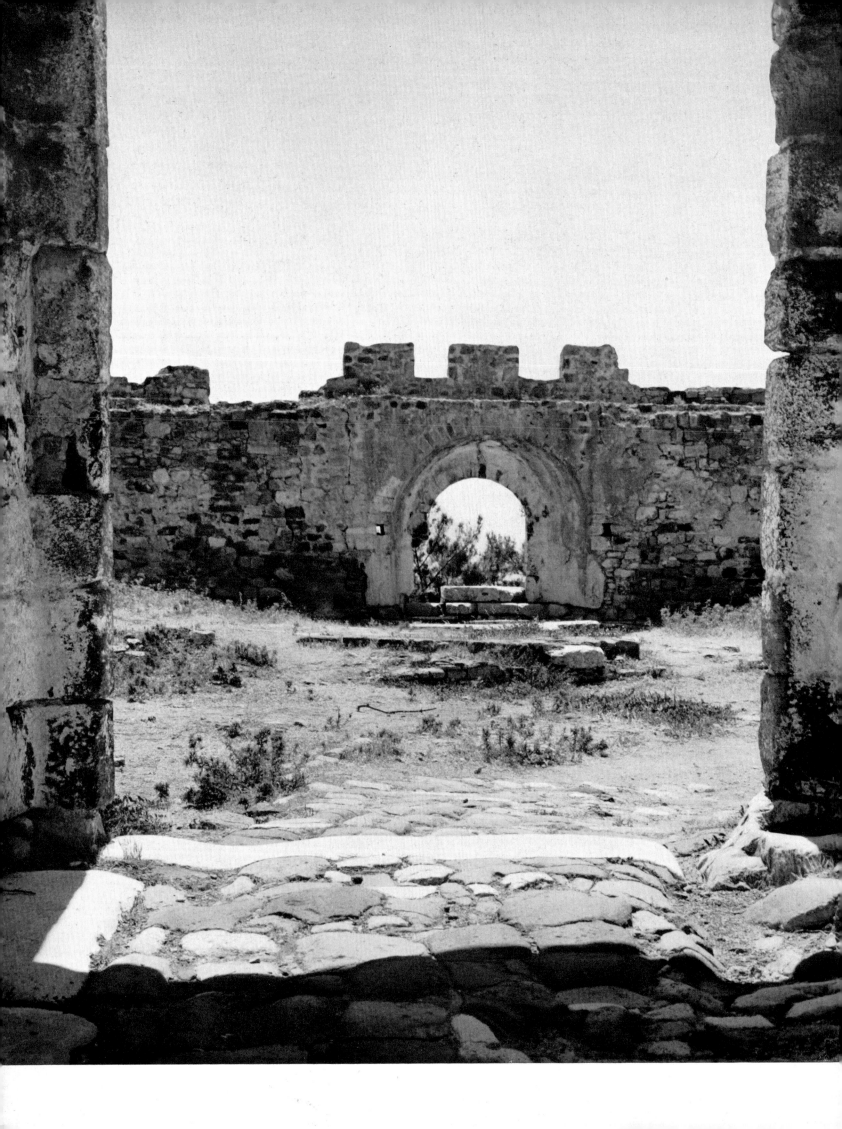

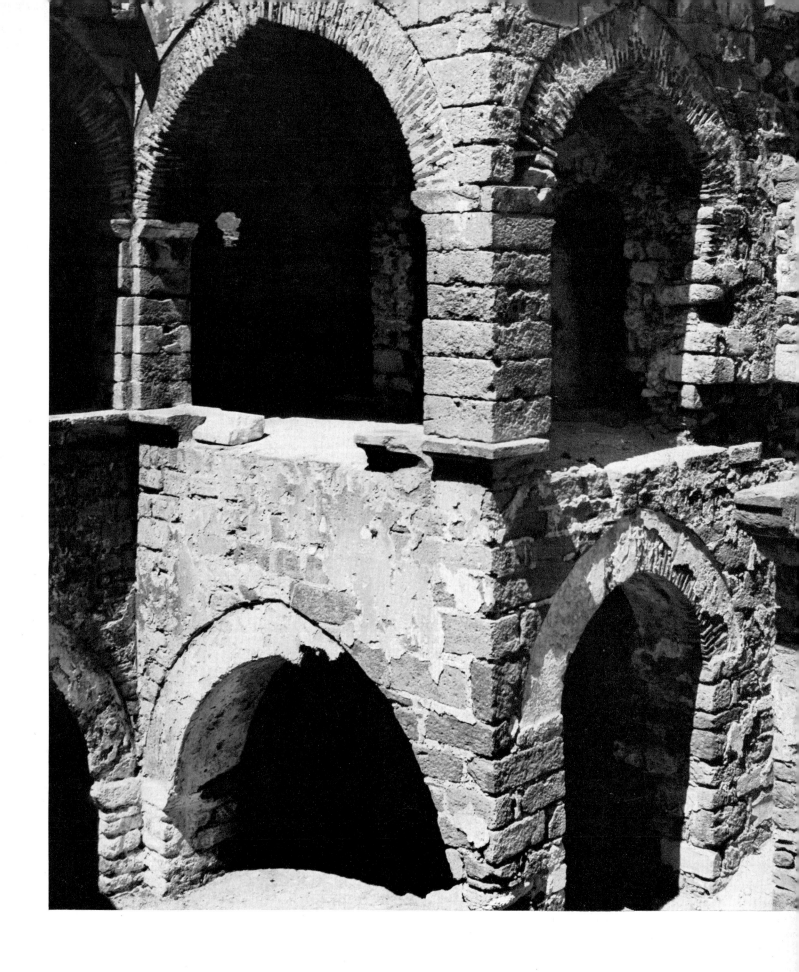

125 *Southern Gate of the Genoese Castle of Mytilene*

126 *Mediaeval Secular Building in the Genoese Castle of Mytilene*

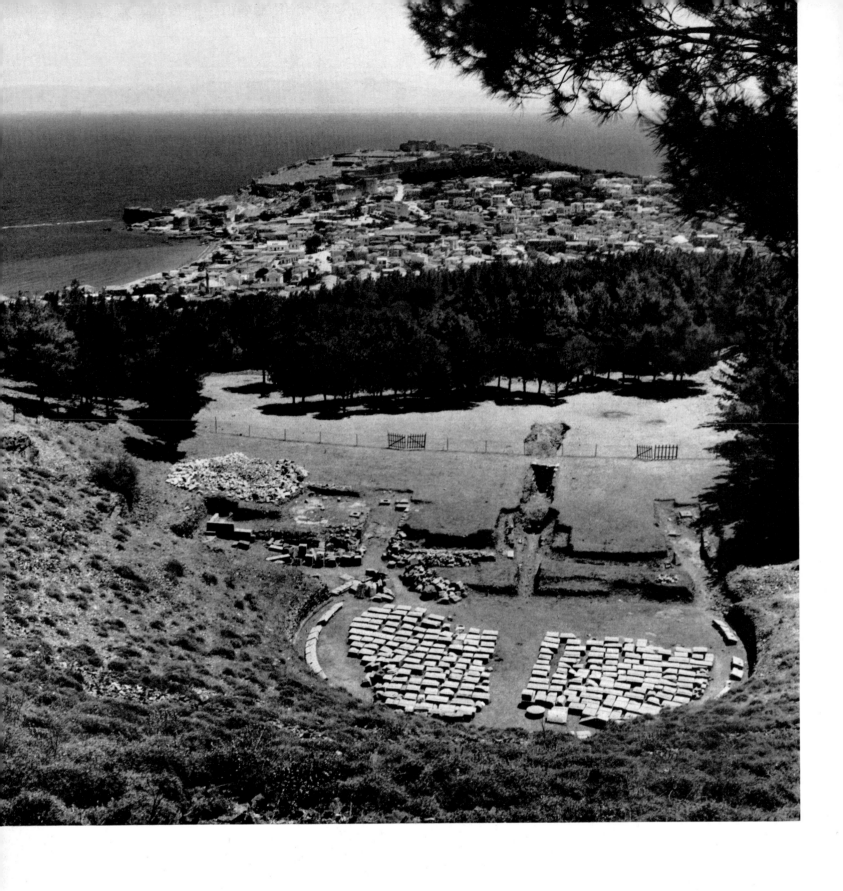

127 *The Amphitheatre of Mytilene*

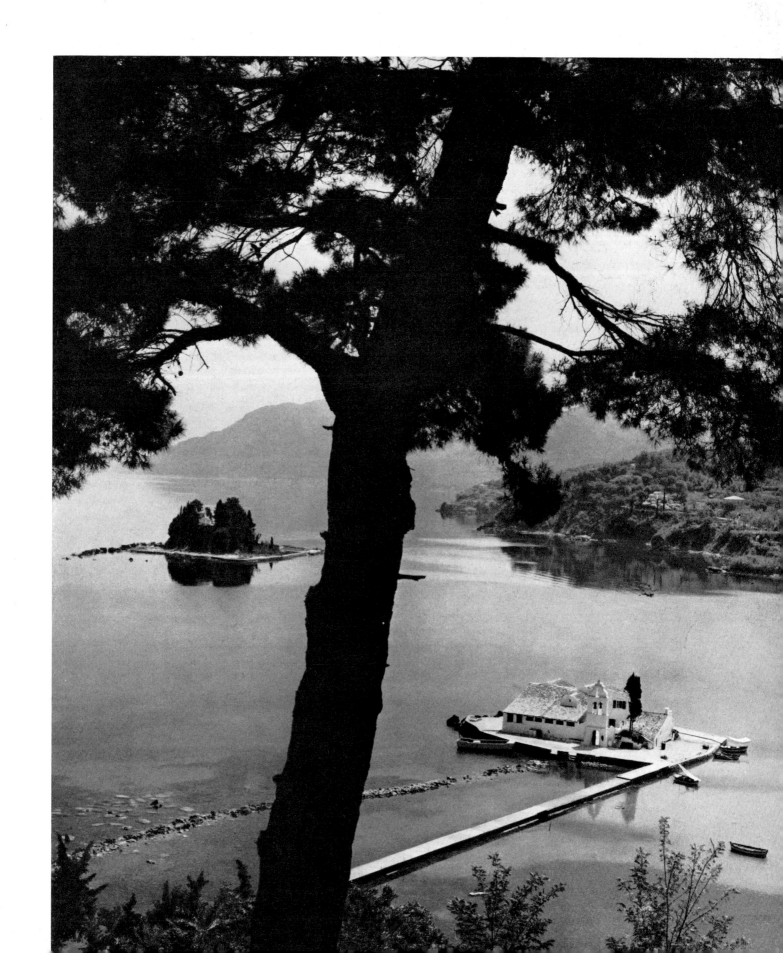

129 *In the Quadrangle of "Palaio Kastritsa" Monastery, Kérkyra*

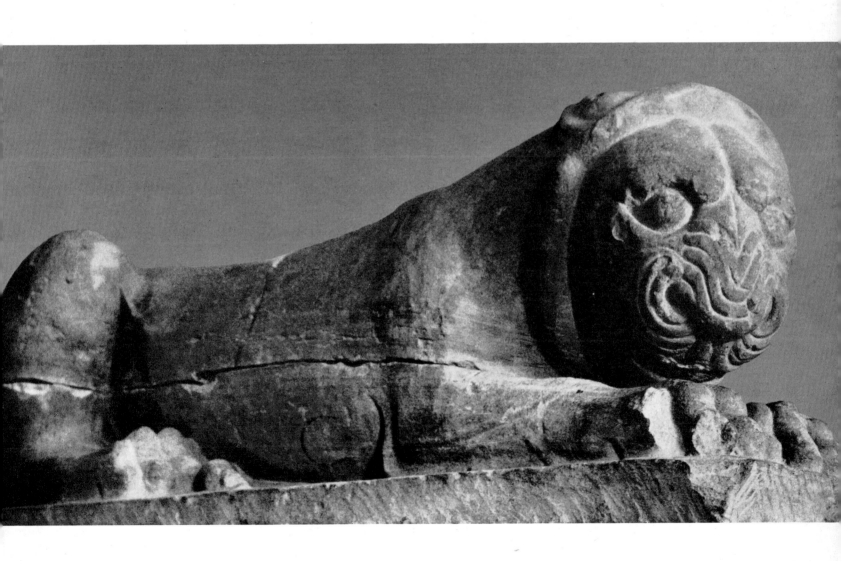

130 *Archaic Monument from Garitsa Necropolis, Kérkyra*

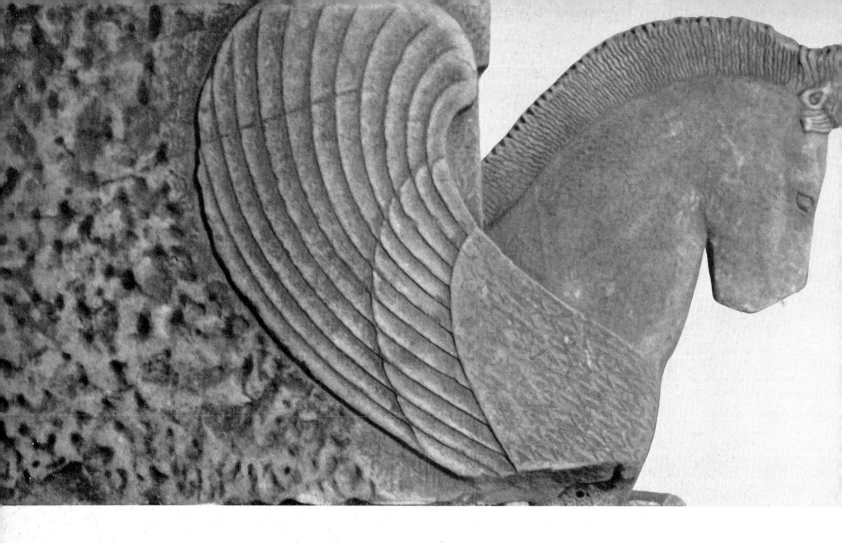

131 *Protome of a Winged Horse, 5th century* B. C.; *Museum, Thasos*

132 *Top of a Sacrificial Altar with Griffins and Stag, 2nd century; Museum, Thasos*

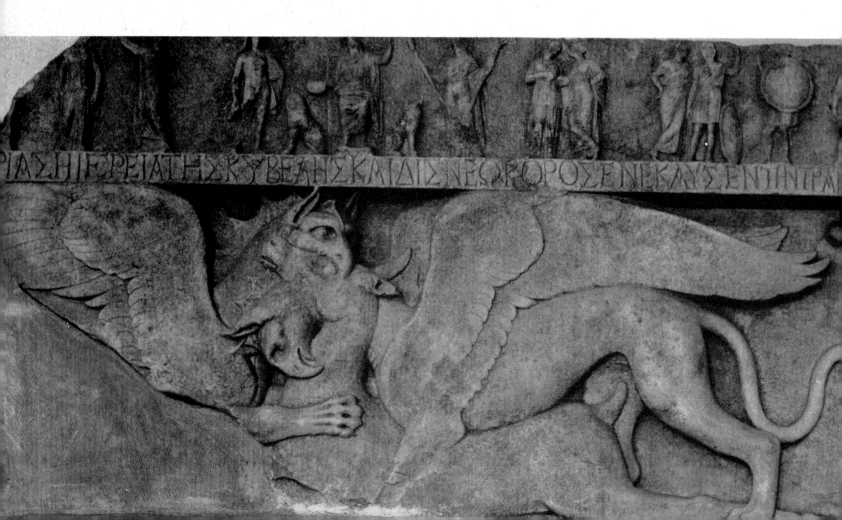

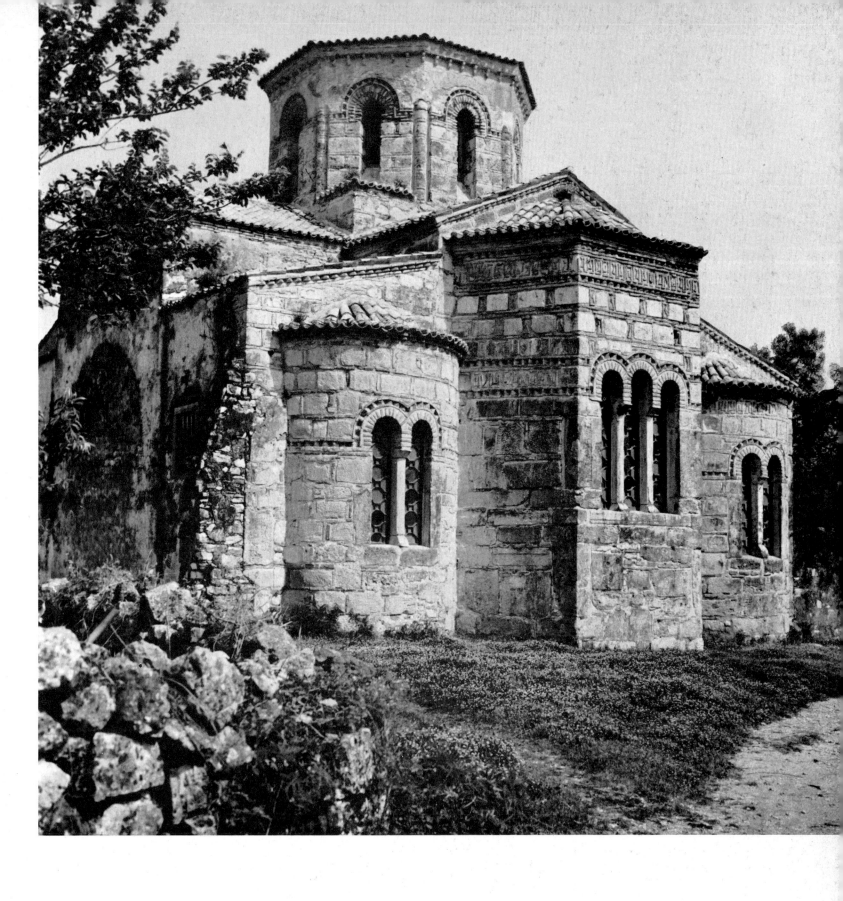

133 Sts. Jason and Sosipater's Church, built in the Byzantine Style, 12th century; Kérkyra

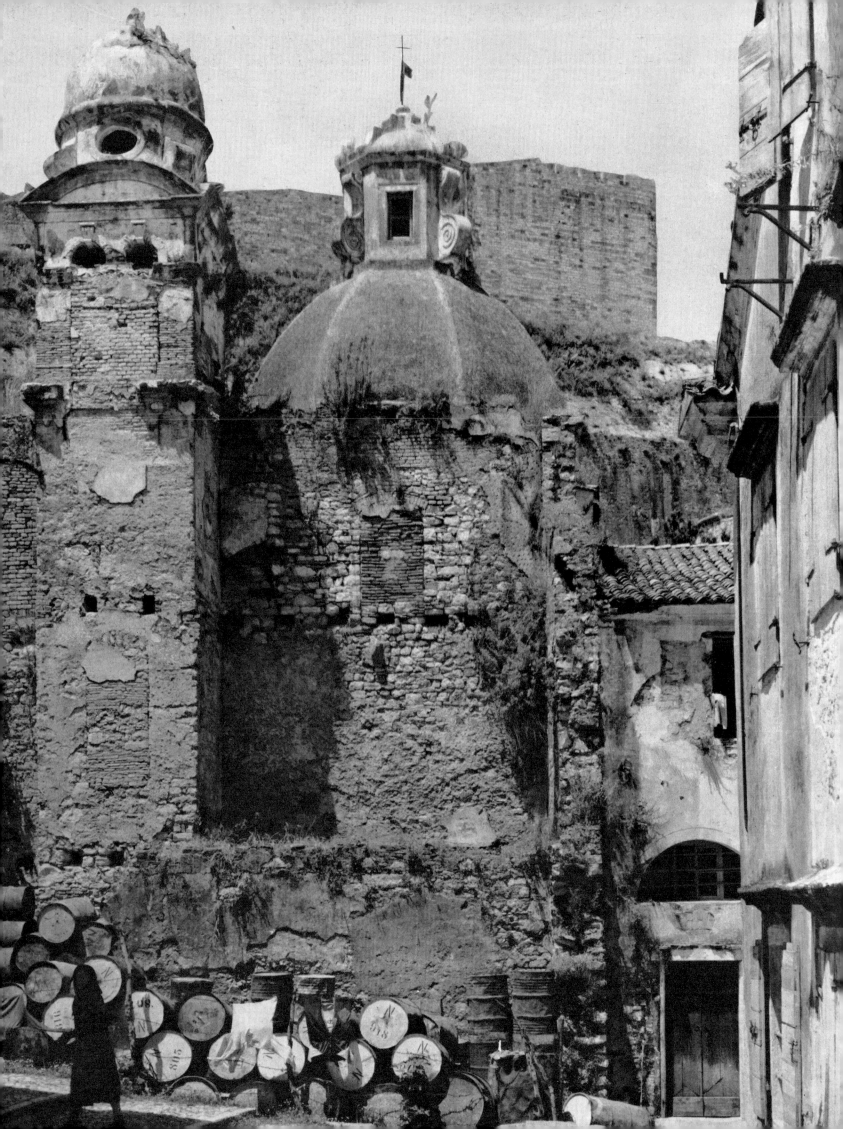

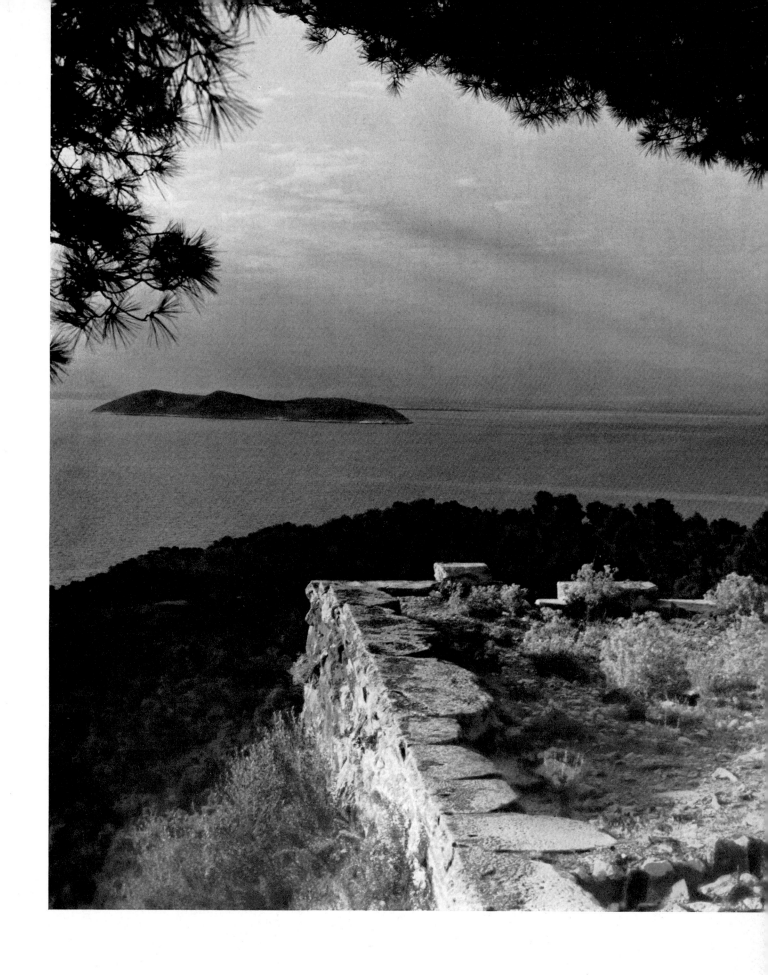

134 *Ruins of a Baroque Church near Kérkyra Citadel*
135 *View of Thasos from the Temple of Apollo*

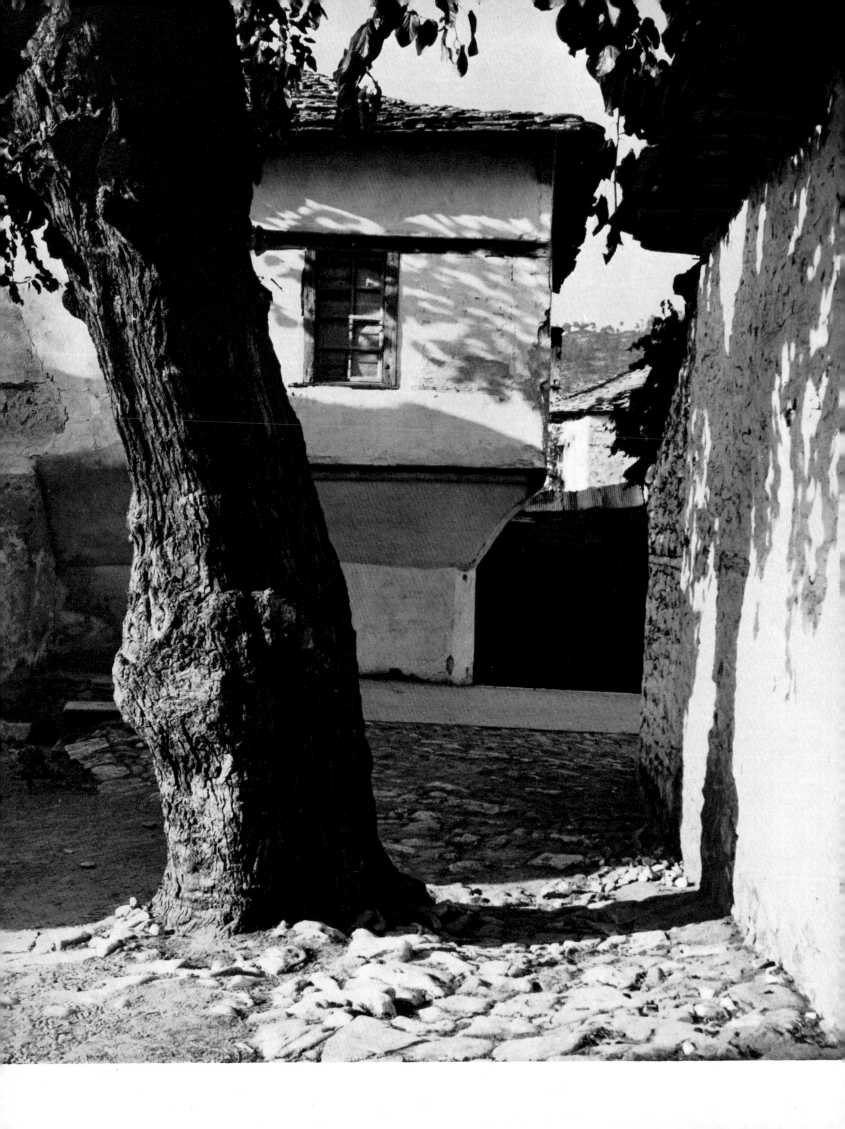

136 *Street in the Mountain Village of Panayia on the Island of Thasos*

137 *Farm-House with a Roman Head in the Wall, Thasos*

138 Fragments of Ancient Statues; Museum, Thasos

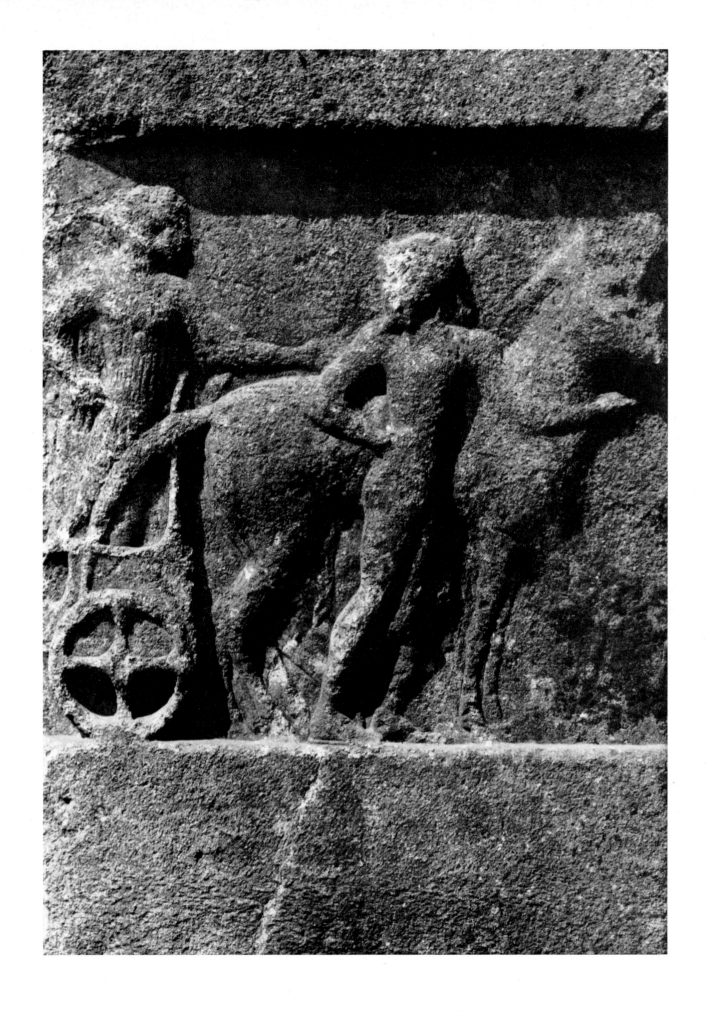

*139 Bas-Relief showing Goddess on a Chariot and Hermes
at one of the Gates of the Ancient Town-Wall of Thasos*

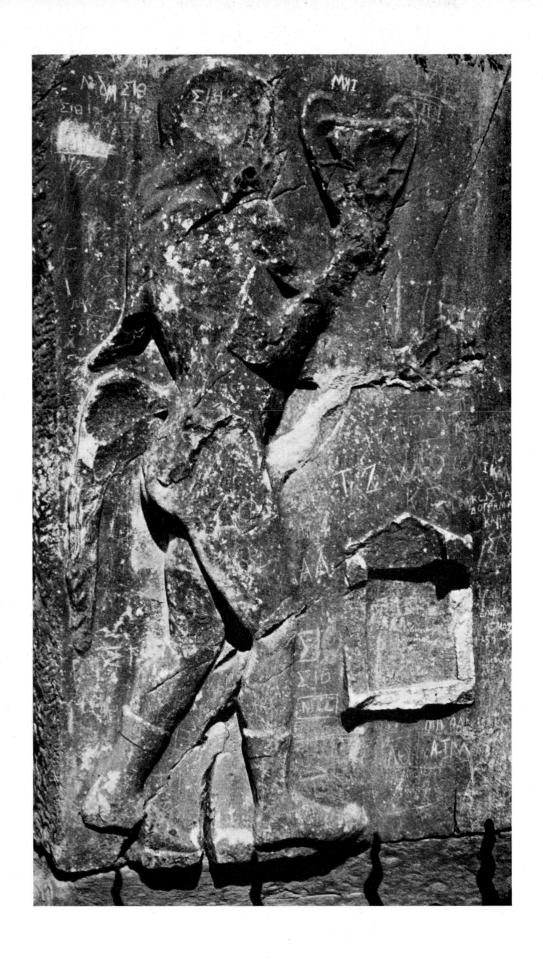

140 *Ithyphallic Satyr with a Cantharus, Hellenistic,*
 Relief in the Ancient Gate Walls of Thasos
141 *Kouros (Apollo?) with Ram from the Acropolis of Thasos,*
 3.50 m high; early 6th century B. C.

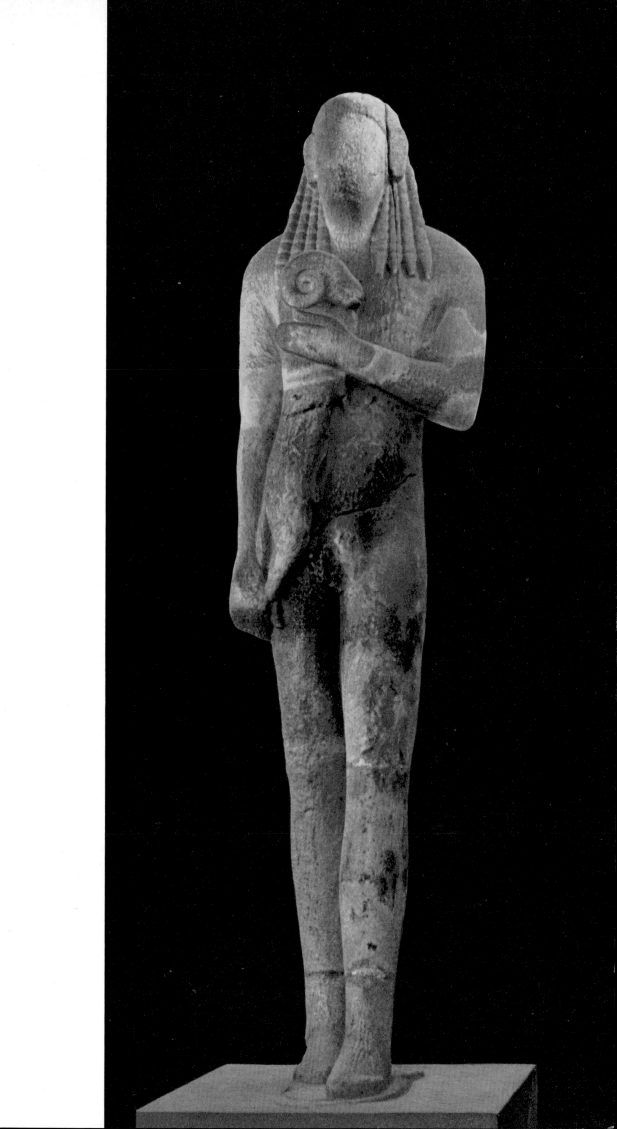

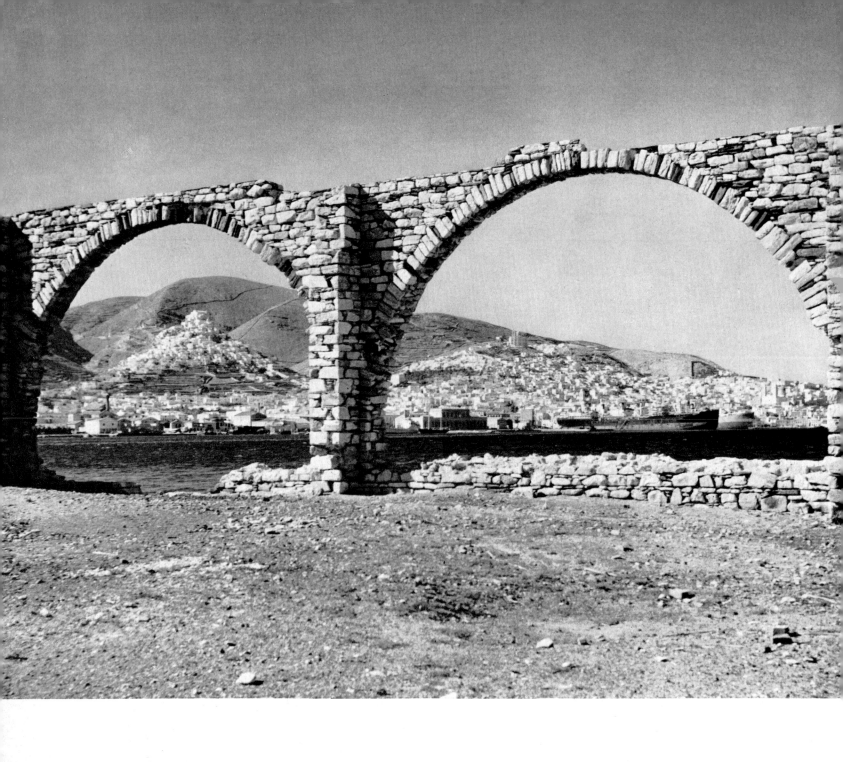

142 *The Town of Siros with Ancient Aqueduct*

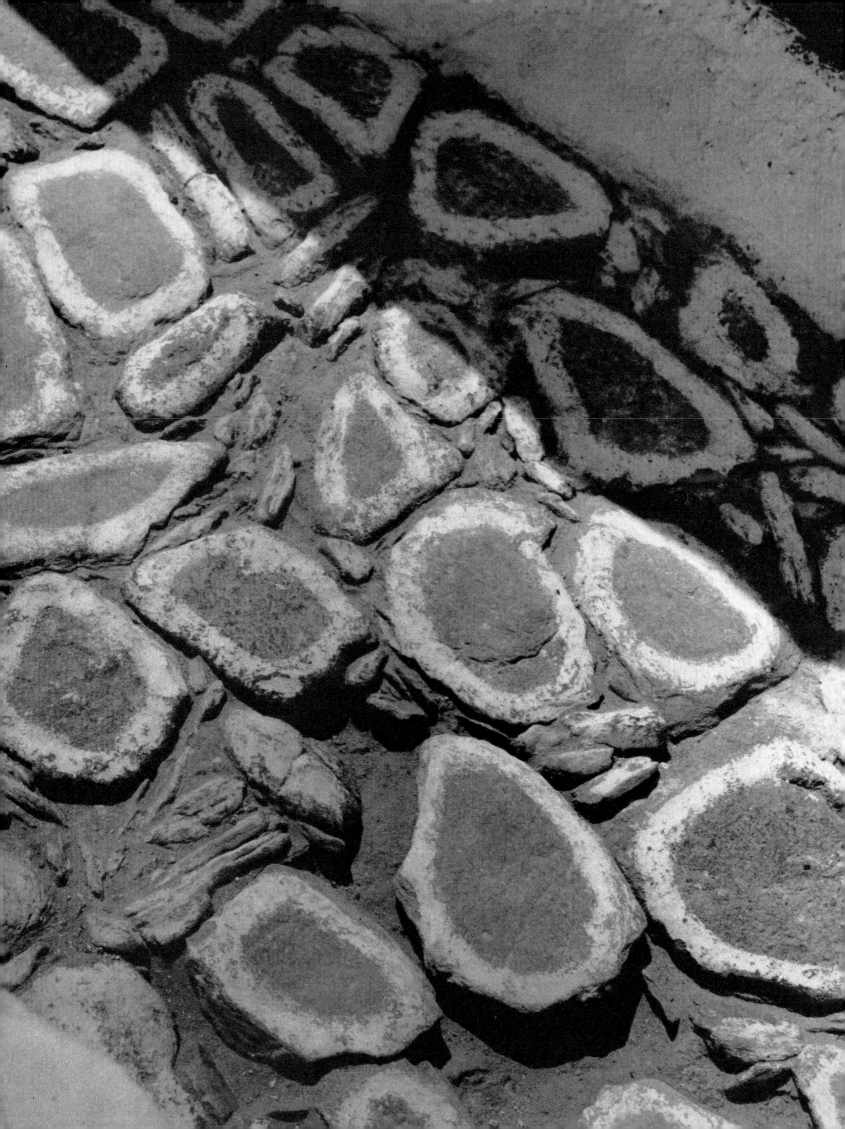

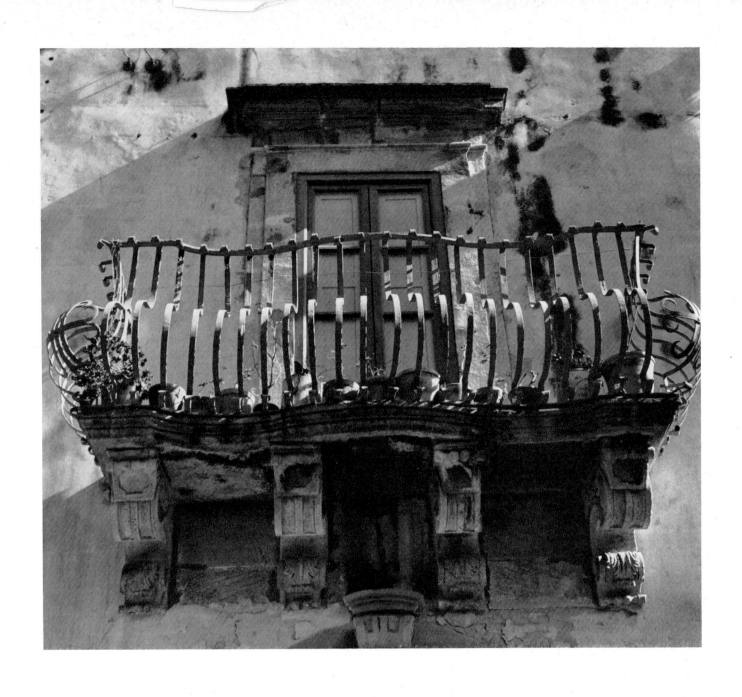

144 *Pavement of the Mountain Town of Ios*
145 *Balcony of a Dwelling-House at Ios*

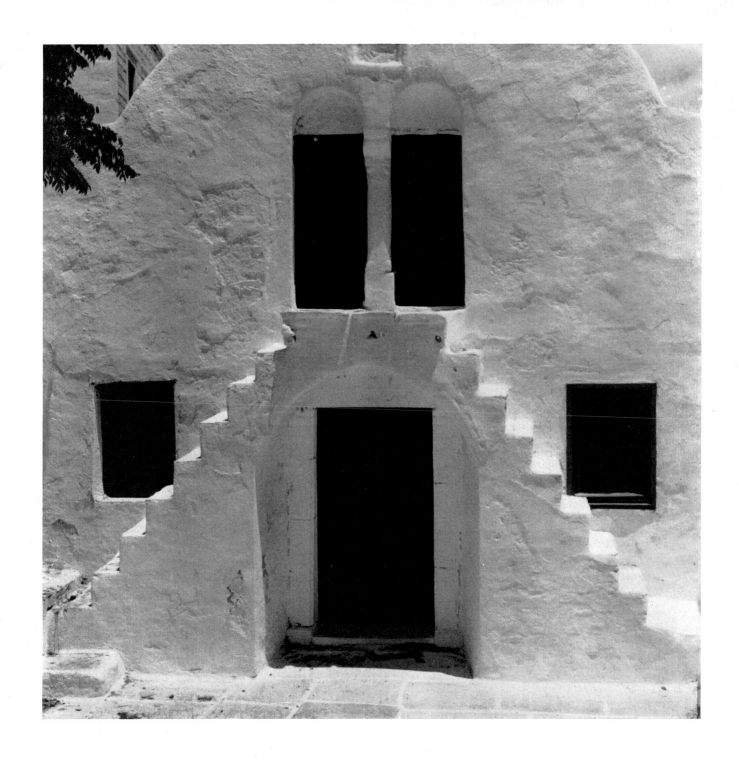

146 Portal Façade of a Byzantine Chapel in the Town of Ios

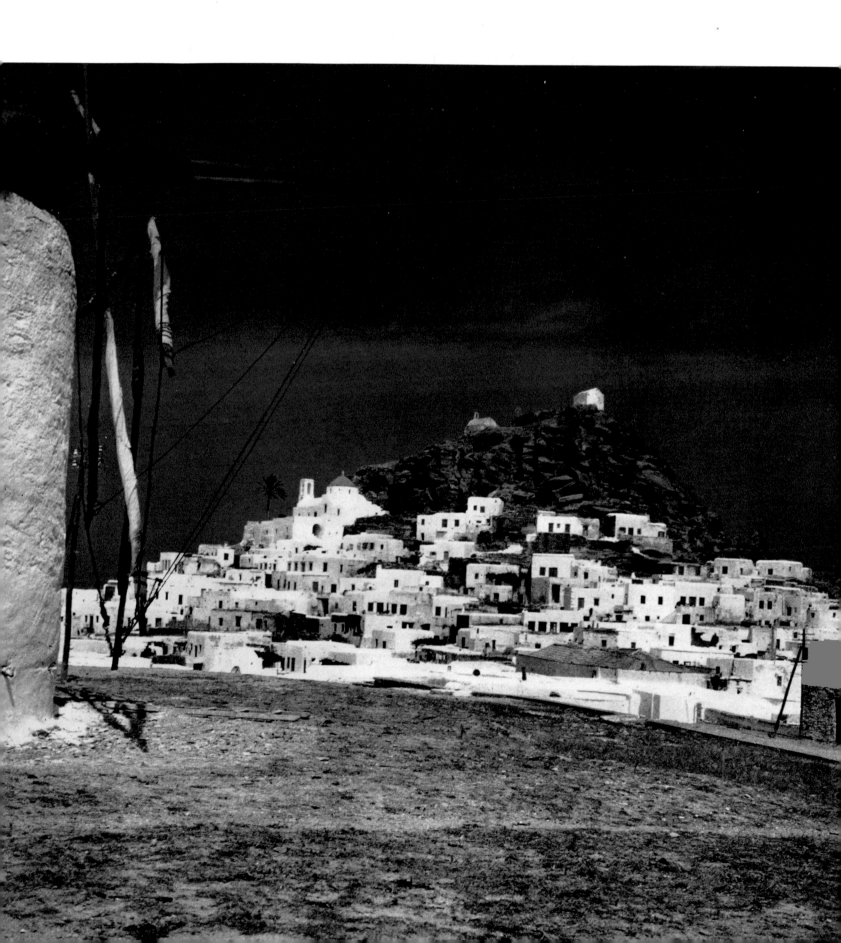

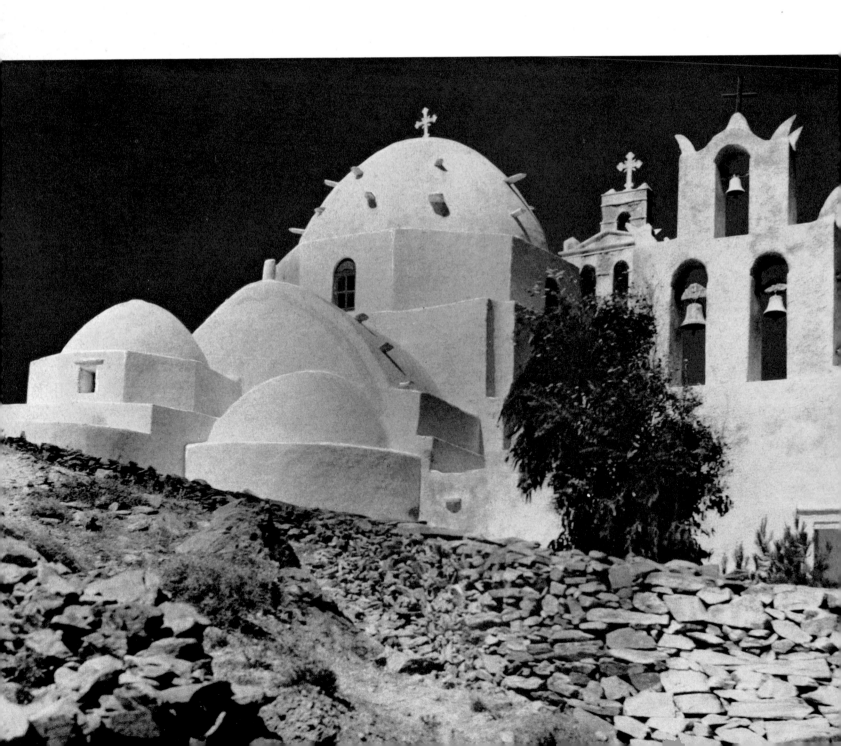

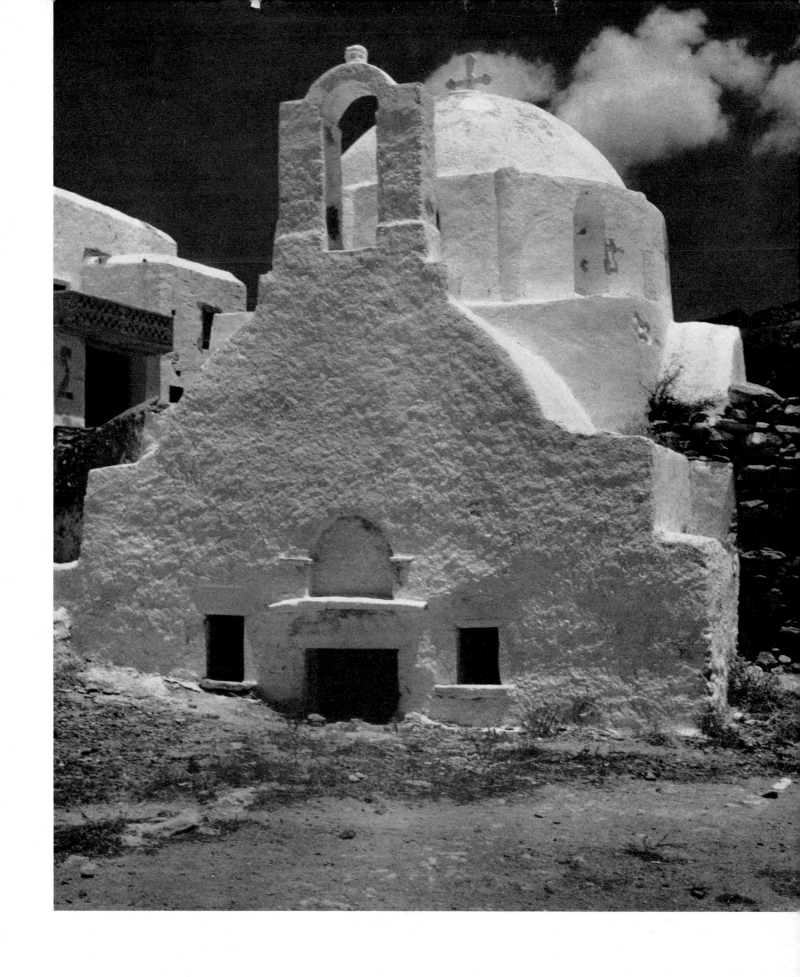

149 *Early Byzantine Church on the Island of Ios*

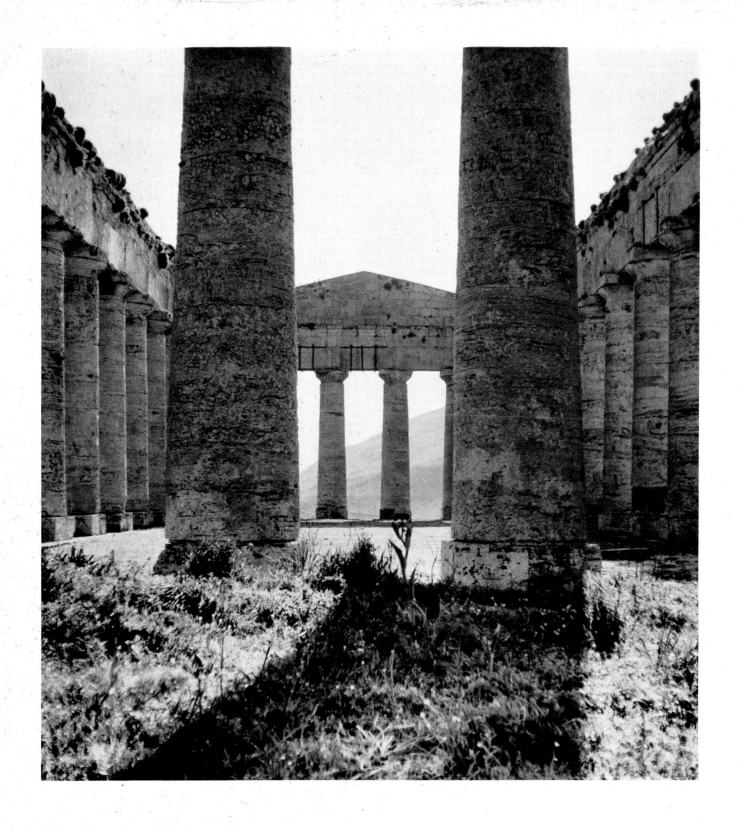

150 *Inside the Temple of Segesta, Sicily*

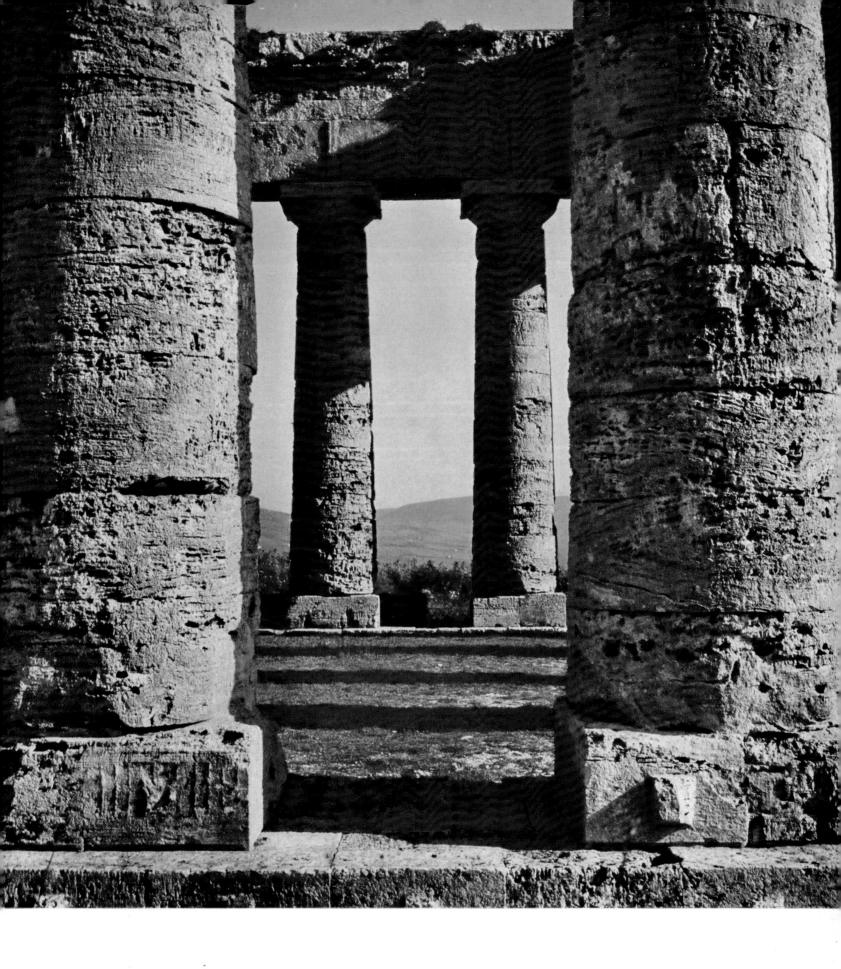

151 *Columns of the Unfinished Temple of Segesta*

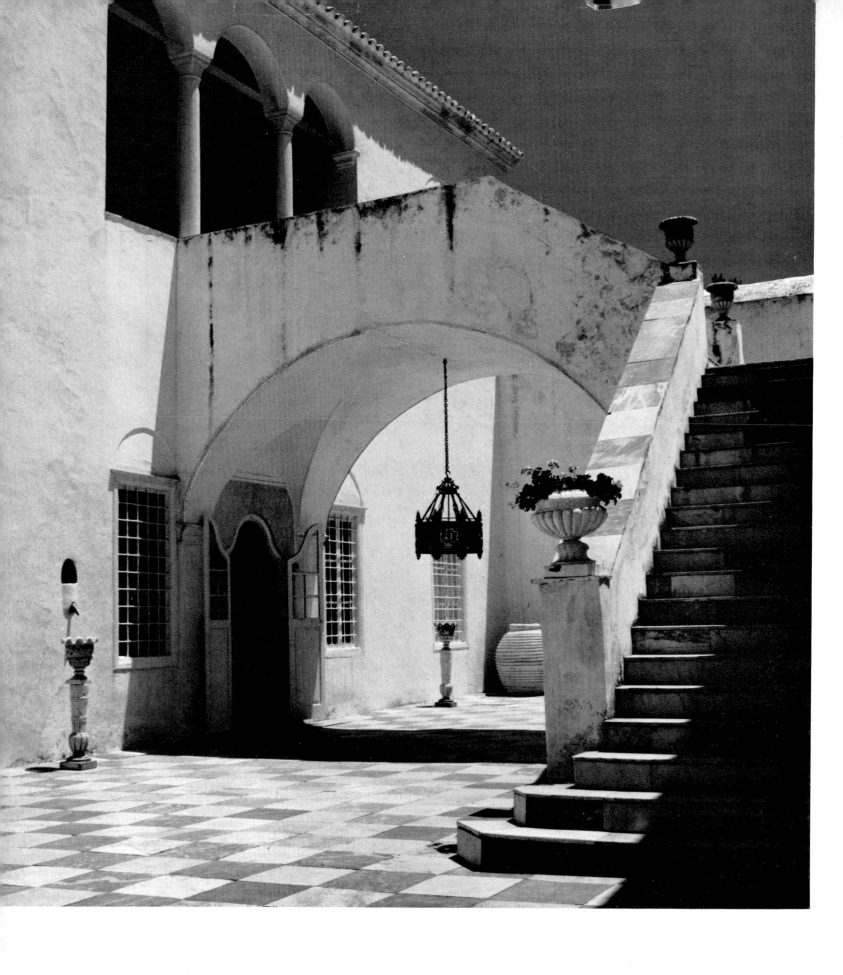

152 *Courtyard of Palazzo Koundouriatis, Isle of Hydra*

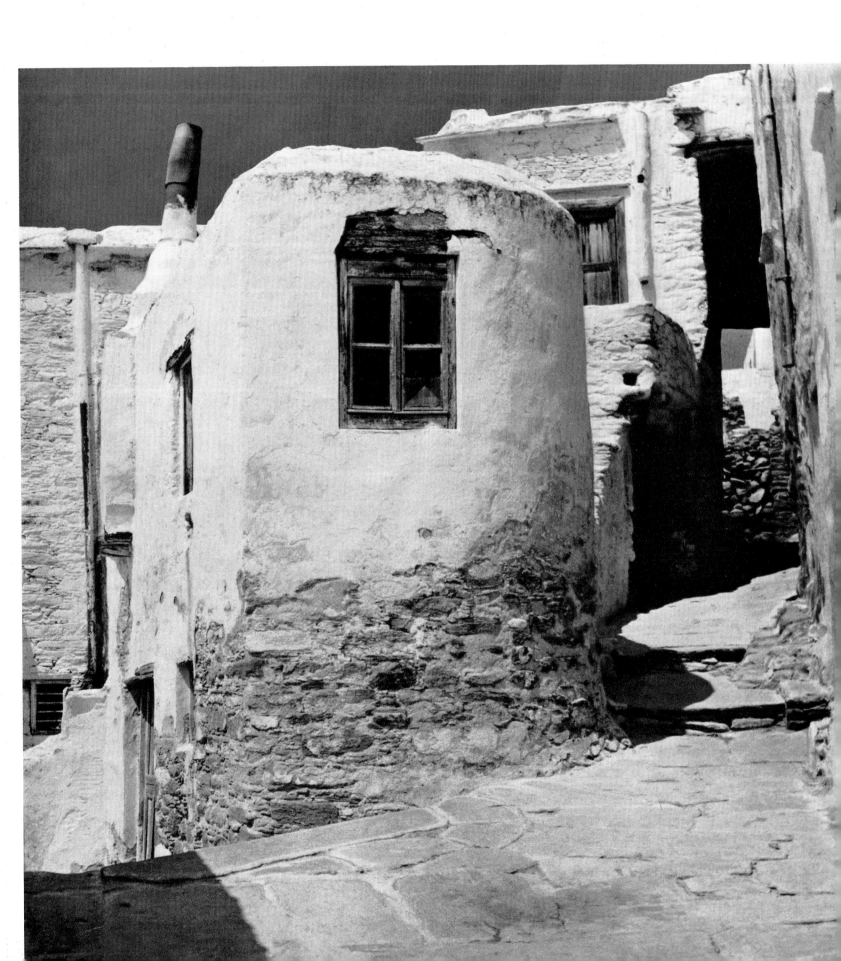

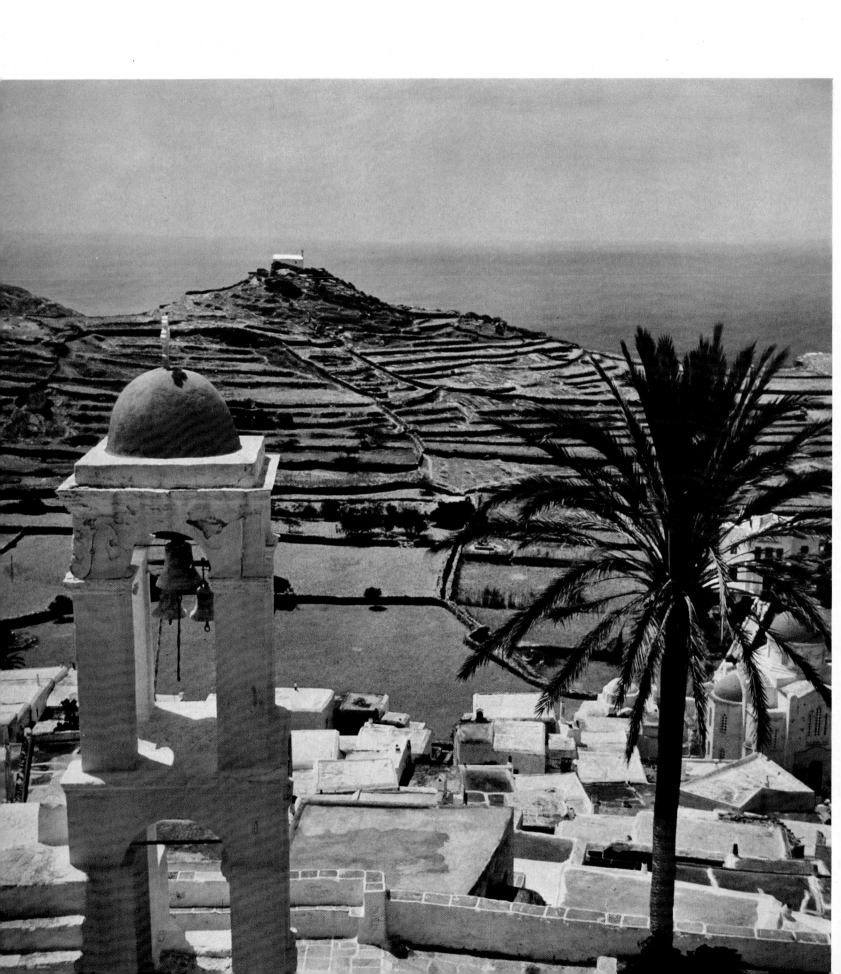

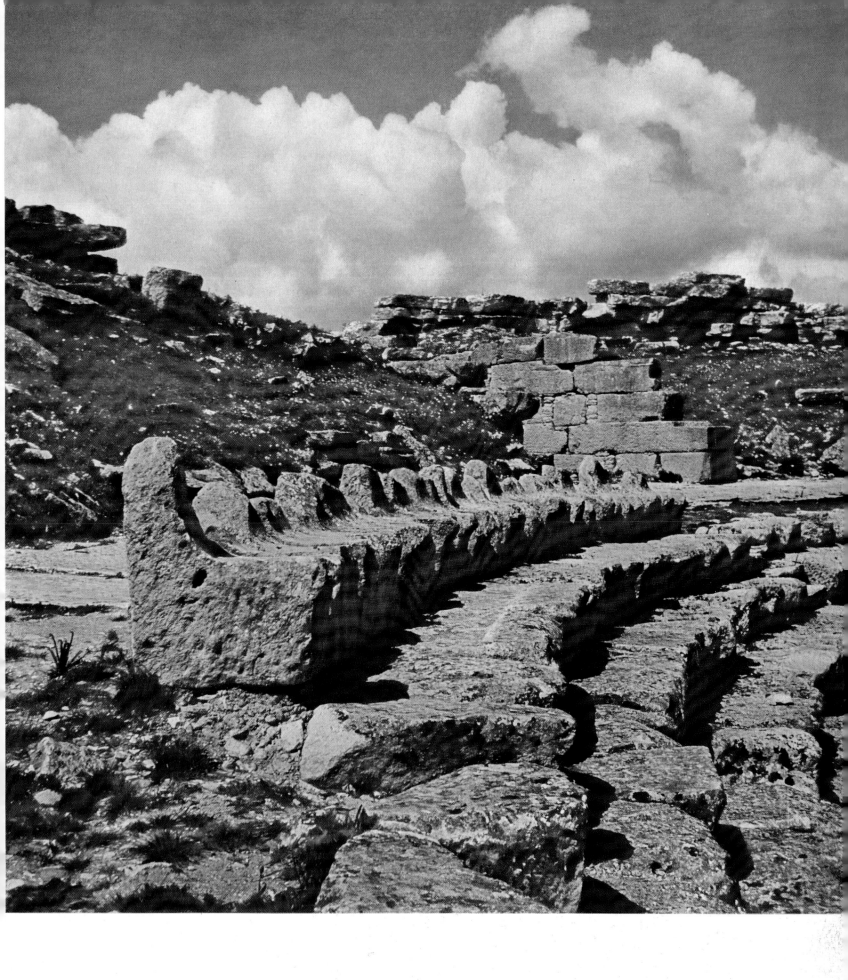

155 *In the Amphitheatre of Segesta, Sicily*

156 *Neolithic Cave-Dwellings, Sperlinga, Sicily*
157 *Rock-Relief of the Cybele Worship, 3rd century* B. C., *near Palazzolo Acreide, Sicily*

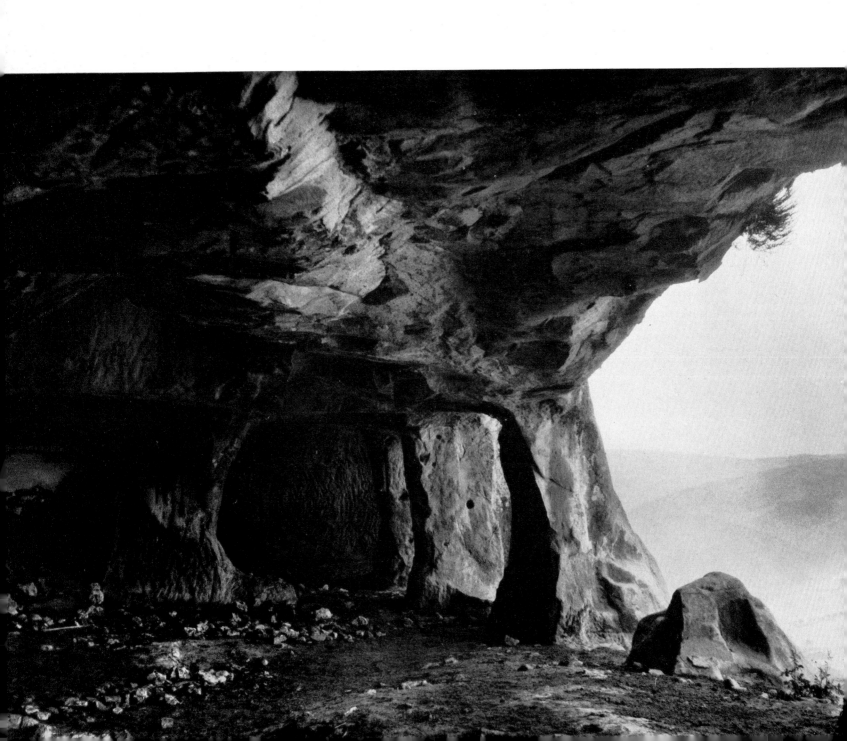

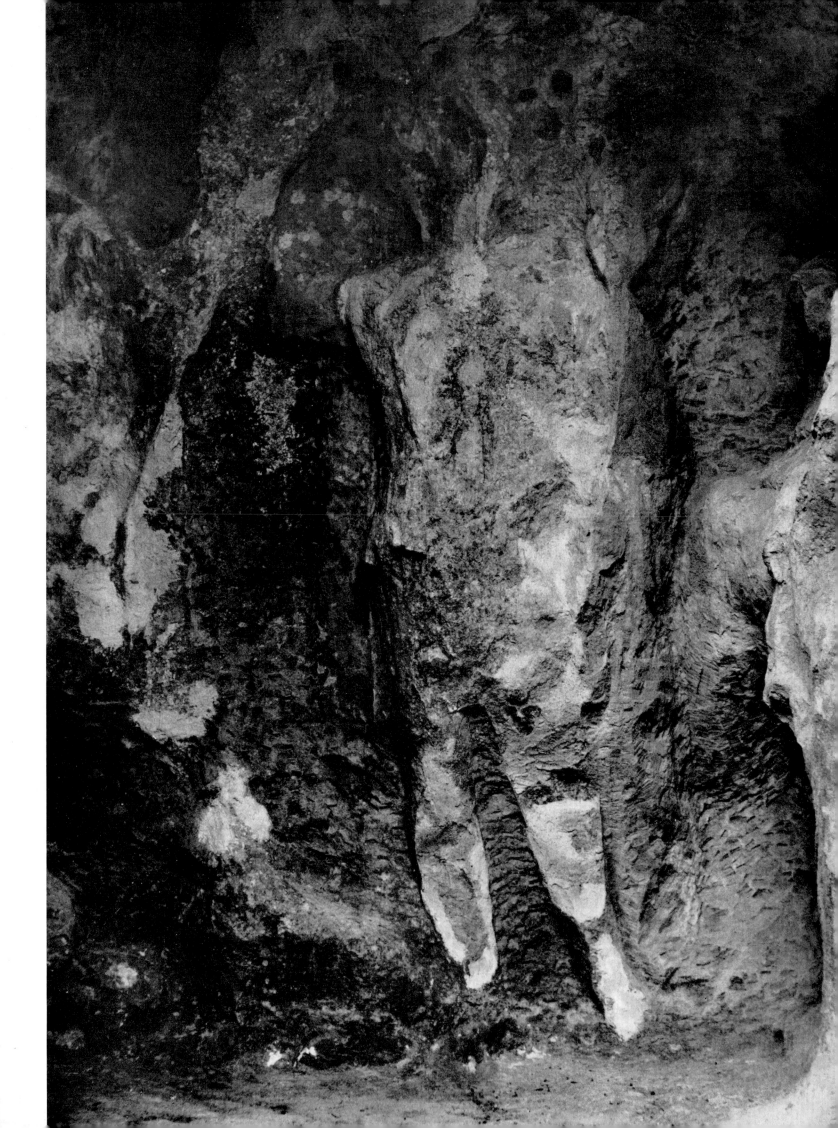

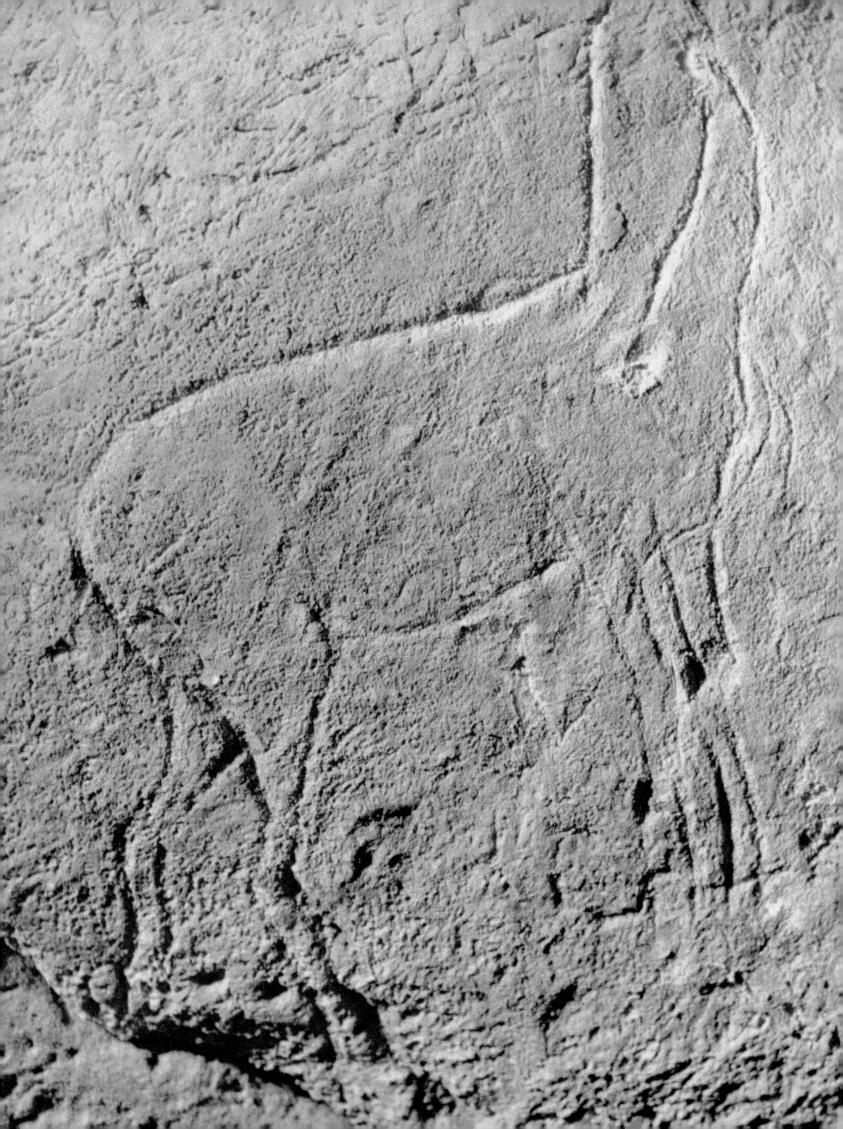

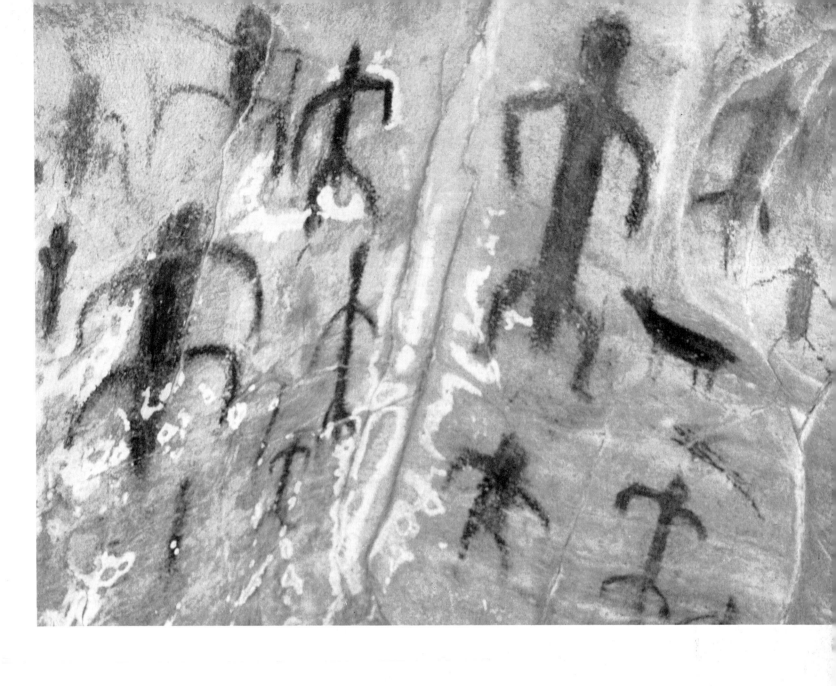

158 *Prehistoric Stone-Carving,* 20,000 *B. C., on the Island of Levanzo*
159 *Cave-Painting on the Island of Levanzo,* 6,000 *B. C.*

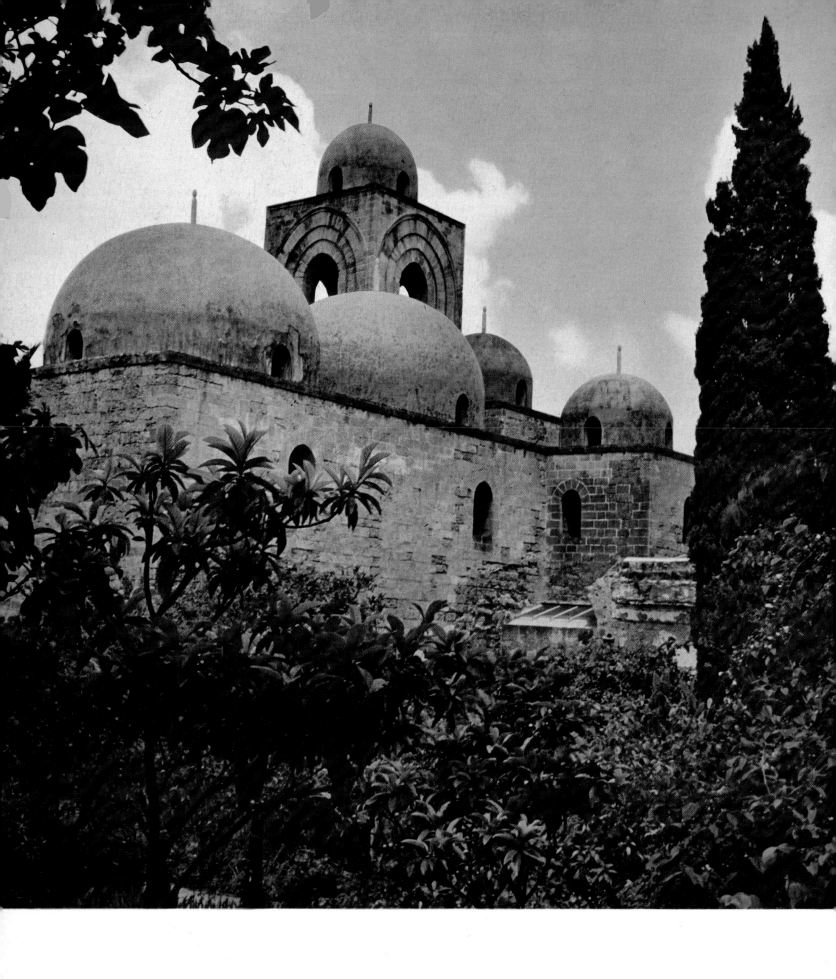

160 *San Giovanni degli Fremiti, Palermo*

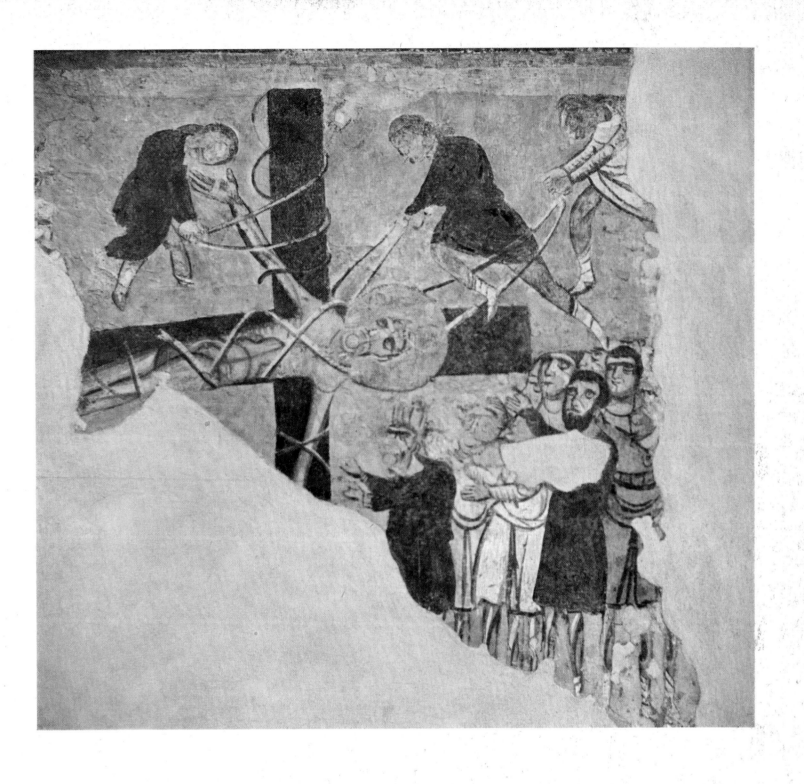

161 Mediaeval Fresco, Descent from the Cross, in the Convento Benedicto, Catania

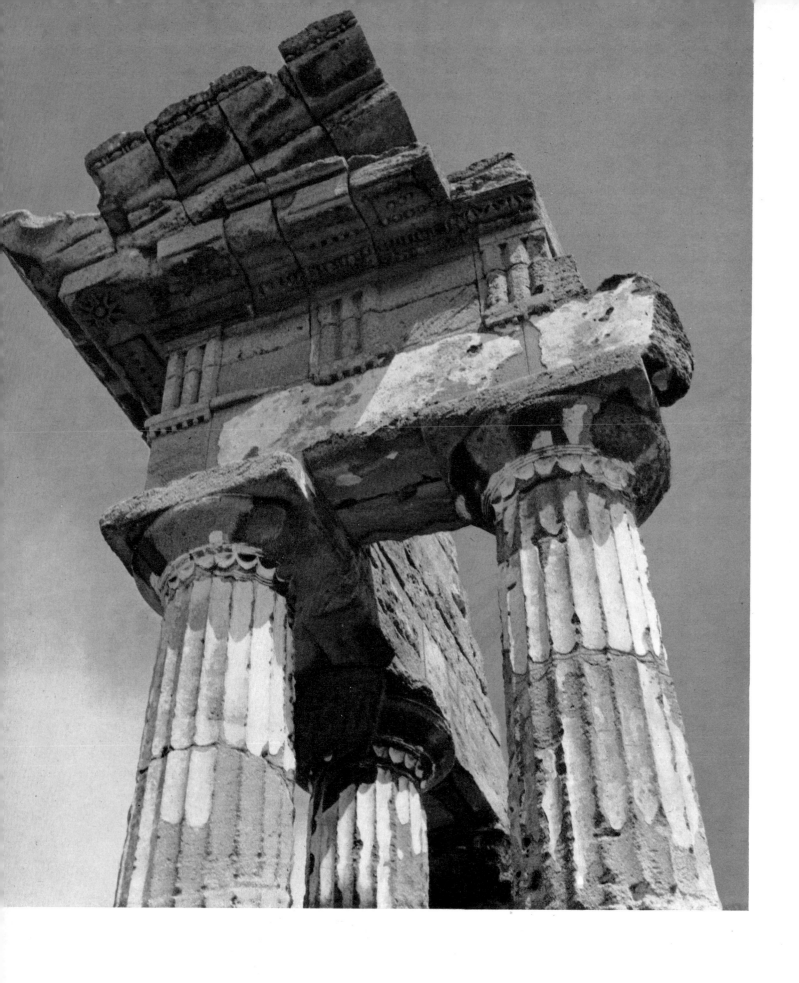

162 *West Gable of the Temple of the Dioscuri, Agrigento*

63 The Temple Ruins of Selinunt
64 Field of Ancient Ruins of Selinunt

165 *Gate of a Vault from the Necropolis of Castelluccio,*
 Bronze Age; National Museum, Syracuse

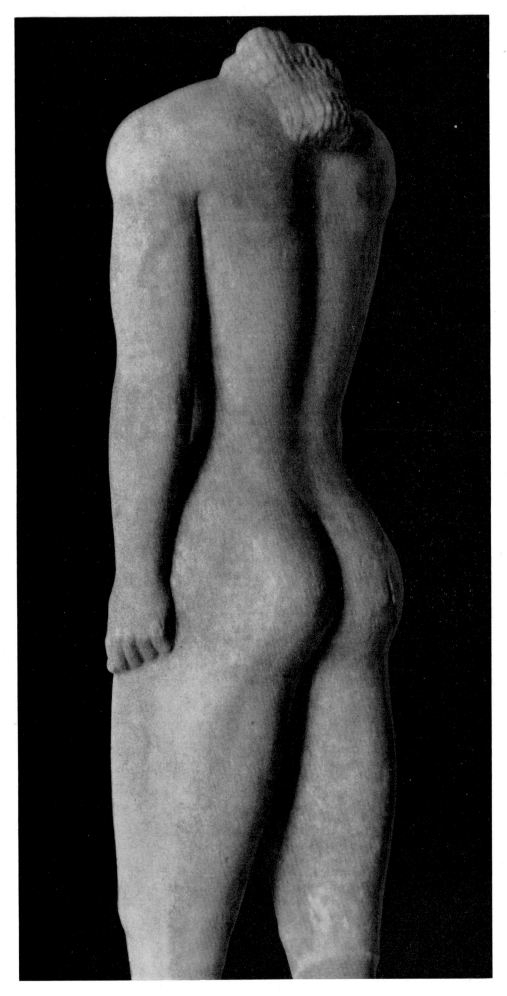

166 *Kouros; National Museum, Syracuse*

167 *Baroque Chapel at Scicli, Sicily*

168 *View of the Towers of the Main Stronghold in Euryalos Castle, Syracuse, Sicily*

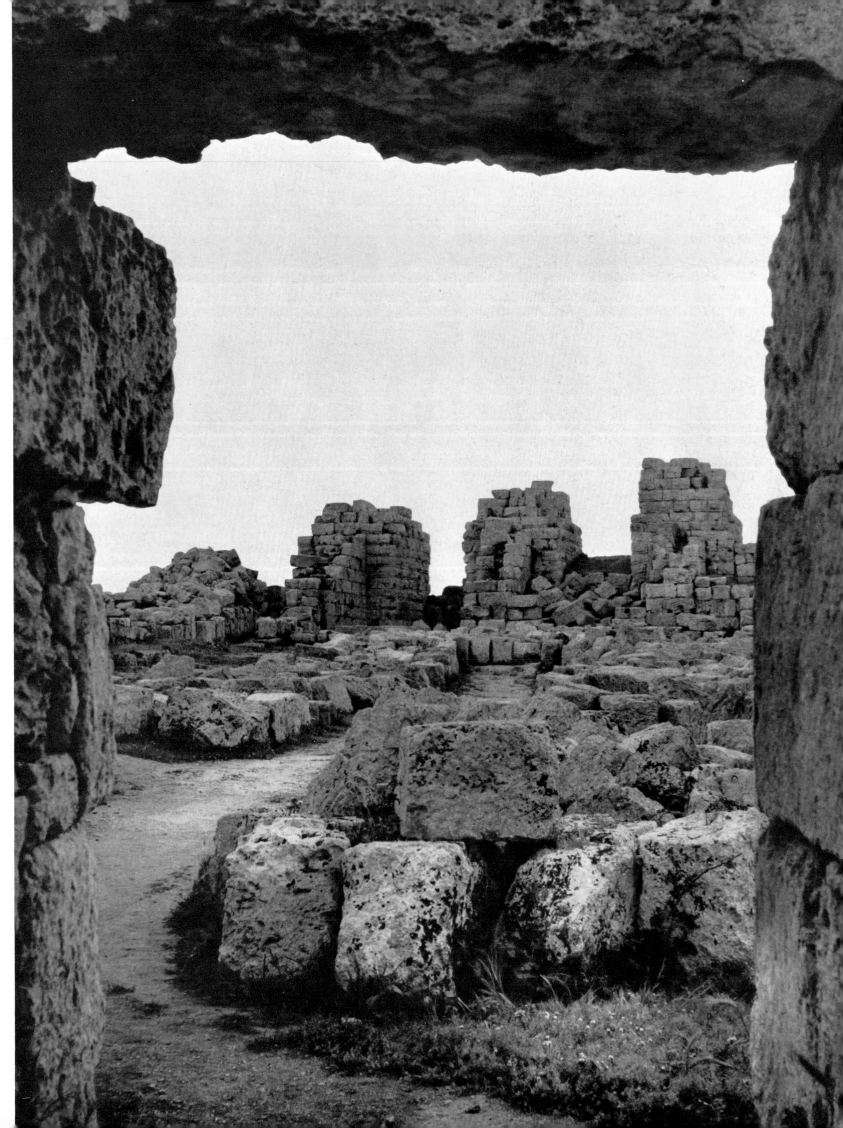

169 *Outskirts of the Mountain Town of Nicosia, Sicily*

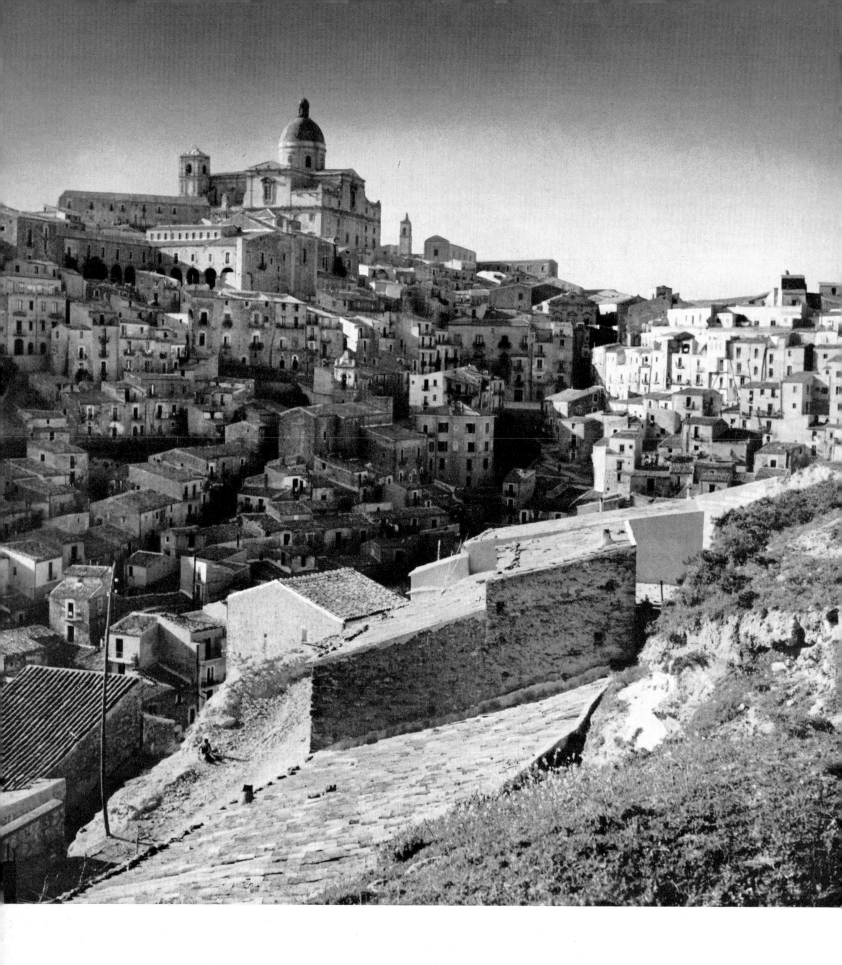

171 *View of Piazza Armerina, Sicily*

175 Side Portal of Chiesa Madre, Taormina, Sicily
176 Ashlar Façade of Palazzo Steripinto at Sciacca, Sicily

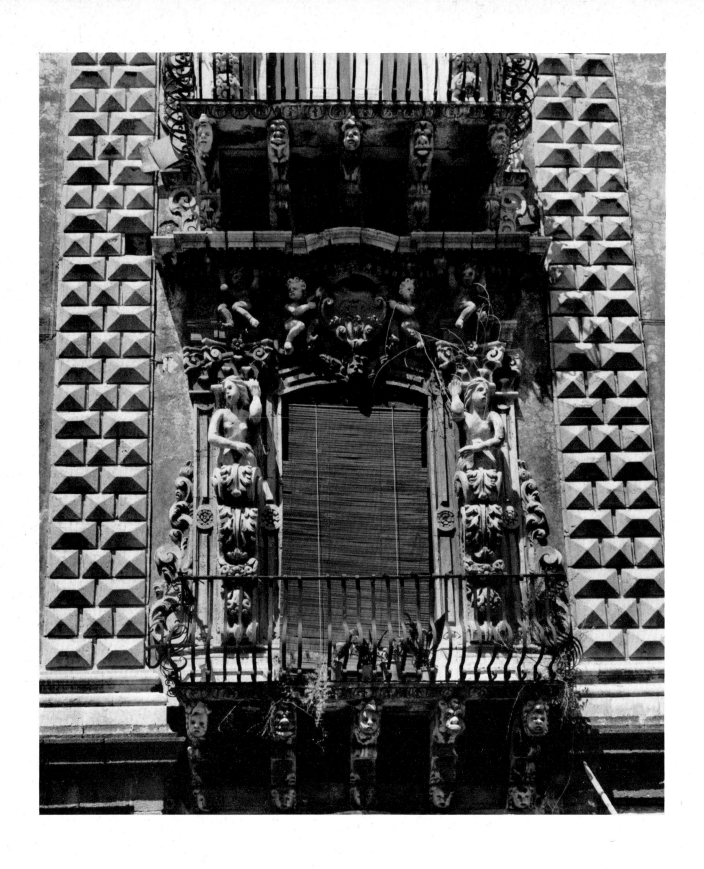

177 *Balcony of the Convento Benedicto, after 1693, Catania, Sicily*

178 *Aisle of Syracuse Cathedral with the Columns of the Ancient Temple of Athene*

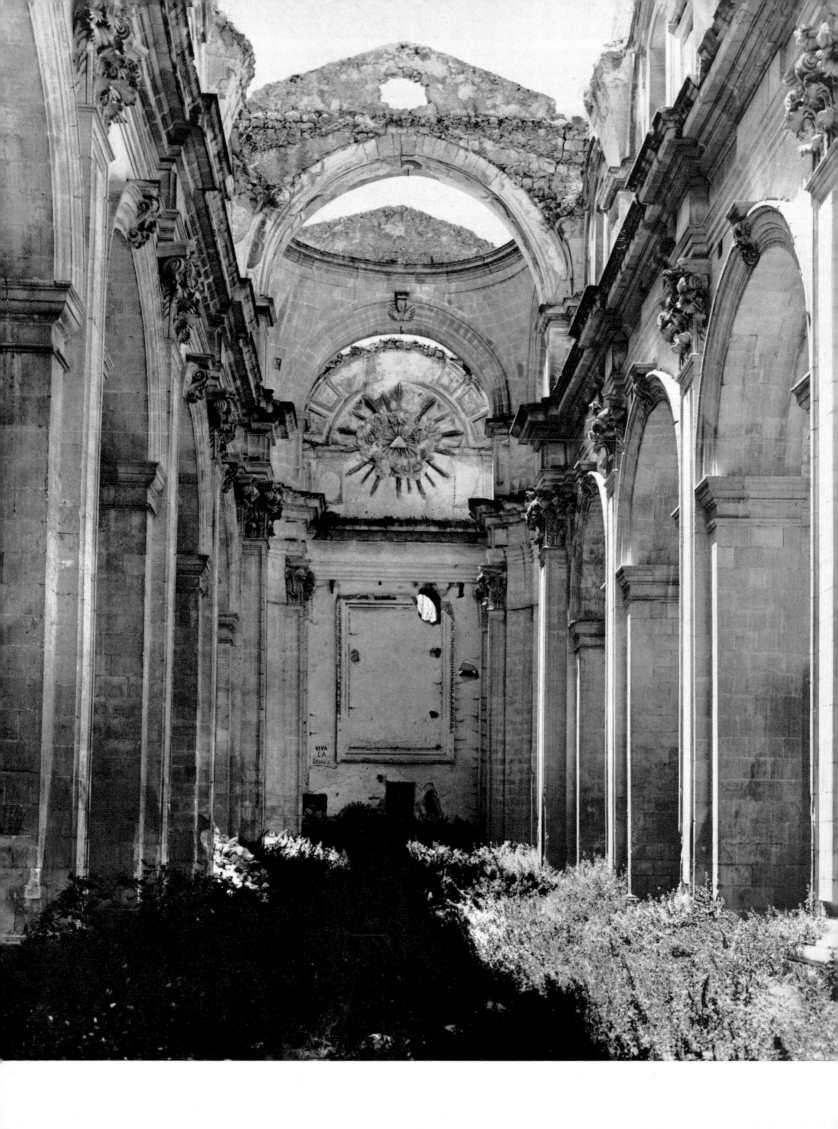

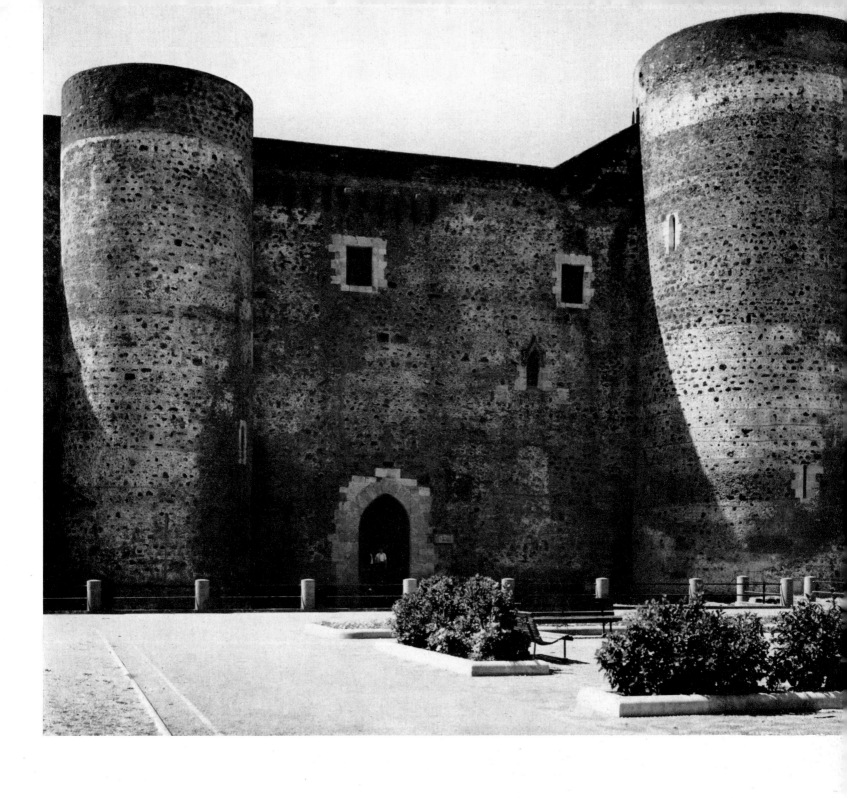

179 *Interior View of the Ruined Mountain Church of San Matteo above Scicli, Sicily*
180 *Castle of Ursino*, A. D. *1250, Catania, Sicily*

181 *Mediaeval Cornice on Palazzo Bellomo, Syracuse, Sicily*

182 *Chiesa Madre with Well-Figure, Taormina, Sicily*

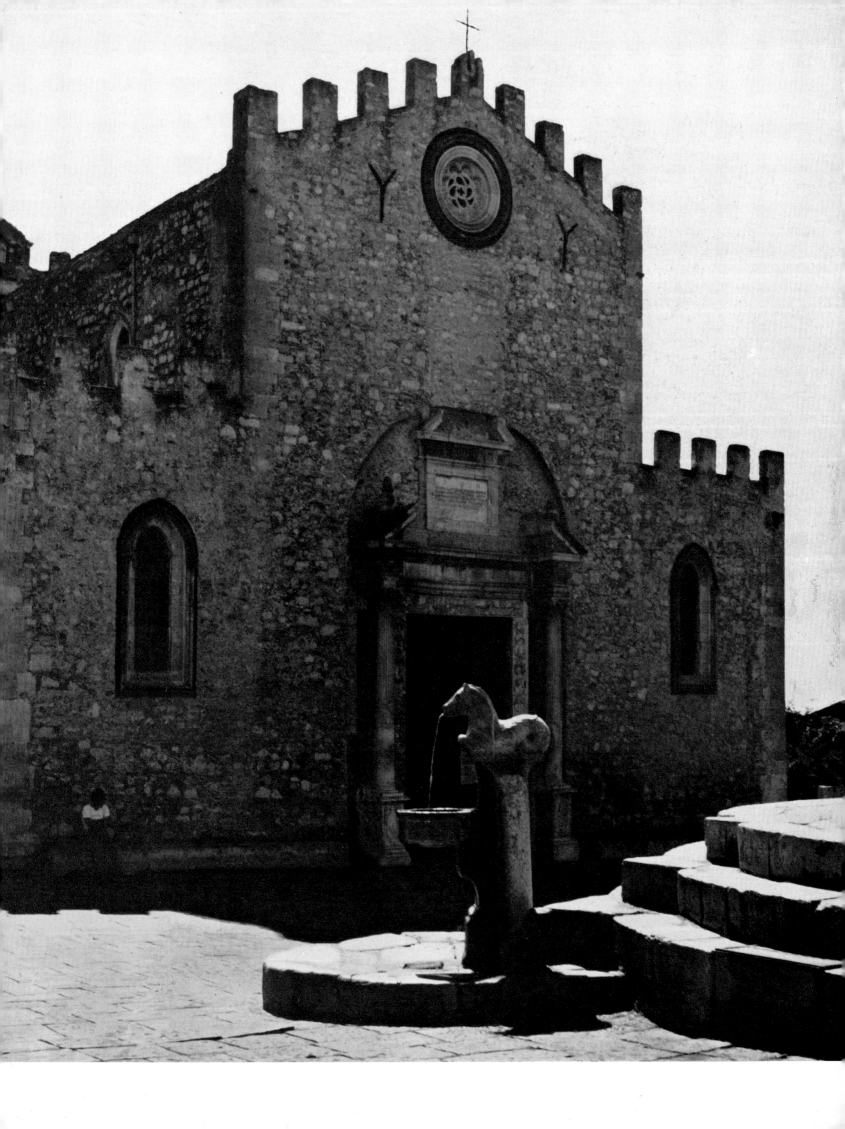

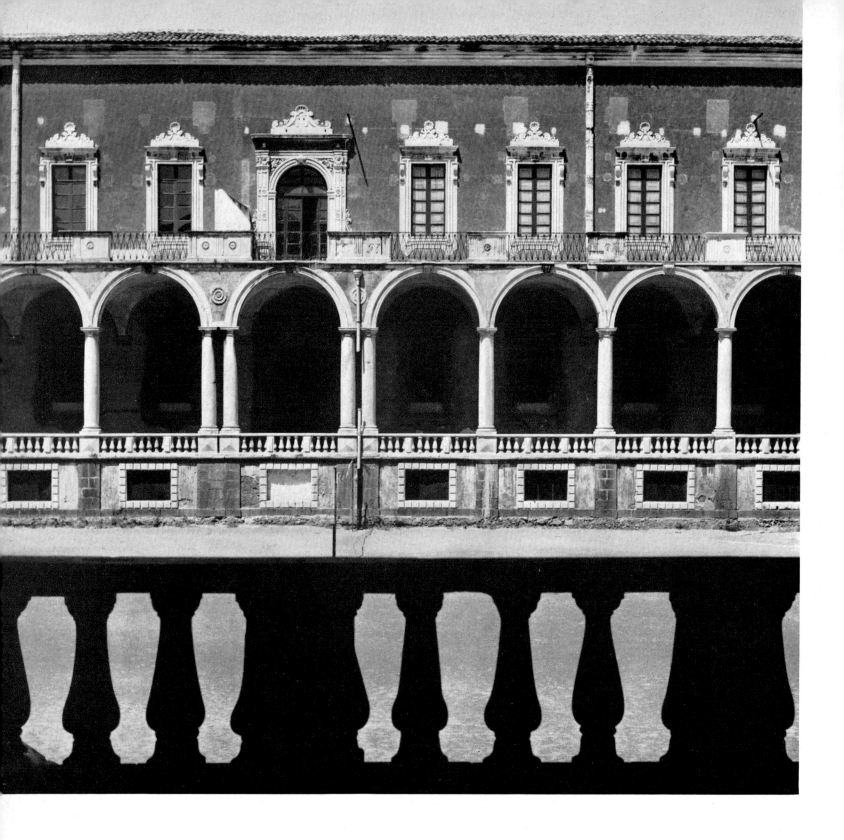

183 *Courtyard of a Renaissance Palace at Catania, Sicily*

184 *Basilica San Giorgio at Ibla-Ragusa, Sicily*

185 *Part of a Mosaic in a Late Roman Villa at Casale near Piazza Armerina, Sicily*
186 *Detail of the Bronze Gate of the Norman Cathedral of Monreale,* A. D. 1182, *Master Bonanos of Pisa*

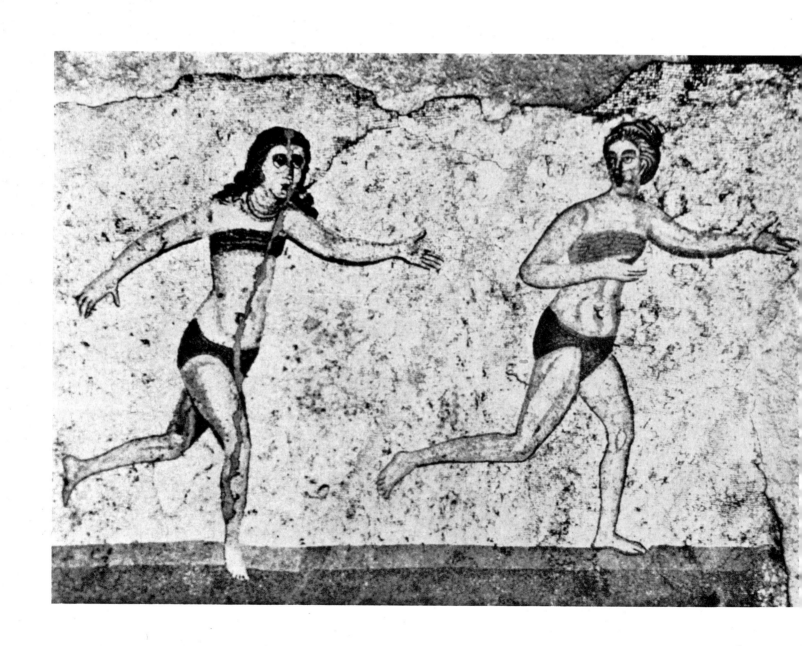

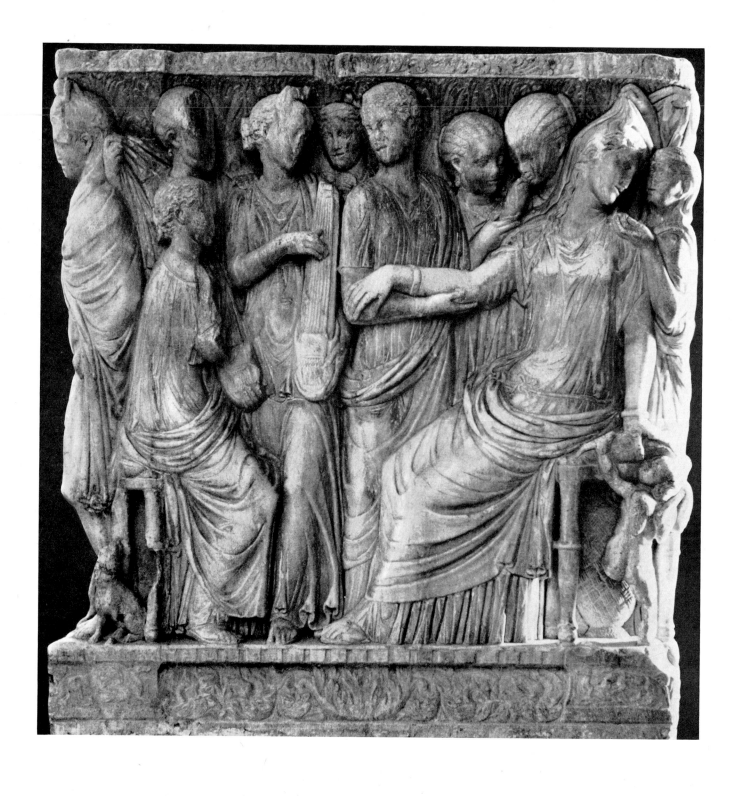

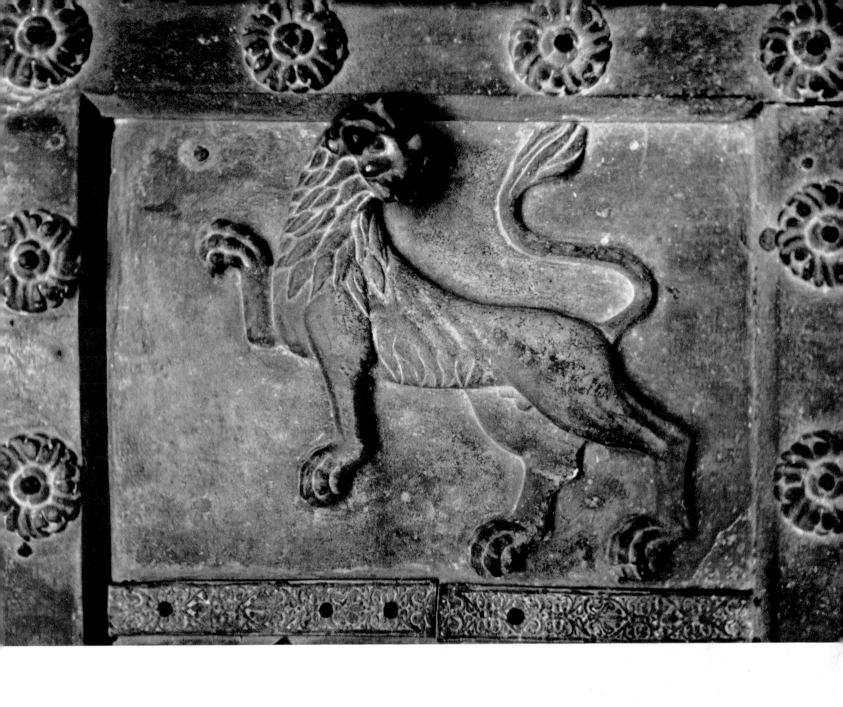

188 Detail of the Bronze Gate of the Norman Cathedral of Monreale, A. D. *1182, Master Bonanos of Pisa*

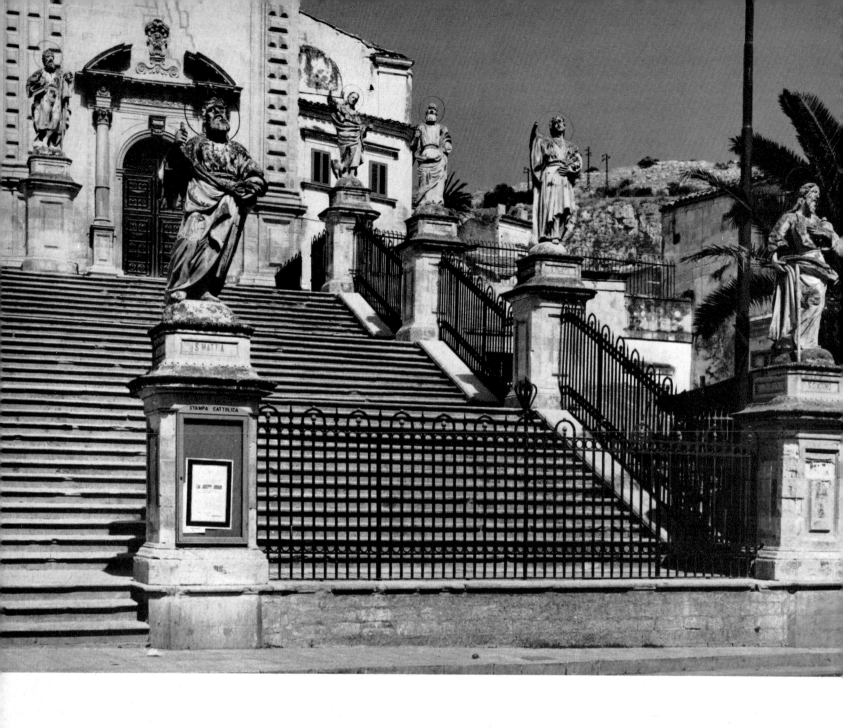

189 Flight of Stairs of Chiesa San Pietro, Modica, Sicily
190 Baroque Church of San Giorgio at Modica, Sicily

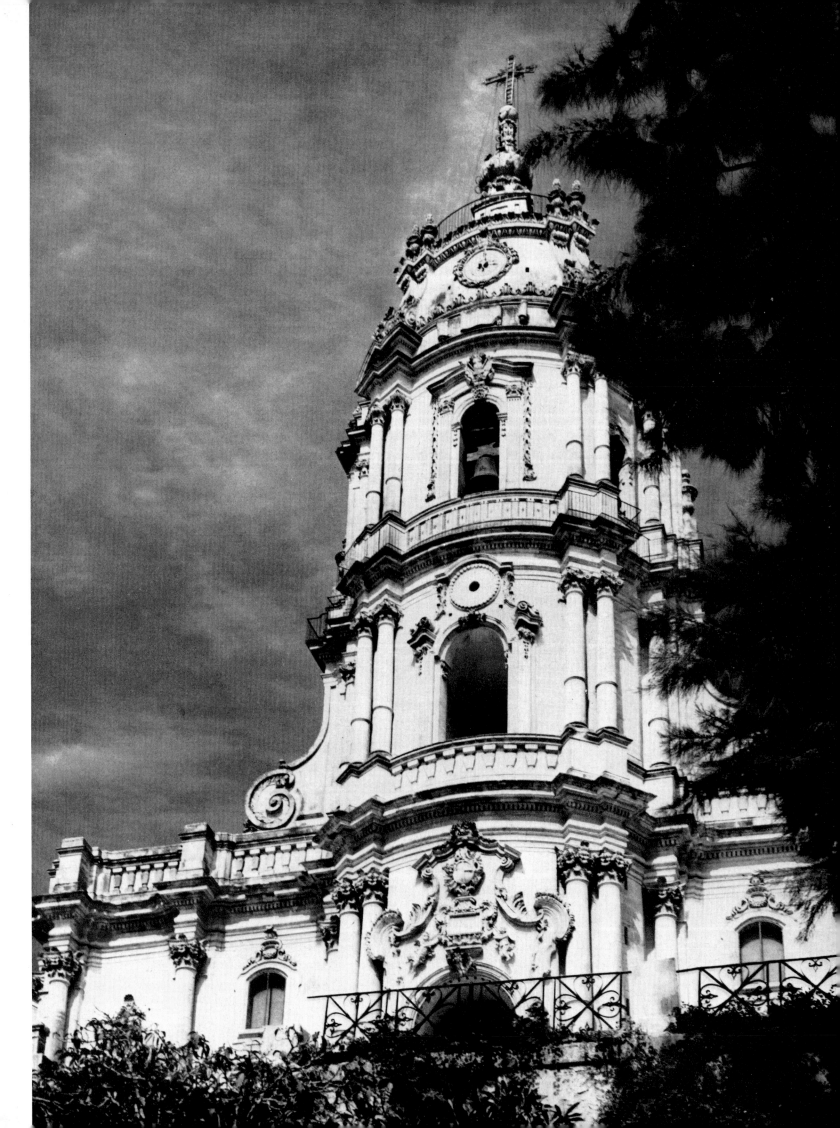

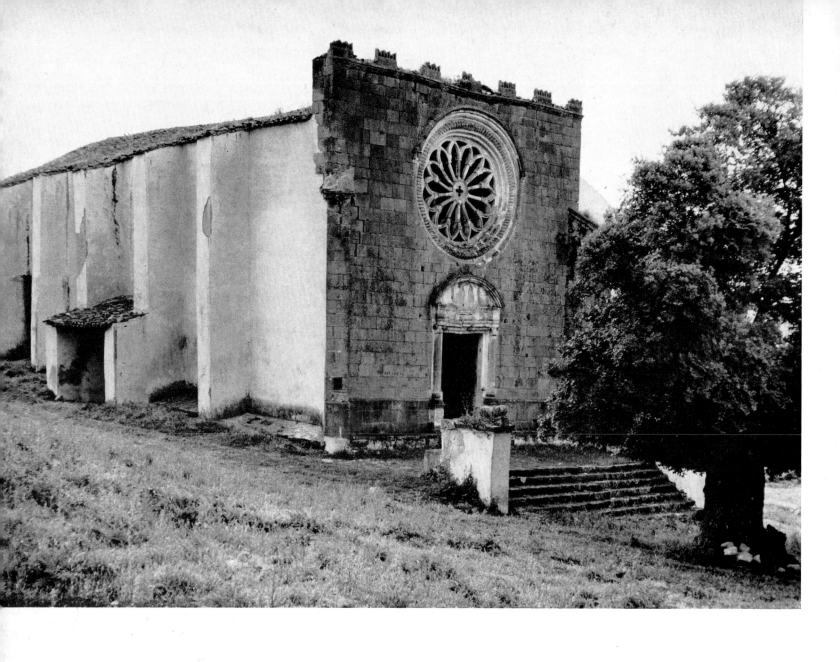

191 *Pisan Church of San Mauro near Sórgono, Sardinia*
192 *Detail of the Baroque Façade of Syracuse Cathedral,* A.D. 1693

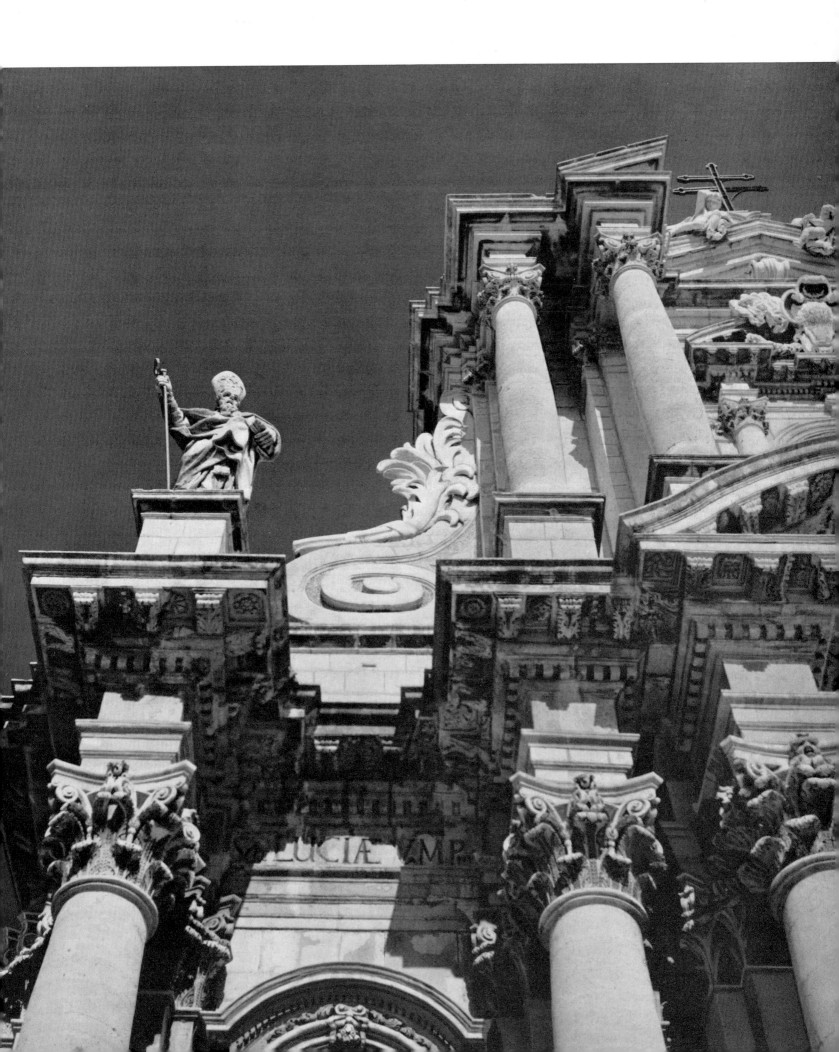

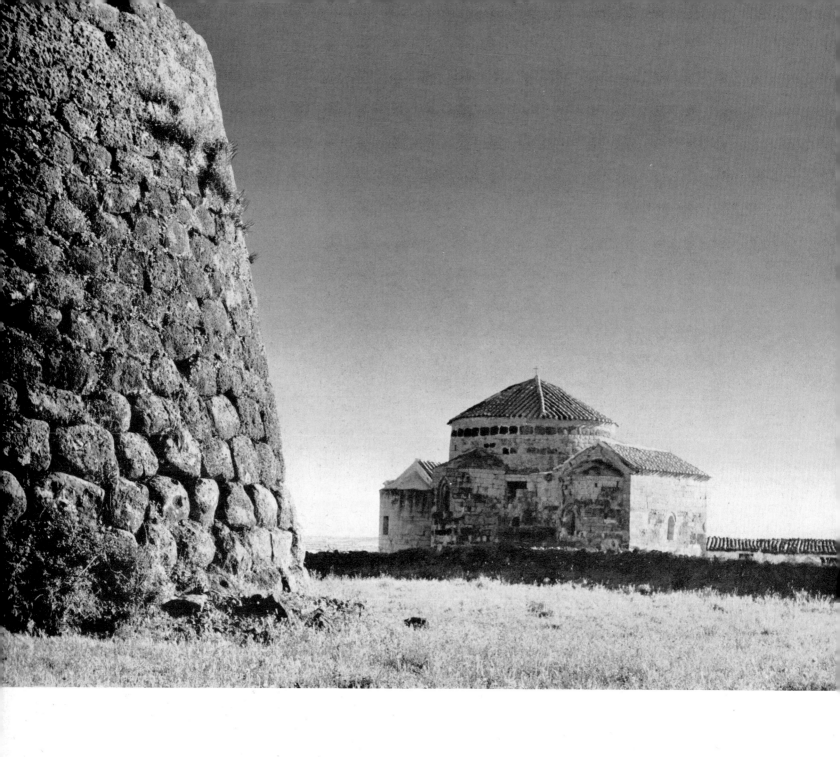

193 Nuragh and Chiesa Santa Sorban, 11th century, near Silanos, Sardinia
194 A "Betili", Neolithic Symbol of Fecundity, at Silanos

195 *Mediaeval Church at Fonni, Sardinia*

196 *Ruined Street, Island of Stromboli*

197 *Pilgrimage Church on Monte Ortobene near Nuoro, Sardinia*
198 *Street at Marciana Alta on the Island of Elba*

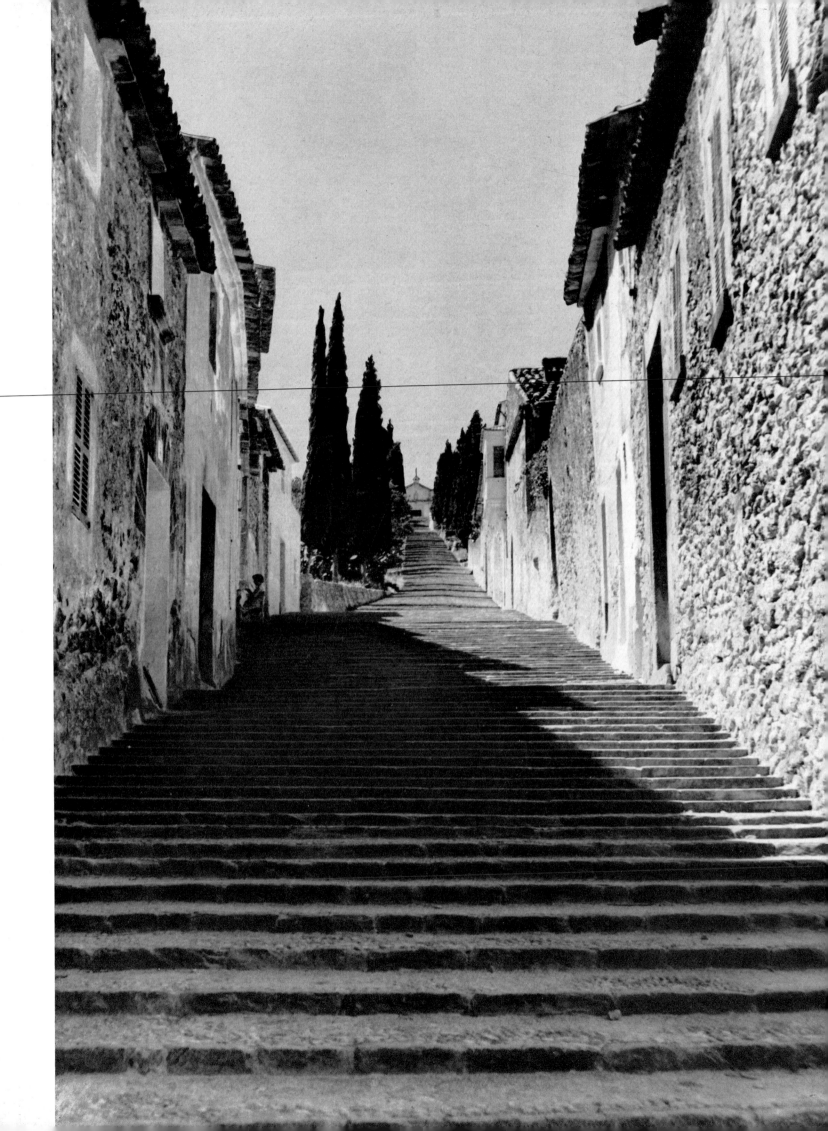

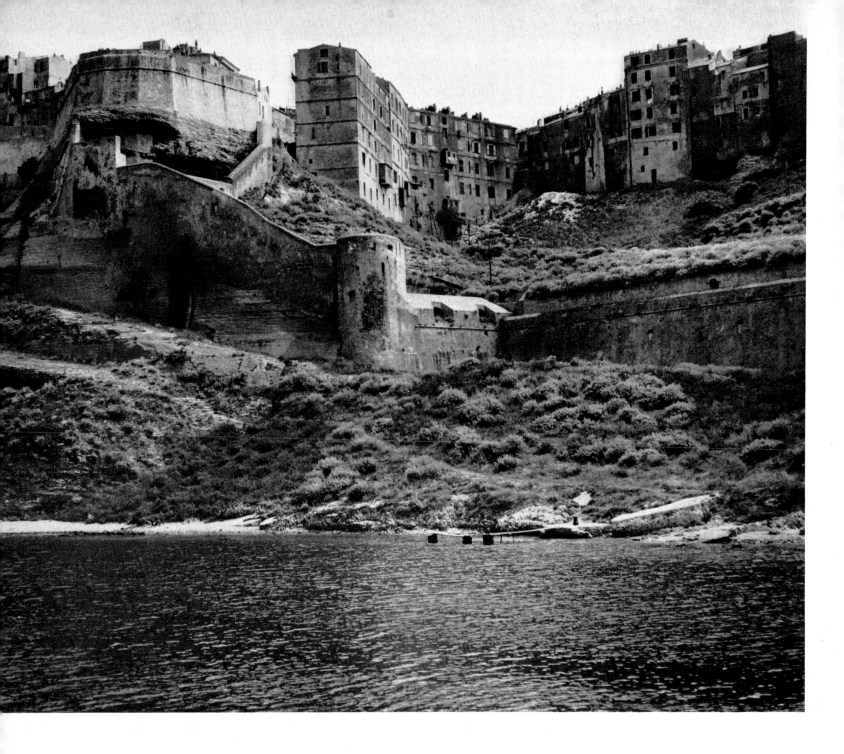

On the preceding pages:

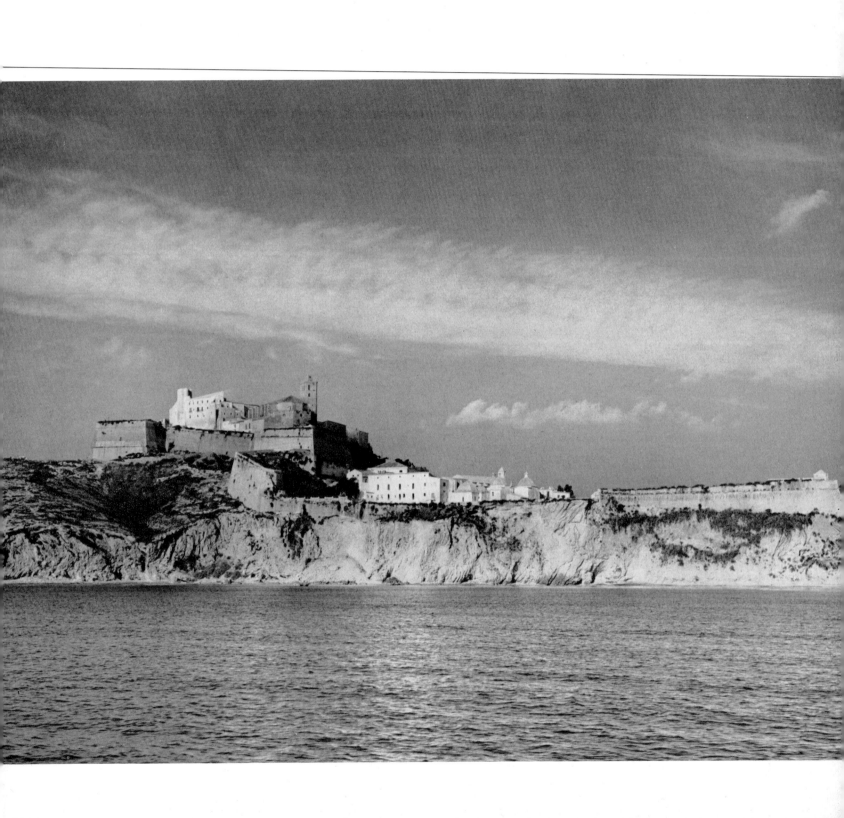

205 *The Church of Santa Eulalia, Ibiza*

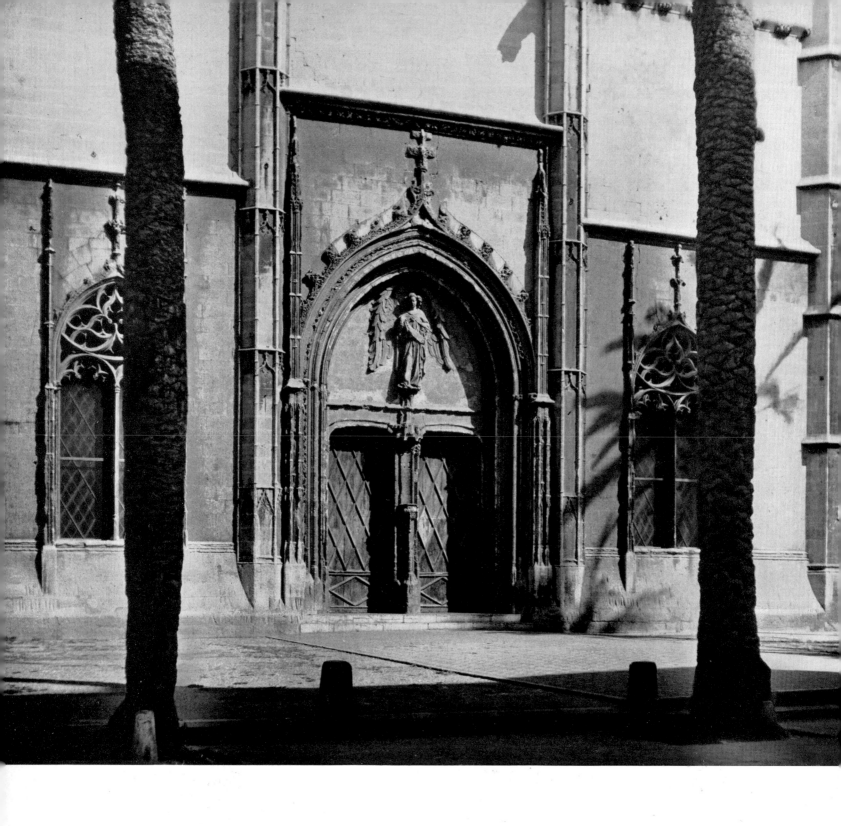

207 The "Loggia" (Exchange) of Palma de Mallorca

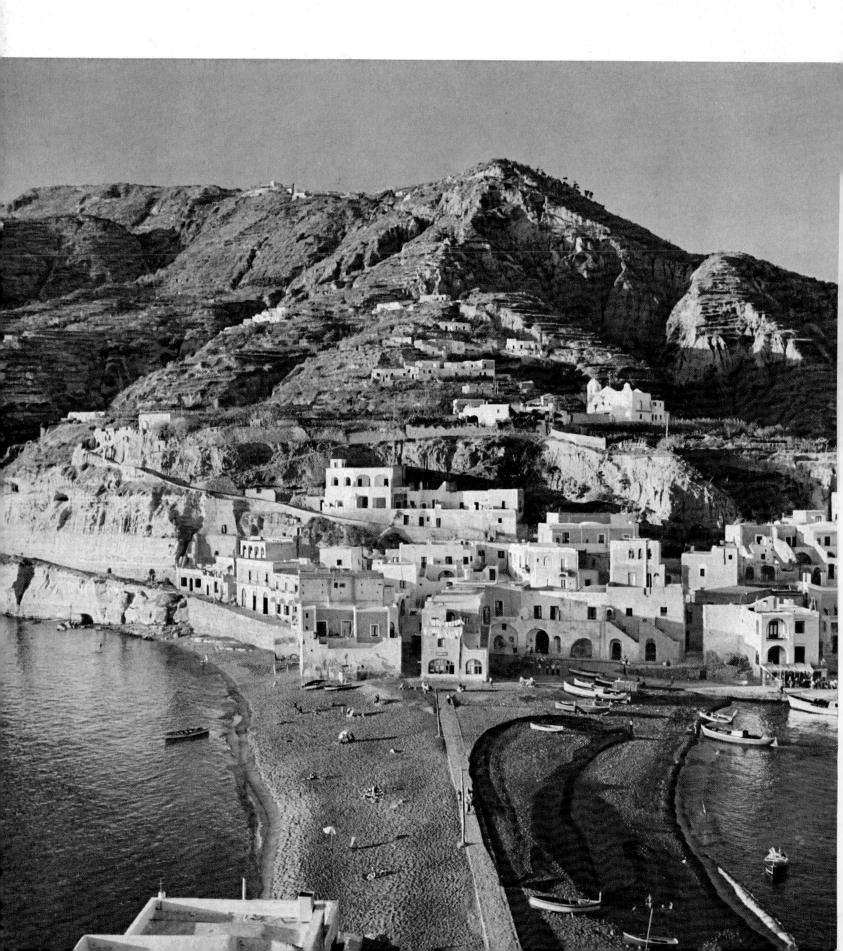

210 *Portal in the Enclosure of the Country Church of San Jesús, Ibiza*

On the following page:

211 *City-Gate with Roman Statue at Ibiza*

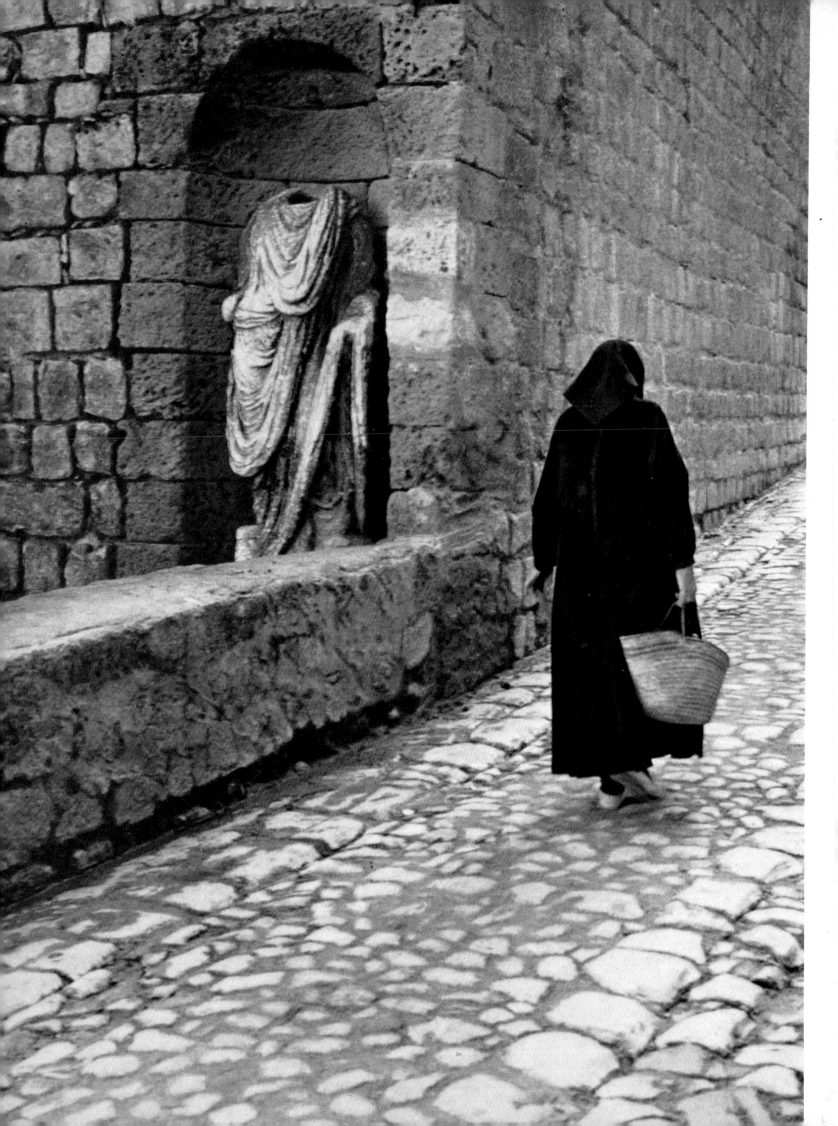